Creativity in the Classroom

Creativity in the Classroom
Case Studies in Using the Arts in Teaching and Learning in Higher Education

Edited by Paul McIntosh and Digby Warren

intellect Bristol, UK / Chicago, USA

First published in the UK in 2013 by
Intellect, The Mill, Parnall Road, Fishponds, Bristol, BS16 3JG, UK

First published in the USA in 2013 by
Intellect, The University of Chicago Press, 1427 E. 60th Street,
Chicago, IL 60637, USA

A catalogue record for this book is available from the
British Library.

Cover designer: Edwin Fox
Copy-editor: MPS Technologies
Production manager: Bethan Ball
Typesetting: Planman Technologies

ISBN 978-1-84150-516-9

Printed and bound by Bell & Bain, UK

Contents

Apologies for absence

It is with sadness that we note the absence of four original contributors to this text. Gina Haynes, Nicki Dabner and Annette Searle of the University of Canterbury, New Zealand experienced the devastating impact of the earthquake that hit Christchurch in February 2011. Though, thankfully, their families and they survived, they lost many local resources and life's work in the wreckage of their buildings. Nicki and Gina's work was set to discuss the making and use of masks in initial teacher training, while Annette would have explored the use of dance in the classroom. We are also short of a chapter from Khaled Albaker who resides in Bahrain and teaches at the Bahrain Teachers College. Having met Khaled in Cambridge in 2010 prior to the Arab Spring in 2011, I was looking forward to his chapter, but sadly other priorities in his home country have taken precedence. He was planning to discuss learning about assessment through role play and drawing. I hope that he remains safe and well.

This mixture of natural disaster and political upheaval has robbed us of the chance for a truly international text and further innovative ideas, but at a personal level we wish them good fortune and full and happy futures.

Paul McIntosh

Acknowledgements

This project would not have become a reality without the goodwill and financial support of the London Metropolitan University. Not only have a number of academic staff and ex-staff participated fully in the contribution of chapters, but the university also pump-primed the start-up costs of the book. For both reasons we are entirely grateful. The Collaborative Action Research Network was also a great source of recruitment, and it is positive to uncover such a wealth of practitioners engaged in such work on an international scale, usually in isolation of other like-minded academics. We hope this brings them together and strengthens the position of such creative practice.

Paul McIntosh
Digby Warren

Introduction

The Current Educational Climate: Why the Creative Arts and Humanities are so Important to Creativity and Learning in the Classroom

Paul McIntosh
(Barts and The London School of Medicine and Dentistry, Queen Mary University London)

In recent years Higher Education has become as embedded in the consumerist economy as much as any other industry in the public or private sector. In the United Kingdom during 2011, policies were put in place in England to restructure funding to Higher Education Institutions (HEIs), reducing the core funding from the Higher Education Funding Council for England (HEFCE) and altering the funding system by leaving HEIs themselves to levy tuition fees up to £9000 per annum for three-year undergraduate studies in order to make up the difference. This is the situation as of September 2012, the date of this draft, though this is a rapidly changing arena. These fees will be met in the first instance by the taxpayer and then repaid by the student on graduation from studies. Core Funding for STEM provision (Science, Technology, Engineering and Mathematics) remains in place as these subjects are described by HEFCE as strategic and vulnerable (HEFCE 2010). Though the current government in the United Kingdom has been open about why they feel this is a legitimate change in policy and funding allocation for scientific and technical innovation to support the scientific and manufacturing economy, the employers of graduates from these fields of study, while needing technically proficient workers, are also looking for people who are creative and innovative. This does not necessarily mean creative in an 'artistic' sense, but with abilities to effect change by approaching problems from a different perspective. The STEM funding issue is related to both compulsory and further education in that there are concerns that there is a lack of interest and motivation shown by young people to engage with these subjects, and that consequently there is a projected deficit in the skill base needed for any future economic growth. For instance, in 1999, the report 'All Our Futures: Creativity, Culture, and Education' (NACCE 1999) cited factors such as rapid cultural and technological change, which exert specific pressures on children and young people in the development of social skills, powers of communication and teamwork, and further, a seeming lack of vitality in science education. It also suggested that the curriculum was inhibiting young people's creative capabilities and that those who taught them, and there was a perceived marginalization of the arts and humanities in education. The report set out a framework for how the application of creativity in learning could inform knowledge and cultural exchange and development within the boundaries of the National Curriculum and at a wider national strategy. Whether this has been implemented fully or not, the vicarious effect of the current focus on the funding of STEM subjects due to their being 'strategic and vulnerable' has left the arts and humanities subjects in a tenuous position, despite their considerable contribution to the United Kingdom, both culturally and economically. More recently, in response to some of these issues, the

Henley Review (2012) made recommendations, among others more specific to cultural life, to increase the exposure of trainee teachers to cultural education as a cross-departmental venture inclusive of the Department for Education and the Department for Culture Media and Sport, and to preserve funding for professional arts training. As yet, the potential for learning through the arts and culture for professional fields such as medicine or education has not been fully realized and remains in the margins; and yet when delivered by artists and performers and contextualized by practitioners from the professional discipline, arts-based methods can be powerful learning experiences.

The second area that has increasingly affected Higher Education in recent years is a move towards a more technical-rational approach to teaching, learning and assessment. Though there is a sound basis to some of this approach, that is, in relation to educational alignment so that teaching and assessment occurs within a framework of learning aims and objectives, it can also lead to a culture of safety, and, as a result, opportunities for innovative teaching and learning are rejected in favour of providing evidence of standardized processes. The 'what works' agenda and its techno-rational foundations have led to crude measures of performance and outcome upon which 'quality' of education and learning is judged within specific criteria found in documentation rather than the learner's experience. Learners themselves are measured through this same process. Driven by national policy that accentuates pursuit of economic capital, students' quests to satisfy the required learning outcomes of subjects studied for successful entry into the employment market often overwhelm the process of learning. Teaching, therefore, in order to deliver this agenda must work to specific learning outcomes and assessment criteria driven through curricula. The question of where this leaves Higher Education as a place for intellectual activity and whole person development, and as a catalyst for learning for life for social capital, consequently becomes an important one. What we are therefore left with are concerns as to how the human and spiritual aspects of learning can be connected as part of the Higher Education experience.

The aim of this book is to present alternatives to this instrumentalism and its impact upon critical thinking and learning. It provides illustrations that through the use of the creative arts and humanities, flexible and creative teaching and learning can take place that goes beyond the delivery of pre-existing knowledge and enables critiques of socially constructed thinking at various levels. This approach can foster deeper awareness of self, one another and the world, richer engagement with study, greater confidence and resilience. In essence, the teaching methods illustrated in this book provide the means to dialogue and debate in the classroom and to support personal, academic and social integration. Through this process, spaces are created for transformative learning to occur. Another premise is that, when used, these methods should be methodologically grounded and rigorous; their validity should be visible and they should have purpose and utility as teaching and learning practices; and in these case studies, there are some compelling examples of how this can be achieved.

The subject specialists' backgrounds to the work in this book are diverse, ranging from fields such as economics, nursing, business studies, medicine and compulsory education. Yet their questions remain the same: firstly, where is the creativity in the education we deliver, and what

purposeful use can it serve? Secondly, how can the creative arts and humanities contribute to this process? As Elliot Eisner (2008) argues, any use of the arts (whether for educational research or learning) should be more than just aesthetic or provide novelty; it must have utility to have any value. Ultimately each contributor provides some qualitative evidence through their writing of the value of such approaches that cannot be measured by the kinds of instrumental structures in which they function. And this is no bad thing, for it places learning for personal growth and social capital in its proper place: at the centre. The question of 'what constitutes evidence?' is crucial to this debate, for as McIntosh and Sobiechowska (2009) argue, this should include the messiness and complexity of an experience as lived by learners and others (296).

In the current climate of Higher Education, the work presented here is evidence of brave endeavour, for it suggests that the values and principles of learning and teaching in higher (and in some cases compulsory) education should not be buried beneath a raft of 'what works' practice in a technical-rational sense. What this means for recipients is that they begin to see that there is more to learning about a subject than merely learning about the subject itself, for behind it there is always impact on human beings. Learning through the creative approaches developed by the contributors here not only provides this opportunity, but also does this in such a way that learners can engage in exciting and stimulating modes of learning that offer an alternative to more reductionist approaches.

What the case studies also illustrate is how effectively scholarly endeavour can be applied to the practical discipline of teaching and assessing. Though presented as descriptions and reflections on their experiences of teaching, the depth of scholarship in the following chapters required to enable these forms of learning cannot be overstated. These methods have not occurred by chance: they have occurred through reading and critical thinking applied to the subject and learner requirements. As such, what we have done is to keep the voices of the contributors as authentic as possible.

To begin to discuss the title of this foreword, why are the creative arts and humanities so important to creativity and learning in the classroom? There are a range of arguments that can inform this discussion. For instance, it is well recognized that as young children we learn through play and experimentation. We also learn socially about moral values through being told stories and watching plays. Narratives and storytelling are cornerstones of social and intellectual identity. Our early lives are rich with the arts and literature, creating vivid visual pictures in our minds, and during this time it is permissible to play and get things wrong because we will learn from this. We then enter a process of learning that becomes subject-focused, and the skills and enjoyment we gained from our early learning can become lost in a more technical and abstract form of learning due to a perception of increasingly higher level learning that removes play and creativity from the experience. From my perspective, this approach can ironically become a less intellectual process, relying on absorption of facts rather than cognitive or exploratory processes. Returning to learning through play and storytelling in later life can seem both a retrograde and challenging step – to begin with, feeling childish and irrelevant – but in time can result in activity of a highly intellectual nature. Symbols and metaphors are part of our visual literacy and convey messages that

other means cannot. Paintings, poems and stories provide us with opportunities for dialogue not possible by more literal language (McIntosh 2010).

Using the arts and humanities for learning involves learners as active participants. They are not being fed information, they are actively exploring a subject; deconstructing and re-constructing it as they dialogue and reflect upon these dialogues as professionals or professionals-in-the-making (see Fook 2012 for an examination of critical reflection for learning and research). Using the arts and humanities for learning is a collaborative and embodied experience. It requires creating and co-creating senses of understanding, enabling creative pauses (De Bono 1992) in which problems can be engaged with in ways that factual knowledge acquisition cannot provide. This is the essence of Schon's (1983) argument that factual subject-based learning alone is not enough for professional action, and that this requires deeper personal learning in order to negotiate the messiness of professional life and social interaction with others. Perhaps most importantly, in the following chapters, what we most often implicitly see is what Bernard et al. (2010) call 'joining in' and 'knowing the I'. In this, they refer to the ways in which participants attend to one another and respond to the emotions and associations that emerge through the discussions. For them:

'Joining in' meant listening for emotions, bringing them inside our discussion rather than banishing them from our minds and consideration. Instead, we sought ways to use our emotions as objects of reflection.

(Bernard et al. 2010: 485)

Stories, poems, images, and other embodied practices, such as drama or sculpting, can act as catalysts to an exploration of the 'I' and dialogue in ways that emotions and experiences are felt or understood. This is not a replacement to the academic learning of a subject; it acts in addition to this, offering important reflexive learning complimentary to that which is technical. The following chapters do this reflexively, transpersonally and critically through a wide range of media, and remind us that the arts and humanities are not aesthetic luxuries of life second in status to the scientific and mathematical traditions; they are fundamental to what it means to learn and grow, regardless of the path of learning followed.

As a final point, I would like to suggest that the constituent chapters included here are more than just examplars of creative teaching: they are in their own way case studies of practitioner researchers at work (McIntosh 2010), testing out ideas, reformulating them and theorizing upon them. Though not necessarily constructed as such, they are evidence of educational action research – a form of practice-based evidence: though not empirical or scientific in the truest sense, they offer ideas, structures, and inspiration for aspiring innovative teachers to risk creative teaching safely – for themselves and their learners. As John Elliott (2007) writes:

The fact that commonsense concepts of classrooms are not precise enough for scientific purposes does not mean that they are not sufficiently precise for others. They may well

be precise enough for the purposes of action in particular classroom situations. In fact I would argue that commonsense concepts are generated for such purposes. They orientate the practitioner to practically relevant features of particular situations.

(Elliot 2007: 91)

Though the chapter contributions here are perhaps more in the margins of teaching than Elliott envisaged initially at the date of original publication, the sentiment behind them is the same: Orientation, Relevance and Action. In all cases they reflect on the experience of developing and conducting such work while at the same time offering ideas for further testing and the pitfalls to be avoided along the way. It is not a book for educational theorists, though it is rich in theory generation; it is a book for those seeking to extend the limits of their teaching into uncharted and exciting territory and be reassured by those that have, and continue, to take worthwhile risks in their teaching and assessing.

References

Bernard, R., Cervoni, C., Desir, C. and McKamey, C. (2010), '"Joining In" and "Knowing the I": On Becoming Reflexive Scholars', in W. Luttrell (ed.), *Qualitative Educational Research: Readings in Reflexive Methodology and Transformative Practice*, London: Routledge.

De Bono, E. (1992), *Serious Creativity*, New York: Harper Collins.

Eisner, E. (2008), 'Persistent Tensions in Arts-Based Research', in M. Cahnmann-Taylor and R. Siegesmund (eds), *Arts-Based Research in Education: Foundations for Practice*, London: Routledge.

Elliott, J. (2007), 'Classroom Research: Science or Commonsense?' in J. Elliott (ed.), *Reflecting Where the Action Is: The Selected Work of John Elliott*, London: Routledge.

Fook, J. (2012), 'Developing Critical Reflection as a Research Method', in J. Higgs, A. Titchen, D. Horsfall and D. Bridges (eds), *Creating Spaces for Qualitative Researching: Living Research*, Rotterdam: Sense Publishers.

HEFCE (2010), *Guide to Funding: How HEFCE Allocates its Funds*, London: Higher Education Funding Council for England.

Henley, D. (2012), *Cultural Education in England: an Independent Review*, Department for Culture, Media, and Sport and Department for Education, London: HMSO.

McIntosh, P. (2010), *Action Research and Reflective Practice: Creative and Visual Methods to Facilitate Reflection and Learning*, London: Routledge.

McIntosh, P. and Sobiechowska, P. (2009), 'Creative Methods: Problematics for Inquiry and Pedagogy in Health and Social Care', *Power and Education*, 1: 3, pp. 295–206.

NACCE (1999), *All Our Futures: Creativity, Culture, and Education*. National Advisory Committee on Cultural and Creative Education; Her Majesty's Inspectorate of Education, London: HMSO.

Schon, D. A. (1983), *The Reflective Practitioner: How Professionals Think in Action*, New York: Basic Books.

PART I

Encouraging Creativity in the Classroom

Chapter 1

Using the Creative Arts for Collaboration

Babs Anderson
(Liverpool Hope University)

Jo Albin-Clark
(Edge Hill University)

Introduction

The academic study of the Early Years of Childhood, from birth to eight years of age, encompasses a diverse learning community with a wide range of students, from foundation degree students, who may have significant practical experience and training yet few formal academic qualifications, to Early Childhood Studies students, who may have little or no experience of caring for young children at the beginning of their undergraduate course at university.

The content of Early Childhood (and Early Years) courses include aspects of academic disciplines such as history, philosophy, psychology and sociology in addition to applied areas, such as leadership and management, with an Early Years focus. The concept of critical pedagogy utilizing interdisciplinary spaces, while promoting the strengths of each component discipline (McArthur 2010), is one that rests easily within the subject area, focusing on emancipatory ideals in advancing social recognition of the value of studying Early Childhood so that any perceived lack of status of not only the subject area itself but also those who work within its remit can be addressed. Harvey and Norman (2007) suggest that university assessment procedures need to recognize learning within the workplace as valid, and this would appear to benefit the links between theory and its application in practice.

However, structuring courses at university around intended learning outcomes set by the teaching team or tutor, such as advocated by Biggs and Tang (2007), may not provide for the students' engagement with their own learning, incorporating their own ideas of what they would need and wish to know, as the learning outcomes for their course of study have been predetermined and transmitted as such explicitly to them. Additionally Blackmore (2009) examines the need for a more complex investigation into what constitutes valued knowledge in student-lecturer learning interactions rather than a simple reliance on student evaluations as unilateral sources of participant perspectives.

Hockings (2009) suggests that for a small but significant number of students, student-centred learning is ineffective, and one example of this is that when students are overwhelmed by competing claims on their time and energy they actively seek surface-level learning approaches in order to reduce their stressors. She argues further that to increase the educational potential for these students, the 'teacher' needs to have a clearer perspective on the historical sociocultural backgrounds of the students, recognizing the variance of experience, beliefs, attitudes and sense of identity within the student population.

Recognition of the teacher's expertise as a negotiator of a projected learning journey initiated by the interests of the learner has long been a cornerstone of Early Childhood pedagogy, both in this country and internationally (Waller 2009; Rodd 2006), and it would appear that there is much to learn in teaching and learning in Higher Education in the creation of independent autonomous and self-directed learners, following a pedagogy based on experiential learning, like that we employ for our youngest children.

The influence of the Reggio Emilia approach

As part of the teaching, training and professional development of Early Childhood teachers and practitioners, core aspects of many modules offered in our institutions include the influence of international approaches. The educational approach of the city of Reggio Emilia in Northern Italy is world renowned and referred to in almost reverential tones in the world of Early Childhood education. We wished to explore aspects of this approach that might be compatible with our own contexts, recognizing also that it is not replicable outside of its origins.

As Early Childhood lecturers and teachers, it was a rite of passage for us to travel to Reggio Emilia on an international study week in 2010 and understand first-hand its pedagogy and practice. Our wish was to engage in reflective dialogue and reflexive action to understand how our own thinking could be deepened and challenged. The aim was to consider how our work as lecturers could be enriched and perhaps transformed. 'Our job is to learn why we are teachers' (Rinaldi 2006: 139). We were intrigued as to how we could use this experience to extend and deepen the quality of our work with our diverse groups of students.

It is important, however, to set this approach in its historical sociocultural context in order to fully appreciate the origins and development of the Reggio Emilia approach to Early Childhood education and care. Reggio Emilia is historically a wealthy region, and after the devastation of the Second World War, a group of parents decided that they wanted to build a school within the community that was significantly different in its primary aim and sought to raise their children to think for themselves and be valued as strong and competent learners (Rinaldi 2006). A young Reggio Emilia teacher named Loris Malaguzzi (1920–1994) saw something extraordinary in this way of viewing young children and in response developed a city-wide approach that continued throughout his whole career. Indeed, his influence is still core to the approach today. His view of a child's limitless capacity as a learner, together with the philosophy of 'The Hundred Languages' (Edwards et al. 1993) in which a myriad of means of self-expression are recognized and promoted, enables children to explore their thoughts in multiple creative and expressive ways. The schools in this approach are characterized by aesthetically organized spaces, including an atelier (studio or laboratory) with an emphasis on open-ended, recycled and natural resources. This grows from the kitchen at the heart of the school and a light-filled central space, termed piazza that mimics the central squares of Italy as a place to meet and converse within the family of the school.

The staffing of the schools is significant in that the pedagogical team is made up of a *pedagogista*, a coordinating and advisory role, and an *atelerista*, a trained artist. The cooks are seen as part of the pedagogical team and teachers work in pairs. There is no imposed curriculum, assessments or inspections; only a very slim volume termed 'Indications' that outlines the philosophical approach. Teaching evolves from children's responses, and these projects (Vecchi 2010) grow over months and sometimes years.

There are three significant inferences that informed our future enquiries as Early Childhood university lecturers. First, we have a distinct view of a child as a protagonist of their own learning and a citizen with rights, rich in potential (Dahlberg and Moss 2005). Second, the adult role is defined in response to this as primarily within the pedagogy of listening (Rinaldi 2006). This view of teaching is to create provocations, to organize an aesthetic learning environment and engage in a co-construction of learning between children and adults within a social construct. Third, the concept of teacher/researcher and the reciprocal nature between these roles is illuminated from the use of documentation of thinking and learning to make that learning visible. This documentation takes the form of narrative commentary, photographs and video that describes and interprets the children's learning. This documentation is also explored as a means of professional development and as way for the whole community to share and understand young children's worlds. These inferences created our enquiries.

Collaborations using creative arts

In the case studies that follow, we aimed to use our contact sessions with students to create enquiries into collaborative aesthetic expression and its connections with student and lecturer learning. We also wished to make the distinction between cooperative group learning and collaborative group learning clear. In our view, cooperative group learning involves working together to achieve a goal, whereas collaborative group learning requires the possibility of adjusting one's own intention to take account of the input of another or others and thus requires a higher level of self-awareness, self-belief, motivation and negotiation. Dweck (2006) proposes two observable mindsets with regard to learning from perceived failure in which one sees either a setback or failure as a learning opportunity. In negotiation in groups, the possibility of an individual's suggestions being rejected is present but so too is the possibility of seeing that another's suggestion has potential. The willingness to proceed in this situation requires a commitment from the students to engage with the process and an awareness of the lecturer of how to support their students through these challenges.

Case study 1

Exploring children's thinking over time through documentation and its potential as a form of professional development for university students was an aspect that was developed in response to the learning experience at Reggio. Detailed observations of a

two-year-old child in terms of his interests and explorations were used as a vehicle for engaging in professional dialogue between two staff members with pedagogical roles within a local authority in understanding and co-constructing meanings within an ethical framework. This took the form of an analytical commentary that ran alongside descriptions of his learning depicted in a series of photographs and video.

Another layer was then developed to support the learning of university undergraduates on a BA Honours Early Years Leadership degree studying a module on international perspectives. Students had the opportunity to explore the documentation of the child's learning alongside the analytical commentary with the underpinning pedagogy of the Reggio approach. Thus, photographs and video are used as interpretive illustrations of the everyday experiences of a child at nursery.

The value of this exercise revealed other interpretations and nuances through the shared reflection that may not have been possible if this were completed as an individual task. The collective reflective dialogue that this provoked between students resulted in another layer of understanding being inferred from the original child observation and analysis, demonstrating the creative processes of understanding and the significance of a social construct within it. Unfortunately, in a busy and unpredictable play-based learning environment with many demands on attention, not to mention the presence of very young children, this sort of dialogue can be underexploited for the Early Years practitioner or teacher. The university learning environment can provide this provocation of intellectual curiosity, with space to think and challenge, and therefore allow students to learn from others, to make connections, examine them and develop new definitions.

The benefits of this are clear, and can be gained on many levels. Sharing documentation of their learning with children adds other multiple perspectives and provides opportunities for rich thinking and talk, importantly including the chance for children to represent and revisit ideas and experiences. Recognizing that definitions of creativity and its stages have many parallels with this sort of meta-learning and the concept of ideas needing to incubate and simmer (Bruce 2008), while also being reviewed and revisited, are cogent to the Reggio approach.

This documentation was able to demonstrate the stratum of understandings (Bronfenbrenner 1979) of learning at teacher, advisor, lecturer and student levels. This complexity yet accessibility of thinking firstly enabled an exercise of child observation to be analysed and understood from two perspectives through a reflective dialogue. Secondly, university students had a first-hand learning experience that demonstrated creative approaches that had evolved beyond the descriptive. Students commented that this teaching allowed them to see and understand the process of learning and supported their ability to articulate its complexities in an accessible way. Teaching at the university level in this example was a co-construction between tutor and students that valued first-hand observations, explored the potential of professional dialogue and, most significantly, creatively built a multi-layered interpretation with each fresh analysis. This collaboration was a creative process and demonstrates a vibrant vehicle for teaching and learning.

The role of the lecturer here is that of a provoker of thought, reflection and dialogue that seeks to find new meanings and understandings, ultimately engaging in meta-learning.

Case study 2

Examining the theoretical aspects of team building within the framework of leadership is an important element of a number of courses, such as the Foundation Degree in Early Years Leadership and the taught components of Early Years Professional programmes. For students on these courses, it is essential that they have not only a theoretical knowledge and understanding of leadership, but also recognize their own skills and identify areas for development. The use of practical experiential sessions alongside more theoretical knowledge-based information-led sessions makes the material more accessible to the students by enabling them to experience the embodiment of the given concepts. The intention is also to give the students ownership of their own learning so that insights from practical sessions are not predetermined but the result of a learning journey with the lecturer seen by both student and the lecturer as facilitator with expertise rather than as instructional expert.

One such example arose with a group of students on the Early Years Professional programme. The cohort had created a group identity over a period of weeks, so each individual had developed a public persona within the shared space. This varied according to a wide range of characteristics, including how comfortable they were with the formal teaching environment of mostly tables and chairs arranged to view the whiteboard controlled by the lecturer.

The group was provided with a basic range of resources, masking tape and a large amount of newspaper and were given the task of designing a den. The students were free to use as much or as little of the given resources or to add to these with objects found in the seminar room. Interestingly, the furniture itself was commissioned to form an infrastructure by each group. Once each group were satisfied that their den was complete, they viewed the other dens, talking to their colleagues and asking questions. This open-ended activity was photographed with the informed permission of the students in order to document the process of planning, design and creation of the group den. The students were then encouraged to analyse these processes by group reflection on the phenomenon (Schön 1983). This enabled each individual to recognize how they had responded to the activity and supported their reflections as to whether this was a customary response or whether the activity had provoked an unexpected reaction. Aspects of leadership and team development were clearly evident in these analyses.

One unexpected response arose, which gave rise to thoughtful discussions later for the whole group, requiring them to re-evaluate their attitudes. One student arrived late for the session, due to unforeseen circumstances. This lack of presence, initially physical, had an impact on her full engagement with the collaborative project. The absence of ownership became apparent through missing the planning phase and the challenge of engaging with the group intention deliberated within this phase was clear, both in the physical way the student

positioned herself on the outskirts of the activity and her elucidation of the reasons for this distance in the discussions afterwards. An example of an unintended learning outcome, this offered the opportunity for a collaborative enquiry into the implications for this insight.

Case study 3

An established group of postgraduate students were given the opportunity to explore their experiences so far in their course through a walk on campus in which they collected a number of found objects that represented their ideas, such as a found sweet wrapper and a flower head. The intention of the session therefore was that of object analysis, moving from a personal, implicit meaning to an overt shared meaning for a wider audience, accepting of student identity (Finnigan 2009).

On their return to the shared space, they created an individual representation of their ideas, feelings and thoughts. Once completed, they engaged in a sharing of their construct with a group of their peers. On listening to the whole group's work, the groups then set out to gather together threads of similarity and attempted to organize the individual constructs into a collective piece. Discussions on how to represent the uniqueness of experience for students in addition to the common themes were matched by the physical representations of the metaphorical concepts.

Efland (2002) considers that interpretation by and for another using the medium of art enables students to construct their own meanings and to extend these in regard to those of others – to deepen their thinking through close observation of how another has responded to the same stimulus – with a personal expression of their perspectives. The use of collaborative activity as a vehicle for teaching and learning supports the creative process of learning in Higher Education, so that individual and collective expression is explicitly viewed and used as a focus for open-ended dialogue.

One of the difficulties encountered by the students on this occasion was how to facilitate others' creativity without imposing their own ideas. More overtly confident students were encouraged to recognize that the manner of their own input may have consequences for the other members of the group and to aim for a balance of initiation of ideas with the scope for listening and acting on the ideas of others. This required sensitive facilitation on the part of the lecturer, as can be imagined.

(For an accessible source of ideas for creative activities, see Coats et al. 2006)

Case study 4

In order to promote widening participation in university life, groups of sixth form students studying for AS and A-Levels in schools and colleges are encouraged to partake of a summer university programme as potential entrants to undergraduate study at university level. One

particular group engaged with a single session, lasting two hours, to explore Early Childhood studies.

One of the activities within this session included the practical design of a hat, as this is a common project enjoyed by young children. Within small groups, self-selected by the students, each student created their own hat design, using a simple range of drawing and colouring tools. They then shared each individual design with their group with sustained group discussion, culminating in the implementation of a collaborative design, using a wider range of resources.

The learning from this session was twofold. For some students, there were difficulties in expressing their own ideas. These included concerns about the judgement of others in that their practical technical skills, such as drawing technique, might be called into question and made a matter of ridicule. Hughes (2010) also suggests that one facet of group learning is social identity and, in this instance, the group was at the early stages of forming a social identity and this may have led to a reluctance to expose too much of the self through self-expression for particular individuals.

The four case studies illustrate the use of creative approaches to explore the means of supporting students in collaborative experiences of constructing meanings, both individually and collectively. Within the context of the Reggio Emilia approach to Early Childhood pedagogy, this collective construction of meaning is termed co-construction of knowledge and understanding and as such forms an explicit cornerstone for the social interactions of the children and their practitioners, supporting the children with a range of media through which to articulate their thinking. The use of the creative approaches above enables students to revisit their own hundred languages of self-experience, to reconnect with alternative means of elaborating on their ideas. By using collaborative methodologies, we expose them to the expression of others in a supportive space, aiming to foster a curiosity for students to examine and reflect on their own responses, personal, social, cognitive and affective, and to extend and deepen their understanding through considering the responses of others.

The use of the creative arts to explore the development of human potential has been of interest in the fields of health, social care and education, for example, Titchen and McCormack's work in critical creativity (2010) and how this might be expressed through personal and collaborative expression. McIntosh (2010) also discusses the notion of creativity as a means of paying deliberate attention to our thoughts and our experiences, thus giving a space for creativity as an active experiential process, adding new and innovative ideas through interaction. The particular forms in the case studies, such as photographs, video, den-making, found objects and paper sculpture, were used as vehicles for such active engagements, to provide a specific area of focus and activity and to delineate a phenomenon under investigation. Collaboration on such projects enhances the opportunity to engage with others in a combined endeavour, recognizing, valuing and affirming the worth of both individual and collective responses.

> Our understanding of others' perspectives is enabled by our active participation in webs of interpersonal interactivity, not from mental feats of 'mind-reading'.
>
> (Martin et al. 2008: 313)

An aspirational view of the students' experiences underpins the teaching and learning intentions. Instead of using the concept of education as transformation, the notion of 'iterative reframing' is used in its place to highlight the potential for reframing ideas and perspectives, a process to encourage students to review their own ideas, concepts and beliefs in the light of those of others and that of their own learning. To understand their own current framing of ideas and the experiences that have influenced them can be highly challenging philosophically on both personal and professional levels and hence requires a commitment to the learning process for themselves and others. That this process is fluid and responsive to the learners recognizes a dynamic emancipatory trajectory, consistent with that of critical pedagogy (McArthur 2010), in that learning in one or more interconnecting academic disciplines can strengthen the students' own self-belief in themselves as capable and valuable contributors to the learning community and ultimately the wider Early Years arena. The use of iteration requires an ongoing set of experiences, which cumulatively create a stronger sense in the students of their own ontological perspectives and how these impact on the ways they seek to act on the world, including the lives of the young children and their families with whom they interact. Elaborating on their own sense of themselves within a collaborative framework of action gives them the potential for understanding others.

Conclusion

The danger of content-led curriculum models is that of the expert lecturer with students as passive recipients of information, bypassing the need to support learners as deep thinkers beyond the demands of the assessed learning outcomes.

Considering the nature of learning as a slow investigation of responses, including incubation of creative ideas, we need to examine whether this model can support Early Years practitioners in coping with the complexities and intellectual challenges of fostering the learning and development of young children. Ideally, our students are able to engage with Schön's (1983) Reflection-on-action and Reflection-in-action, so that the professional and personal spheres of action are the result of self-awareness and enable the student to act in a congruent manner, where their professional stance reflects their own values and beliefs.

As teachers and researchers, we see our role as a provocation, a prompt in that we set up an environment to create a critical space for reflection. This way of working with students is more demanding of the lecturer role and less hierarchical by nature than might otherwise be the case of a transmitter of information, requiring a deep knowledge of the role of facilitator, including that of the distinction between being an acknowledged expert in the field and a

possessor of expertise willing to learn from others. We want our students to learn and to make connections with their prior knowledge and understanding, so it becomes a habit of the mind, a lifelong disposition, and one way to illustrate this is to model it as learners ourselves.

In order to maintain this disposition of lifelong learning, then, it is clear that as lecturers we also need the challenges we intend to present to our students. For us, the week-long study trip enabled us to experience a learning situation, which we could then explore in dialogue with each other. The four aspects of Kolb's learning cycle (1984) can be used to illustrate something of this process.

The experience of actually seeing the infant-toddler and pre-schools of Reggio Emilia and being able to observe first-hand the daily organization provided a rich seam of material to consider in our reflections. We were able to theorize how this pedagogy supported the learning and development of young children, connecting this with our prior knowledge and understanding. This then supported us in the application of this theorizing to our university context with our students, adapting it to meet our specific contexts.

References

Biggs, J. and Tang, C. (2007), *Teaching for Quality Learning at University* (3rd ed.), Maidenhead: Society for Research into Higher Education and Oxford University Press.

Blackmore, J. (2009), 'Academic Pedagogies, Quality Logics and Performative Universities: Evaluating Teaching and What Students Want', in *Studies in Higher Education*, Vol. 34: 8, pp. 857–872.

Bronfenbrenner, U. (1979), *The Ecology of Human Development*, Cambridge, MA: Harvard University Press.

Bruce, T. (2008), *Cultivating Creativity in Babies, Toddlers and Young Children*, Abingdon: Hodder & Stoughton.

Coats, E., Dewing, J., and Titchen, A. (2006), *Opening Doors on Creativity: Resources to Awaken Creative Working. A Learning Resource*, London: Royal College of Nursing Institute.

Dahlberg, G. and Moss, P. (2005), *Ethics and Politics in Early Childhood Education (Contesting Early Childhood)*, Abingdon: Routledge.

Dweck, C. S. (2006), *Mindset: The New Psychology of Success*, New York: Random House.

Edwards, C., Gandini, L., and Forman, G. (eds.) (1993), *The Hundred Languages of Children: The Reggio Emilia Approach to Early Childhood Education* (2nd ed.), Westport, CT: Ablex.

Efland, A. D. (2002), *Art and Cognition: Integrating the Visual Arts in the Curriculum*, New York: Teacher's College Press.

Finnigan, T. (2009), '"Tell Us about It": Diverse Student Voices in Creative Practice', in *Art, Design and Communication in Higher Education*, Vol. 8: 2, pp. 135–150.

Harvey, M. and Norman, L. (2007), 'Beyond Competences: What Higher Education Assessment Could Offer the Workplace and the Practitioner-researcher', in *Research in Post-Compulsory Education*, Vol. 12: 3, pp. 331–342.

Hockings, C. (2009), 'Reaching the Students that Student-centred Learning Cannot Reach', in *British Educational Research Journal*, Vol. 35: 1, pp. 83–99.

Hughes, G. (2010), 'Identity and Belonging in Social Learning Groups; the Importance of Distinguishing Social, Operational and Knowledge-related Identity congruence', in *British Educational Research Journal*, Vol. 36: 1, pp. 47–63.

Kolb, D. A. (1984), *Experiential Learning*, Englewood Cliffs, NJ: Prentice Hall.

Martin, J., Sokol, B., and Elfers, T. (2008), 'Taking and Coordinating Perspectives: From Prereflective Interactivity, through Reflective Intersubjectivity, to Metareflective Sociality', in *Human Development*, Vol. 51, pp. 294–317.

McArthur, J. (2010), 'Time to Look Anew: Critical Pedagogy and Disciplines within Higher Education', in *Studies in Higher Education*, Vol. 35: 3, pp. 301–315.

McIntosh, P. (2010), *Action Research and Reflective Practice: Creative and Visual Methods to Facilitate Reflection and Learning*, London: Routledge.

Rinaldi, C. (2006), *In Dialogue with Reggio Emilia, Listening, Researching and Learning*, Abingdon: Routledge.

Rodd, J. (2006), *Leadership in Early Childhood* (3rd ed.), Maidenhead: Oxford University Press.

Schön, D. (1983), *The Reflective Practitioner: How Professionals Think in Action*. New York: Basic Books.

Titchen, A. and McCormack, B. (2010), 'Dancing with Stones: Critical Creativity as Methodology for Human Flourishing', in *Educational Action Research*, Vol. 18: 4, pp. 531–554.

Vecchi, V. (2010), *Art and Creativity in Reggio Emilia (Contesting Early Childhood)*, Abingdon: Routledge.

Waller, T. (ed.) (2009), *An Introduction to Early Childhood* (2nd ed.). London: Sage.

Chapter 2

Introducing Arts-based Inquiry into Medical Education: 'Exploring the Creative Arts in Health and Illness'

Louise Younie
(Barts and The London School of Medicine and Dentistry,
Queen Mary University London)

Introduction

The real world of doctoring and meeting patients draws on more than student learnt knowledge, communication and clinical skills. Encountering patient suffering, working with uncertainty, complexity and subjectivity, and facing our own vulnerability and mortality are challenges that face the future medical professional. Yet medical student training predominantly involves developing the medical toolkit of diagnosis and treatment through disease-focussed and depersonalized ways of knowing and learning. Patients become cases, their illness narratives, a case history.

My interest in finding alternative ways to develop and educate future medical practitioners arises from my own journey from student to general practitioner and there finding the limits of this medical toolkit. For the last eight years I have been exploring the use of the arts and creativity as a vehicle for practitioner development. Borrowing the term 'arts-based inquiry' from Liamputtong and Rumbold (2008: 10) in the research literature, I have applied it to this form of medical education. I use the term to mean medical student practical engagement with any art form – poetry, photography, painting, narrative, sculpture, dance, music, etc. – as they reflect on their experiences.

Figure 1.

My journey into this field began with a Student Selected Component (SSC) that I developed in 2003 called 'Exploring the Creative Arts in Health and Illness' and have continued to deliver and develop annually. This offers a small group of students (approximately twelve) the opportunity to hear about and experientially engage with creative therapies that are offered to patients. I co-facilitate this course with a variety of arts-based tutors. In this chapter I will draw on both my experience of delivery and research in this field to consider learning through the arts with medical students with a focus on this SSC in particular.

Context

Embracing the arts and humanities within medical education has received increasing attention over the last 10–20 years in the United Kingdom, following similar traditions in the United States (Charon et al. 1995; Lazarus and Rosslyn 2003). The arts and humanities penetrate the medical undergraduate curriculum in different ways – often within the context of optional SSCs although there are a few examples where students across the whole year have the option for creative engagement (Younie 2009; Thompson et al. 2010). The literature offers many examples of students engaging with the creative work of others (e.g., Jacobson et al. 2004; Lazarus and Rosslyn 2003; Lancaster et al. 2002). However, increasingly, medical students are being given opportunities to engage in their own creative process (arts-based inquiry) – sometimes this is led purely by artists such as the Performing Medicine group (de la Croix et al. 2011), other times by clinicians with an interest in literature (Charon 2006) or film (Memel et al. 2009) or more generally the creative process (Shapiro et al. 2006).

Arts-based inquiry is a fairly new field within medical education that expands the concept of medical humanities, taking students beyond 'being consumers of the artistic output of others' and creating space for them to 'become artistic creators themselves' (Weisz and Albury 2010: 172). This mode of education moves away from the more traditional 'transmissive' approach to learning, instead inviting students into a 'transformative, dialogical, and reciprocal encounter' (Milligan and Woodley 2009: 134). It breaks the bondage of student rote learning of facts and skills with a focus on passing exams, instead nurturing their curiosity, offering space for collaboration and the sharing of experiences and perceptions. The arts can offer a space to engage with a culture other than the dominant positivist medical education approach, thus allowing students to view their studies and journey to doctorhood from other angles. A number of different students opting for my arts-based inquiry SSC have used the phrase 'a breath of fresh air' to describe their experience of learning. They talk about it being 'liberating' not having to find the 'right answer'.

Arts-based inquiry is not so much a case of putting learning into students as drawing it out. (The origin of the word 'educate' is derived from the Latin 'educere', which means to 'lead out' [Oxford Dictionaries 2012]). Learning through the arts allows students to engage in other forms of communication (e.g., visual, movement, music, etc.) and other ways of knowing (embodied, intuitive, imaginative, interpersonal). Embracing other languages and

Figure 2.

ways of knowing extends the reflective space and potential for new understandings and also provides a platform for the often neglected patient and student voice (Younie 2011).

The creative work is an opportunity for students to begin to 'author' their words in the face of otherwise being slowly encultured into more traditional medical discourse:

> … medical discourse is monological, largely omitting the patient's voice. Another relatively neglected voice is that of the medical student … medical training in general tends to

silence personal voice ... students learn to tell one kind of story – the case presentation of the patient ... through an impersonal, passive voice that obscures the identity of the teller ...

(Shapiro 2009: 12)

Ethos of the course

Your curriculum tends to be focused on the 'what' question – what diagnosis, what investigation, what treatment. ... [T]his course offers the space to think about the 'how' question – how will you as a doctor deliver medical care to your patients, how will you listen and facilitate the healing process for your patients. There is much more to medicine than just getting the right diagnosis and treatment. The art of medicine encompasses the whole way in which you use the science that you have learnt.

(Introductory reading material for the students)

Medical students are trained to disregard personal knowledge – whether it be that of the patient regarding their lived experience with illness (seen as subjective) or their own intuitive interpretations and perceptions. Their exams look for the delivery of a correct diagnosis or treatment, objective facts that are right or wrong.

We are bombarded with information and forced to absorb it like sponges.

(Medical student, 2005)

Schon (1983) laments this dominance of the techno-rational epistemological approach (how to manage known situations) in the education of professionals, at the expense of neglecting 'professional artistry' – dealing with complexity, subjectivity and uncertainty (Maudsley and Strivens 2000).

The issue with medical education is that we are seeking to develop doctors who will bridge both the world of the patient and their illness experiences as well as the medical world of diseases and treatments, yet the former is often neglected at the expense of the latter. Levenstein et al. (1986) affirm this importance of developing an understanding of our patients alongside the knowledge and skills relating to disease. They write about the doctor having two tasks in a consultation – understanding disease *and* understanding the patient. Das Gupta (2008) adds another dimension, that of understanding the doctor, that is, developing our own self-awareness.

Developing understanding of patients and their lived experiences or developing the self-awareness of future doctors cannot simply be taught. Instead safe spaces need to be created conducive to gaining new insights and awarenesses, where perspectives can be realized and challenged (Younie 2006). Such learning has been termed transformative learning (Mezirow 1997; Cranton 2000), and the arts have been recognized as a key ingredient to

facilitate such learning (Boyd and Myers 1988; Dirkx 1997). Boyd (1991) suggests that creativity can open the door to the deeper self potentially bringing to light unrecognized emotions, attitudes or beliefs.

Student reasons for choosing this course

Students in their second year have the option of choosing this course. Reasons students give for opting for it (in their pre-course questionnaire) include a desire to engage with their own creative process, to explore links between art and science in medicine and to experience a different learning environment. Other more clinical reasons relate to the 'art of doctoring', becoming the 'type of doctor I aspire to be' and regaining a focus on the patient as person.

> Whilst I enjoy the scientific side of medicine, I do sometimes feel I am forgetting the fact that my patient is a person, just like me, rather than a machine that needs fixing.
>
> (Medical student, 2010)

Teaching methods

The course is set up for students to learn about the use of the arts for health, but the method of learning is predominantly experiential and reflective, which means students often find themselves going on their own personal learning journey alongside their understanding of the application of the arts in health care. Here is one student's description of how they experienced this:

> I've really enjoyed the opportunity to participate in the course and as well as learning a lot about a range of therapy options, it has been good for learning a lot about ourselves …
>
> (Medical student, 2005)

The course begins the first session with an overview and setting the tone for group learning. Students engage with poetry, imagery and metaphorical thinking as well as considering a multi-sensory approach to experiences. It is important to help the students feel at ease as there are often concerns about being exposed for lack of creative talent. We go to lengths to encourage the idea that dialogue with the materials is what these sessions are about rather than producing beautiful artefacts.

The second session involves students sharing either a piece of creative-reflective work produced during the week or a meaningful object with the group. Often this session really starts the process of group bonding and appreciation of each other with their different experiences and perceptions.

Figure 3.

It felt like quite a privilege to listen to people opening up and describing things that really touch and matter to them.

(Medical student, 2005)

I … enjoyed being able to discuss other people's opinions alongside mine.

(Medical student, 2005)

Subsequent sessions are made up of co-facilitated sessions with art therapist, music therapist, creative writer, artist-researcher, dance therapist, etc. Some of the themes addressed across the sessions include depression, addiction, death, mental health, cancer and palliative care, and these are approached both from an arts and a clinical focus.

Each session runs very differently, but they all have a mix of facilitator talk, group dialogue, group creative expression, sharing and reflection. For example, the music therapy session, led by Jane Lings involves the students choosing and responding to different instruments scattered across the room, sharing memories around their connections with music and engaging in group music-making. This can be challenging and feel uncomfortable:

I definitely know the therapeutic effects of music but I don't think the word music fits the noise we were making.

(Medical student, 2005)

I was amazed how sceptical I felt after the first ten minutes of the session. I couldn't see how all of us randomly playing instruments would achieve any greater level of mutual understanding let alone therapy …

(Medical student, 2009)

Jane also shows a video of her work with children who have been referred to her and later goes on to play some recorded songs that she has helped patients with terminal cancer to write and record. These often contain powerful and emotional messages – sometimes to their loved ones, to friends, to the health profession and beyond. One example had the following lyrics:

It's simple, just so simple
Don't tell me what I feel – ask me
Don't run off half way through – follow through
Don't think you know how I feel – just ask
'Cos it's simple, just so simple
'Cos you don't have to find a solution,
And you don't have to make it better
And you don't have to solve the problem,
Just be with me,
Just be with me.

The power of the patient narratives and the patient voice is often what communicates with students something of the value of the arts for health.

… Even until the coffee break, I was having a nice afternoon but didn't think there was much of a therapeutic value. Listening to the songs the patients had written completely changed my perspective. I could begin to see how those emotions that are perhaps a little taboo to talk about – such as self-loathing – are much easier expressed in a song. Being a musician myself, I had assumed music therapy would focus on the buzz I feel when beautiful music is being played, but actually the end performance has little relevance. It is all about the interplay between the therapist and the patient – music is simply a substitution for words.

(Medical student, 2009)

Much of my work in running this course actually happens before the sessions, for example, finding arts facilitators of similar ethos who also value the importance of student time for creative work and for their sharing of work as well as the balance of the arts-facilitator talk with space for students to question and dialogue. I like to see students making their own connections from the arts world to clinical practice (sometimes also bridged with my own stories from general practice).

Within the group sessions, I am most active in the first few, working to create a good learning and sharing atmosphere. Subsequently, I provide continuity across the sessions with different facilitators. Sometimes difficult or emotional stories are shared, such as the death of a friend, or a friend with depression or eating disorders, or a distressing encounter with a patient. My role here is to hold the space, to keep it safe, but also to allow the students to manage what has been shared as a group, to allow them to remain present to each other as I hope they might to future patients.

Assessment methods

There are three parts to the assessment for this course: a reflective log written/drawn after each session, a creative-reflective text and a referenced essay on any aspect of art and science that link in some way with medicine (e.g., previous titles have included 'Poetry as therapy', 'The artist and his illness'). These assessment methods are chosen in order to attempt to reflect the nature of the learning on the course – with critical thinking being tested through the essay, depth of reflection and capacity for self-awareness through the reflective diary and metaphorical and imaginative thinking with their communication through an art form in their creative-reflective piece.

Grading students for this course is always a challenge as so much of the course is about collaboration, learning from each other and offering themselves as a gift to the group (as they might to their future patients).

I am quite a chatty person and during my time doing creative arts I have learnt to listen to people more and not only this but to watch them too and their body language.
(Medical student, 2005)

Marking creative-reflective work can also be a struggle. Over the years and in collaboration with artist-researcher Dr Catherine Lamont-Robinson, I have created a mark scheme that takes into account global impact, aesthetics, perception and reflection (these terms also resonate with Richardson's [2000] five criteria for evaluating ethnography).

Evaluation

Interpersonal learning

Evaluation of the course takes place annually with pre- and post-course questionnaires as well as a group evaluation discussion in some years. I also carried out qualitative research into this course for my M.Sc. in medical education, which involved thematic analysis of student semi-structured interviews and their reflective journals (Younie 2006).

Part of what students come to value through these sessions is the space to create and to be heard. Being witnessed as they share their work whether writing, art, clay, etc., and hearing responses back from the group builds confidence and a growing sense of being able to share vulnerability and speak openly.

It taught me to be more open to others and also more honest with people.

(Medical student, 2005)

Students talk in their reflective diaries and sometimes in the final evaluation session about the challenge of exposing themselves creatively and revealing something of themselves. This is usually not necessary within the traditional medical education context, which is pretty firmly located in the realm of the intellect rather than personhood. Exposing vulnerabilities and being at the mercy of another reflects some of what their future patients will have to face. Choosing their boundaries and how much to reveal and share is both relevant to them as future practitioners as well as understanding that patients are continually editing and choosing how much of their lived experience to share.

The emotional dimension of this course is another area students reflect on.

[the course] was emotionally quite hard work. … I think those were the sessions I gained the most out of although they were the heaviest.

(Medical student, 2005)

Emotional engagement arises often in connection with personal creativity or the shared creative expression of others (either presented patient creative work or that of other students in the group). Engaging with the emotional dimension of our lives or our clinical practice is not always comfortable, yet the majority of students valued this opportunity.

Through the course my awareness has developed and it has become obvious that being aware of your own emotions is vital when interacting with patients.

(Medical student, 2005).

During research interviews the question of an appropriate level of emotional expression within the medical education context and the potential risk for the learning group to become a therapy group was addressed with three students raising some discomfort. The majority of students, however, who recognized a therapeutic dimension in the sessions responded positively (Younie 2006).

… because I was writing about something personal it forced me to think about what I felt about the event. It was therapeutic to write the poem which was not expected when I was struggling to start.

(Medical student, 2005)

Reflecting through the arts

Students also sometimes take away new skills or have an awakening to a language and form of expression that they have not engaged with in the past, for example, a couple of painters ended up embracing creative writing.

> I chose to do a composition based upon my experience of free/creative writing. From the first SSC session I have been keeping a diary, which has helped me to get to know myself again after a great deal of upheaval ... Writing down my thoughts and then incorporating techniques introduced to us in the Creative Writing session, helped me to realize what was really important to me ...
>
> My painting is a self-portrait of me, writing. My hair is covering my face, this is to illustrate that when I initially pick up the pen, I am hiding from something; I am not in tune with myself. From the page I am writing on emerges my reflection; the idea that my identity is revealed to me as I write.

Other medical students find it is the endorsement and permission to engage with the arts that is refreshing. Several students have thoroughly enjoyed painting or poetry writing, but would have not engaged in this unless it was part of their medical degree. The student who painted

Figure 4.

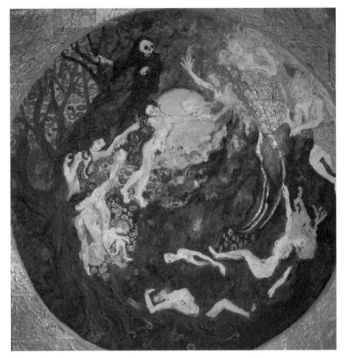

Figure 5.

this piece for her assignment, told us she had not painted since starting her medical degree two years previously. In a focus group at the end of the course she explained that it is not lack of time but a sense of not valuing creativity that has stopped her engaging with artwork:

> … but since doing medicine I haven't done anything like that at all [drawing and writing], … that whole side of my life has been, not even just on hold, I've just decided it's not important. And then doing this really made me think, oh, I've made the wrong decision …
>
> (Medical student, 2007)

Learning

In terms of learning, students inevitably become aware that this is a different way of learning. Some find new eyes and become more attuned to their voice and the voices of others.

> We learn to see beyond clubbing and splinter haemorrhages to the story behind their withered hands, to the person and all their history.
>
> (Medical student, 2011)

... you've got to be able to understand yourself to understand other people and that's particularly important ... in doctor-patient relationships ...

(Medical student, 2005)

Other students are less sure about what they will take away from these sessions:

I think it's been quite strange because a lot of the teaching we've had has been through experience ... and when you learn through experience there's not actually much you can take away ... Sometimes I think that having that experience is really useful and it will make me think about these therapies when I'm a doctor. Other times I think that maybe I haven't taken away that much other than just had a good time. So ... I'm still not quite sure of my learning ... maybe with reflection I'll discover what.

(Focus group, Medical student, 2005)

From student sharing within the sessions and from their reflective diaries and focus groups it is evident that for many, if not all, there is evidence of some transformative learning (Younie 2006), that is, the 'reflective transformation of beliefs, attitudes, opinions, and emotional reactions arising from our meaning schemes' (Imel 1998). Features of this course that might foster such learning include the creation of a safe space where students can present different perspectives and worldviews, learning collaboratively from each other with our different experiences and reflecting together around themes, therapies and patient stories represented. The creative process itself can also draw out the engagement of personal voice and the emotional realm. From the literature, all of these features are recognized as conducive to transformative learning. Mezirow (1997) writes about the importance of safety, participation, experiential learning and reflective learning, and Boyd (1991) adds the realm of emotional learning.

Examples of transformative learning seen on this course include deciding to become more open and honest with each other, listening better to others, engaging with and considering alternative perspectives and opinions, recognizing the importance of self-awareness around their own values and opinions as well as considering the values and meaning-making of others. Engaging in a different educational culture helps students to become more aware of the process of learning and the philosophical question of what education is, in relation to their vocational training. Students also evidence taking on new perspectives (or re-finding old ones) relating to the value of personally engaging with the arts for pleasure as therapeutic or in extending their capacity for reflection.

I think that for me doing the creative work just opens up a broader perspective anyway. I think I think more, generally, when I'm doing creative stuff ...

(Medical student, 2005)

Limitations of the arts in medical education

Some of the limiting factors preventing the extension of arts-based inquiry in medical education include the medical education culture, the time pressure on the medical undergraduate curriculum as well as on medical educators. Funding can also be an issue in terms of paying for external arts-based facilitators. It is a fairly expensive course given the small number of students. In terms of impact, one could only hope that students sow seeds into the background culture through their conversations with colleagues as well as themselves having engaged in significant transformative learning that might impact their future clinical practice. It is important to note that there are many other possible ways for introducing arts-based inquiry into the medical curriculum such as within general practice placements or as an element within university-based small-group work. Regarding the potentially emotional dimension of the course, facilitating safe spaces with clear boundaries as well as allowing students to opt in/out from potentially charged conversations may be important.

So what might the arts have to offer medical education?

Findings from research into arts-based inquiry in medical education (Younie 2011) suggests that the arts can engage students in different kinds of knowledge production from intellectual and factual knowledge to more relational ways of knowing, for example, intuitive, imaginative, interpersonal and interconnected knowing. I have found that arts-based inquiry facilitates expression and development of voice and interpersonal understanding, areas that receive little attention within the undergraduate medical curriculum. Thinking with and through the arts makes space for grappling with the student's inner world (student voice) and also exploration from the student's perspective of the patient's beliefs, stories and motives (patient voice). In this way, complexity, subjectivity and the emotional dimension of daily clinical practice can be explored beyond the realm of words. The arts offer space to engage with metaphor and symbol, with evocation and emotion, with liminality and alternative perspectives.

Students often posses a natural tendency to care at the start of their medical studies, yet the literature suggests that through lack of nurture and the process of undergraduate medical education this capacity for caring seems to diminish (Hojat et al. 2004; Chen et al. 2007). The creative-reflective process has the potential to counter this through offering interconnected and holistic ways of considering experiences, drawing on the personal dimension as well as the professional, the heart as well as the head and hand, to use the triad described by Professor of Medicine, William Osler (1919) (Burns 2003). Arts-based inquiry might facilitate the development of another toolkit alongside the medical one – the doctor as therapeutic agent – where presence, listening, silence and journeying with the patient all reside.

Acknowledgements

I would like to thank all the students who have engaged with this course over the years for what they have been teaching me, also for those who have kindly given permission to use their quotes and images in this chapter. I am also grateful to all the arts facilitators that I have worked with over the years for engaging in this exploratory journey into learning through the arts with medical students and for sharing their passion for their work and enriching my understanding with the arts.

References

Boyd, R. D. (1991), *Personal Transformations in Small Groups: A Jungian Perspective*, London: Routledge.

Boyd, R. D. and Myers, J. G. (1988), 'Transformative Education', *International Journal of Lifelong Education*, 7, pp. 261–284.

Burns, C. R. (2003), 'In Search of Wisdom: William Osler and the Humanities', *Medical Education*, 37, pp. 165–167.

Charon, R. (2006), *Narrative Medicine, Honouring the Stories of Illness*, New York: Oxford University Press.

———— Trautmann Banks, J., Connelly, J. E., Hunsaker Hawkins, A., Montgomery Hunter, K., Hudson Jones, A., Montello, M. and Poirer, S. (1995), 'Literature and Medicine: Contributions to Clinical Practice', *Annals of Internal Medicine*, 122, pp. 599–606.

Chen, D., Lew, R., Hershman, W. and Orlander, J. (2007), 'A Cross-sectional Measurement of Medical Student Empathy', *Journal of General Internal Medicine*, 22, pp. 1434–1438.

Cranton, P. (2000), 'Individual Differences and Transformative Learning', in J. Mezirow & Associates (eds.), *Learning as Transformation: Rethinking Adult Learning and Development*, San Fransisco: Jossey-Bass.

De La Croix, A., Rose, C., Wildig, E. and Willson, S. (2011), 'Arts-based Learning in Medical Education: the Students' Perspective', *Medical Education*, 45, pp. 1090–1100.

Dirkx J. M. (1997), 'Nurturing Soul in Adult Learning', *New Directions for Adult and Continuing Education*, 74, pp. 79–88.

Hojat, M., Mangione, S., Nasca, T. J., Rattner, S., Erdmann, J. B., Gonella, J. S. and Magee, M. (2004), 'An Empirical Study of Decline in Empathy in Medical School', *Medical Education*, 38, pp. 934–941.

Imel, S. (1998), *Transformative Learning in Adulthood*, available from http://www.ericdigests.org/1999-2/adulthood.htm. Accessed 5 July 2010.

Jacobson, L., Grant, A., Hood, K., Lewis, W., Robling, M., Prout, H. and Cunningham, A. M. (2004), 'A Literature and Medicine Special Study Module Run by Academics in General Practice: Two Evaluations and the Lessons Learnt', *Medical Humanities*, pp. 30, 98–100.

Lancaster, T., Hart, R. and Gardner, S. (2002), 'Literature and Medicine: Evaluating a Special Study Module Using the Nominal Group Technique', *Medical Education*, 36, pp. 1071–1076.

Lazarus, P. A. and Rosslyn, F. M. (2003), 'The Arts in Medicine: Setting Up and Evaluating a New Special Study Module at Leicester Warwick Medical School', *Medical Education*, 37, pp. 553–559.

Liamputtong, P. and Rumbold, J. (eds.) (2008), *Knowing Differently: Arts-based and Collaborative Research Methods*, New York: Nova Science Publishers.

Maudsley, G. and Strivens, J. (2000), 'Promoting Professional Knowledge, Experiential Learning and Critical Thinking for Medical Students', *Medical Education*, 34, pp. 535–544.

Memel, D., Raby, P. and Thompson, T. (2009), 'Doctors in the Movies: a User's Guide to Teaching about Film and Medicine', *Education for Primary Care*, 20, pp. 304–308.

Mezirow, J. (1997), 'Transformative Learning: Theory to Practice', *New Directions for Adult and Continuing Education*, 74, pp. 5–12.

Milligan, E. and Woodley, E. (2009), 'Creative Expressive Encounters in Health Ethics Education: Teaching Ethics as Relational Engagement', *Teaching and Learning in Medicine: An International Journal*, 21, pp. 131–139.

Oxrord Dictionaries (2012), Oxford University Press, available from http://oxforddictionaries.com/definition/educate#m_en_gb0256470. Accessed 30 January 2012.

Richardson, L. (2000), 'Evaluating Ethnography', *Qualitative Inquiry*, 6, 253–255.

Schon, D. A. (1983), *The Reflective Practitioner. How Professionals Think in Action*, New York: Basic Books.

Shapiro, J., Nguyen, V. P., Mourra, S., Ross, M., Thai, T. and Leonard, R. (2006), 'The Use of Creative Projects in a Gross Anatomy Class', *Journal for Learning through the Arts*, 2 (1), pp. 1–29, available at http://escholarship.org/uc/item/3mj728bn.

Thompson, T., Lamont-Robinson, C. and Younie, L. (2010), '"Compulsory Creativity": Rationales, Recipes, and Results in the Placement of Mandatory Creative Endeavour in a Medical Undergraduate Curriculum', *Medical Education Online*, available from http://www.med-ed-online.net/index.php/meo/article/view/5394. Accessed 9 December 2010.

Weisz, G. M. and Albury, W. R. (2010), 'The Medico-artistic Phenomenon and its Implications for Medical Education', *Medical Hypotheses*, 74, pp. 169–173.

Younie, L. (2006), *A Qualitative Study of the Contribution Medical Humanities Can Bring to Medical Education*, MSc, University of Bristol.

———— (2009), 'Developing Narrative Competence in Medical Students', *Medical Humanities*, 35, p. 54.

———— (2011), *A Reflexive Journey through Arts-based Inquiry in Medical Education*, Doctor of Education, University of Bristol.

PART II

Using Performance

Chapter 3

Using Cinema to Enhance the Relevance of Economics to Students' Lives

Gherardo Girardi
(London Metropolitan University)

Introduction

A number of tutors in disciplines not normally associated with the performing arts are drawing material from this unorthodox source and using it to teach their subjects, including Economics. Economics tutors are using film (see, e.g., Sexton 2006), music (Hall et al. 2008), literature and drama (Kish-Goodling 1998; Watts 1998) and even *The Simpsons* (Gillis and Hall 2010). Of these, film is probably the best established, though still used by a small minority of tutors.

What are the benefits of using film? A fairly comprehensive review of motivations across different disciplines, including organizational behaviour, management, nursing, health and history, is found in Palmer (2007), from which the summary below is mainly drawn.

Film is part of students' culture: 'We teach and live in a culture dominated by film, television and other visual media … Consequently, (our students) are geared to audiovisual rather than written forms of expression and communication' (Kuzma and Haney 2001 in Palmer 2007). Film stimulates two senses simultaneously, so no other medium is more effective in this sense. Film makes abstract concepts concrete by providing meaningful context and creates bridges to the past in an aesthetically attractive way. It engages students emotionally, rather than just intellectually. As a consequence of all this, and especially because it engages multiple senses and the emotions, film aids memory (ibid.). Film offers a wide range of material to choose from across both genre and time. 'Film is a powerful tool for illustrating concepts and demonstrating the application of theory' (Smith 2009). It provides background knowledge on something that may be foreign to students (Marshall 2003 in Palmer 2007). It offers a communal experience if watched by students as a group whereby students experience a sense of trust and of reduced barriers among them (Ostwalt 1998 in Palmer 2007). It presents students with vivid images of characters with whom students can empathize (Marshall 2003 in Palmer 2007) and whom students can adopt as role models. It helps 'to dramatize and frame issues, generate discussion, and provide links with personal experience' (Harper and Rogers 1999 in Palmer 2007). It is 'a powerful vehicle for teaching students conceptual flexibility and the ability to shift perspectives' (Champoux 1999 and Gallos 1993 both in Smith 2009) in part as a result of being able to engage students emotionally, and the real life nature of (some) films helps move the students 'towards intellectual ownership of the material (presented in class), implying long-term retention of economic concepts' (Bhadra 2006). As Bhadra goes on to say:

... students seem to feel more confident having an opinion on economic principles [on film-related papers rather than current events papers assigned], possibly because they understood the material better.

> (ibid.; sentence from concluding paragraph of online version of this article)

In addition to the above, I have some motivations of my own for using film in my Economics classes:

- To increase the classroom participation of non-mathematically inclined students;
- To present the subject of Economics in an aesthetically attractive way, thus offering an alternative to mathematical elegance;
- To treat the subject in a multidisciplinary manner, enabling students to see the link with other social sciences;
- To present the subject in its historical context, in contrast with the present mainstream approach;
- To present a multicultural array of films and works of literature consistent with the wide range of cultural backgrounds of students at my university (London Metropolitan University, perhaps the most multicultural university in the United Kingdom);
- To portray the complexity of the human dimension of economic relationships, rather than merely the technical one of what determines the terms of exchange.

This last point deserves some clarification. Buchanan and Huczynski (2004) study the film *Thirteen Days*, in which President Kennedy, assisted by his aids, must decide how to react to the deployment of Soviet nuclear missiles on the island of Cuba. This is an area in which one might expect the sort of cold calculations typical of our Economics courses, and especially of game theory, to dominate. Instead, the film depicts 'interpersonal influence as a multi-layered phenomenon, shaped by contextual, temporal, processual, social, political and emotional factors' (ibid.: 1). The results from the growing field of Behavioural Economics are in the same spirit in that they reject the simplistic notion of rationality that is assumed by mainstream Economics (Kahneman 2003).

The literature in Economics education on using film in the classroom is scant but growing. Sexton (2006), for example, shows clips of films that illustrate fundamental Economics concepts such as 'trade-offs' and 'opportunity cost'. Leet and Houser (2003) go further by proposing an entire undergraduate Economics course dedicated to the use of films to teach Economics.

The aim of this chapter is to show that films can be chosen so that Economics can be taught in a way that is closely related to students' lives, in a way that cannot be achieved by using conventional tools such as textbooks (which remain essential to teach Economics concepts). The idea is that, by being presented with material closely related to the students' needs and aspirations, students will engage with the subject of Economics in depth, and so come to a better understanding not only of the world around them,

but also of who they are, in a process of self-discovery that I think is what education is essentially about.

I illustrate how film can be chosen in Economics classes to be closely relevant to the needs of students by considering two examples: one involving clips from of a film adaptation of *Death of a Salesman*, which helps students to reflect on their choice of profession; the second involves clips from *Wall Street* and *Francis, God's Jester* and helps students to reflect on the extent to which money can buy them happiness. Both issues seem quite relevant to the students' needs, yet they are not normally considered in Economics education, even though they are felt by students to be more important than some of the fairly artificial theoretical frameworks that we teach.

Method

The method that I propose to utilize in class is as follows. Each week I present a topic and then I show clips from one or more films about that topic. Then I facilitate a debate among students, by asking questions that relate as far as possible to their lives. Finally, to sustain the discussion with some rigorous analysis, I present some related academic material, which can be either theoretical or empirical. For reasons of space limitations, I will put to one side a detailed discussion of method, and will focus instead on selection of material. Readers interested about method are invited to consult the literature, for example, Becker and Watts (1998), Diamond (2009), Macy and Terry (2008) Palmer (2007) and Tyler et al. (2009).

In the Appendix the reader will find a selection of films that I have put together with the aim of satisfying the particular needs I have described for my Economics classes. The range of topics that I cover is wider than that found in Sexton (2006) and Leet and Houser (2003) and covers unconventional topics such as the economics of charities, dowries and the economics of crime (there is a wide range of film material in the online section on films in the *Journal of Economic Education* by Mateer and Li [http://www.moviesforecon.com]). The range of cultures spanned is also wider. Since most of the films that I am suggesting for the proposed module are cinematic adaptations of renowned works of literature, the distinction between using films and works of literature is somewhat lessened; however, I think it remains important, as the two media are likely to appeal to very different student audiences.

Example 1: On the choice of profession by young people using *Death of a Salesman*

An important question that we do not address in Economics classes is to how to help students make their choice of profession. Instead, in conventional Labour Economics courses we simply assume that future earnings are the key determinant of one's choice as to whether to

take up further education or not (the human capital model). This does not appear to be the case in reality: when I asked my Labour Economics students, only a minority said that they chose to read an Economics degree because it offered the prospect of an attractive wage; instead, the students displayed a range of different motivations. *Death of a Salesman* is useful in this respect because it includes a dialogue lasting about ten minutes between two youngsters at pains to decide what choice of profession to make, in which they discuss the pros and cons of very different occupations.

I showed clips of a film version of Arthur Miller's *Death of a Salesman* to students taking:

1. Economics of Industry – this is a 3rd year module taken almost entirely by economics students; sixteen students took part in the experiment;
2. International Business Strategy – this module is part of the MA in International Business; seven students took part in the experiment.

Each session lasted about half an hour, with twenty minutes of clips and ten minutes of discussion. In the beginning, I introduced the tragedy to the students, describing the plot, the main characters and the historical context (America in the late 1940s). In essence, a travelling salesman called Willy makes fewer sales as he gets older. His perception of his self-worth is shattered in the process. He commits suicide hoping that many people will come to his funeral and that his family will get insurance compensation, neither of which materialize. Willy has two sons, Biff and Happy.

I selected a number of topics that I believed to be relevant to the students' lives. Here, I focus on one, namely the role of parents and society in influencing young people's choice of profession. Miller's tragedy provides the following material for debate:

Willy is disappointed with his son Biff because Biff is 34 and still does not know 'who he is' (which includes not having chosen his profession) and also because he does not make lots of money. After expressing his disappointment, Willy finds some hope that his son will discover what he wants to do with himself: 'Some people just don't get started till later in life, like Thomas Edison.'

In fact, Biff wants to work on a farm: he expresses his sense of delight when working with animals. However, he always ends up coming back home because he thinks he is earning too little ('$28 a week') and he is acting 'like a boy' (not married, not in business). He's in two minds as to what he wants to do: 'I don't know what to do with myself', he says. Still, he hopes to reconcile his conflicting motivations: 'With the ranch I can do the work I like and still be something.' The 'still be something' probably refers to the notion of being 'well-liked' and of making money, both of which are very important to his father. Biff's brother, Happy, suffers from the same problem as Biff: 'I'm constantly lowering my ideals.' The two brothers play with the idea of working together on a farm.

The following questions can be used to generate a discussion in class:

- Do you think that parents/society at large are influential in determining what job people do? How influential do you think your parents and society are in determining what job you will take? How influential should parents be, and, in the light of Willy's behaviour, how should they exercise their influence? Does that influence, help or hinder the process of self-finding?
- At what age, if any, does one finally know oneself? Does education help in this respect?
- Do you experience the kind of tension that Biff and Happy experience in choosing their profession?
- Do you think that the human capital model is correct in assuming that wages are the key determinant of one's choice of whether or not to attend university?
- How do you intend going about choosing your profession? What are the key factors that play a role in your decision?

The tragedy can also be used to generate debate and questions, which the dialogue with students below illustrates:

Willy, who is old and wishes to stop working as a travelling salesman, asks his boss if he can have an office job. Willy's boss fires him instead, saying that Willy does not sell enough to retain a position within the firm. Willy is shocked. He complains that '[…] in those days there was […] respect, and comradeship, and gratitude in it. Today, it's all cut and dried and there's no chance for bringing friendship to bear – or personality.' He cries out that 'You can't eat the orange and throw the peel away – a man is not a piece of fruit!'

Questions: Do you think that an employee can be fired on grounds of productivity alone? If not, should the employee's age play a role? What about time spent working for a company? What other factors might play a role? Do you know what protection UK law offers to employees at present? Is it fair?

Biff complains that we 'suffer fifty weeks of the year for the sake of a two-week vacation.'

Questions: How accurate a depiction is this of modern times? Of life in general? What can you do to avoid this?

Willy asks '[…] what could be more satisfying than to be able to go, at the age of 84, into 20 or 30 different cities, and pick up the phone, and be remembered and loved and helped by so many different people?'

Questions: To what extent is human behaviour, including economic behaviour, explained by the desire to be appreciated by others? Do people work very hard to get other people's approval? Does such an attitude benefit an individual?

Willy describes his approach to business in these words: '[…] It's not what you do […] It's who you know and the smile on your face!'

Questions: Do you agree? If you do, does that imply that education is of limited importance? How important are contacts in determining success at work? In getting a job?

Lastly, Willy commits suicide because he perceives his self-worth to be proportional to the volume of his sales, that is, his productivity.

Questions: To what extent is this belief found in our society? What do you think determines self-worth? Should wages reflect self-worth, productivity or any other (mix of) factor(s)?

I assessed the response of students by means of a questionnaire. Most responses were favourable:

- 'It is good to visualize real life examples and to chain them to theory.'
- 'I found the material that was shown relevant to my life situation.'
- 'The movie is quite old so the relevance is minimal.'
- 'It uses a media which young people grow up with.'
- 'One picture says a thousand words.'
- 'People can discuss the matter in relation to their experience.'
- 'It brings the very relevant aspect of Behavioural Economics into the picture.'
- 'It's the best session I have ever had.'
- 'The module would be good before uni.'
- 'It gives Economics students an opportunity to relate to the arts and approach things from a different perspective.'
- 'Seeing a film and relating it to real life is fascinating.'

I also asked students to rate the session they had attended:

Table 1: Students' overall ratings of session on Economics through cinema

	Overall session rating (average score shown, where 7 highest, 1 lowest)	% of students who think module should be introduced	"If you think module should be introduced, how useful would it be?" (average score shown, where 3 = hugely, 2 = a lot, 1 = a little)
Industrial Economics 3rd year BSc	5.6	77%	2.4
International Business Studies MA	5.9	83%	2.4

As the table shows, the overall session rating was high, closer to a 6 than a 5, where 6 is 'very good' and 5 is 'good'. Note the stability of the rating in spite of the variation in the year of study. The vast majority of students thought the module should be introduced; again, the year of study makes little difference to the size of the majority. Finally, students who wanted the module introduced thought it would benefit students considerably, some even hugely. This is consistent with evidence from similar experiments in disciplines other than Economics, such as Organizational Behaviour (Smith 2009).

I also asked students to assess individual aspects of the sessions:

Table 2: Students' ratings of aspects of the Economics through cinema experience

		Average			Average
Film quality	Ec. of Ind.	5.4	Relevance to your life	Ec. of Ind.	5.8
	Int. Bus. Str.	6		Int. Bus. Str.	5.1
Discussion quality	Ec. of Ind.	5.1	Economic content	Ec. of Ind.	5.2
	Int. Bus. Str.	5.7		Int. Bus. Str.	5.1
Total time	Ec. of Ind.	4.6	Will you remember?	Ec. of Ind.	5.9
	Int. Bus. Str.	4.4		Int. Bus. Str.	5.6
Distribution of time	Ec. of Ind.	5	Male	Ec. of Ind.	62%
	Int. Bus. Str.	4.9		Int. Bus. Str.	33%
Academic material	Ec. of Ind.	5.7	Scores from 1 to 7, where 7 highest (except for male)		
	Int. Bus. Str.	5.7			
Structure	Ec. of Ind.	5.6			
	Int. Bus. Str.	5			

Students appreciated the quality of the films they had seen, as well as the quality of the academic material, possibly indicating that they thought the academic material strongly related to the film, as I had hoped. Students' rating of the relevance of the material to their lives was between 'good' and 'very good', again as I had hoped. Students were just about satisfied with the amount of time spent on each session, but this aspect ranked lowest of all: I imagine that they wanted more time, either because they enjoyed the session and wanted more of the same, or because they felt they did not have enough time to properly evaluate the sessions.

Example 2: On whether money can buy happiness using *Wall Street* and *Francis, God's Jester*

Students who took part in the Masters' course in International Business Strategy and from the third year undergraduate course Comparative Economic Development were invited to take part in a focus group discussion. Eight students took part, four from each course. The question I put before them was 'Does money buy happiness?' This question is not discussed in conventional Economics courses, yet seems very important in that the answer that a student will give to it will determine key choices in his or her life such as choice of profession, how generous they will be with money, etc. The growing Economics of Happiness literature suggests that to ask students whether money can buy happiness is not as irrelevant as it might at first sight appear to an Economics tutor; for example, a finding

of this literature is that money does not buy happiness beyond a certain level of income (see Bruni and Porta 2007).

I showed the students clips from *Wall Street* and *Francis, God's Jester*, with contrasting scenes of the lives of the investment banker Gecko and the Franciscan friar Fra Ginepro. Students were shown a number of clips including the famous speech that Gecko delivered to a group of shareholders in which he said that '... greed [...] is good. Greed is right. Greed works [...]. Greed, in all of its forms – greed for life, for money, for love, knowledge – has marked the upward surge of mankind ...' Fra Ginepro, on the other hand, was told off by his superior, Saint Francis, for repeatedly giving away his monastic habit to the poor and ending up naked in winter. To get around his superior's rebuke, Fra Ginepro told the poor that, although he was not allowed to hand out his clothes, they were welcome to take his clothes without waiting for him to hand them out. In addition, students were shown clips of Saint Francis giving his father's riches away to the poor – without his father's consent. The question of whether money can buy happiness seems central in Economics education, yet mainstream Economics takes it for granted that the more money one has, the happier that person is. In other words, we teach the way of Gecko. What did the students think?

In general, students thought health and relationships were the key determinants of happiness. Money gave a sense of security, but it could not buy health, at least not mental or spiritual health, and could certainly not buy relationships. How one makes money is important; in particular, illegally acquired money (Gecko made at least part of his wealth through 'insider trading') could result in 'someone knocking at your door' in the middle of the night. A student remarked that being passionate about one's work, rather than the money one makes from it, gives happiness: 'a prostitute won't be happy, but an artist will, because he's passionate about his work.' Another student commented, 'I find happiness in my family in Africa; my dad and my mum always say to me, try and avoid to be selfish. I think that's good advice. That's always the bottom line from my parents: don't be selfish.' According to one student, 'people in poor countries seem happy, unlike here' because they form close family relationships. Yet another student was able to neatly summarize the contrast between Gecko and Fra Ginepro in terms of opportunity cost: 'Gecko is foregoing [his] human nature [in exchange] for greatness, [whereas] Fra Ginepro is giving up all he has to fulfil the other side, [his] human nature.' However, one student went against the general consensus and said, 'You have to be bad to do good for your business. By bad I mean socially not responsible, selfish.'

Some responses were of a more philosophical nature. A student remarked, 'What makes me happy is if I have a goal, [...] but to know what you want, that's the difficulty for everyone. Because you have to re-ask yourself: you have to change your life, but what do you change it to? It's a journey. [...] Happiness is all about how you respond to changes over which you have no control.' Another student pointed out that 'you cannot say you are happy if you don't have downturns'. Finally – and this is my favourite remark – 'happiness is like a few scenes in a movie, not a continuous thing'.

These comments suggest that, on the whole, 'the way of Gecko', which we teach, is not the way which most students follow. In addition, they suggest that human behaviour is more complex than what we normally assume in Economics classes, as reflected in the following statement made by a student: 'We all have our own definition of happiness, so you can't say that Gecko was unhappy just because he destroyed other people's lives or because he didn't feel loved.'

What did students think of the approach using film? All students thought the approach was 'very good', particularly in terms of engaging students. One student remarked that he does not 'like studying Economics in general, but this [session] was pretty interesting, it [the approach] would promote Economics'. Another student thought that the approach 'brings life to economics classes, rather than just sitting there listening to some boring lecturer'. Another said that Economics students tend to be quiet and listening (to the teacher), but this approach opened up a debate; an unusual occurrence in Economics classes. Yet another student said: '[I]t's a brilliant idea, because everybody watches movies and no one closes their eyes, it's perfect.' Finally, a student noted that 'everybody learns in different ways', some people need to see, some to hear, some to discuss, and film offered a new vehicle to learn, one that engages many senses at the same time, consistently with Palmer (2007).

Some students appreciated the absence of technical, especially mathematical, material. A student said, '... this is a very good alternative, seriously, because I studied Economics in France, it was a Bachelor degree in Economics [...] it was all equations and graphs, so it was maths, and a lot of students, even me, were not attracted by this'. One student commented, 'This module is good because in Economics we tend not to have debates – "a" is "a".' Another student remarked that the session in class was 'how it was initially intended, now people think of Economics as a lot of numbers and figures ... [but] there is always a common sense behind Economics, often people don't see that, it'd be good to make them see it again, [showing] movies [...] promotes that – go ahead.' A student appreciated the broader, social and psychological issues raised by clips shown, which are not normally covered in Economics classes. The same student felt that the approach developed a 'kind of economic consciousness', an awareness of ethical issues, which he felt was very good. Students appreciated the approach of showing two contrasting films. Two students suggested showing documentaries, too.

An unexpected, positive outcome of the focus group was the sense of communal learning pointed out by Palmer (2007). A student said, 'The good thing about this method is that you actually get in touch with your fellow students, you can discuss their viewpoints, from their backgrounds and how they see things.' Another student agreed and said that 'you should do this [session] with a coffee ... you meet new people, a bit more coffee would make you say what you feel like'. Again to my surprise, students said that they were quite happy to watch old films; with particular reference to film material about ethics, one student remarked that 'morals are morals, whether [or not] they are from [...] centuries ago, because what was said then still applied now'.

Negative reactions were few but fairly sharp: one student felt that in studying Economics we should not concentrate on social issues, but rather on money-making techniques. As a matter of fact, although I did not try this in the experiment, film can be used to illustrate money-making techniques, for example, by showing the film *Rogue Trader*, in which Nick Leeson is shown selling 'put' options (eventually this strategy lost him huge sums of money and led to the collapse of the long-established Barings Bank). The point is that films can be selected such that the students find relevance in them.

Conclusion

I hope to have shown that film can be used to teach Economics so that the subject is perceived by students to be very relevant to their lives, engaging students more firmly in their chosen discipline. To do so, topics need to be chosen that are felt to be important by the students, making this approach student-centred, and appropriate film material needs to be selected. Two examples of this have been presented here. Firstly, I used (the film version of) *Death of a Salesman* to show how a discussion can be started with students as to how young people go about choosing their profession, a topic that could be covered in Labour Economics. Secondly, I used *Wall Street* and *Francis, God's Jester* to illustrate how to generate discussion on whether money buys happiness, a topic that could be part of a Microeconomics course. Topics such as these are not discussed in conventional Economics classes; this is a pity, because in doing so we do not give students enough opportunity to reflect on issues close to their needs. I hope that this will change in time. I would like to conclude with an optimistic quotation from a satisfied student in the focus group: 'Who knows, maybe in the future many universities will use this method!'

Acknowledgements

The author gratefully acknowledges the financial support of the Economics Network of the UK's Higher Education Academy for this project. He also expresses his thanks to John Sedgwick and Guglielmo Volpe for their advice.

References

Becker, W. E. and Watts, M. (eds) (1998), *Teaching Economics to Undergraduates: Alternatives to Chalk and Talk*, Northampton, MA: Edward Elgar.

Bhadra, L. J. (2006), 'A Picture is Worth a Thousand Words: Engaging Kinesthetic and Multimodal Learners of Economics Using Contemporary Films', *Inquiry*, 11 (1), pp. 11–19. Available at http://www.vccaedu.org/inquiry/inquiry-spring2006/i-11-bhadra.html.

Bruni, L. and Porta, P. L. (eds.) (2007), *Handbook on the Economics of Happiness,* Cheltenham, UK: Edward Elgar.

Buchanan, D. and Huczynski, A. (2004), 'Images of Influence: 12 Angry Men and Thirteen Days', *Journal of Management Inquiry,* 13 (4), pp. 312–323.

Diamond, A. M. (2009), 'Using Video Clips to Teach Creative Destruction', *The Journal of Private Enterprise,* 25 (1), pp. 151–161.

Gillis, M. T. and Hall. J. (2010), 'Using The Simpsons to Improve Economic Instruction through Policy Analysis', *American Economist,* 54 (1), pp. 84–92.

Hall, J. C., Lawson, R. A., Mateer, G. D. and Rice, A. (2008), 'Teaching Private Enterprise Through Tunes: An Abecedarium of Music for Economists', *The Journal of Private Enterprise,* 23 (2), pp. 157–166.

Kahneman, D. (2003), 'Maps of Bounded Rationality: Psychology for Behavioral Economics', *American Economic Review,* 93 (5), pp. 1449–1475.

Kish-Goodling, D. (1998), 'Using *The Merchant of Venice* in Teaching Monetary Economics', *Journal of Economic Education,* 29 (Fall), pp. 330–339.

Leet, D. and Houser, S. (2003), 'Economics Goes to Hollywood: Using Classic Films and Documentaries to Create an Undergraduate Economics Course', *Journal of Economic Education,* 34 (4): pp. 326–332.

Macy, A. and Terry, N. (2008), 'Using Movies as a Vehicle for Critical Thinking in Economics and Business', *Journal of Economics and Economics Education Research,* 9 (1), pp. 31–51.

Mateer, G. D. and H. Li. (2008), 'Movie Scenes for Economics', *Journal of Economic Education,* online section, www.moviesforecon.com.

Palmer, S. C. (2007), *Two Thumbs UP: Student Reaction to the Use of Popular Movies to Study Business Ethics,* Academy of Legal Studies in Business, Conference Proceedings.

Sexton, R. L. (2006), 'Using Short Movie and Television Clips in the Economics Principles Class', *Journal of Economic Education,* 37 (Fall), pp. 406–417.

Smith, G. W. (2009), 'Using Feature Films as the Primary Instructional Medium to Teach Organizational Behavior', *Journal of Management Education,* 33 (4), pp. 462–489.

Tyler, C. L., Anderson, M. H. and Tyler, J. M. (2009), 'Giving Students New Eyes – The Benefits of Having Students Find Media Clips to Illustrate Management Concepts', *Journal of Management Education,* Vol. 33 (4), pp. 444–461.

Watts, M. (1998), *Using Literature and Drama in Undergraduate Economics Courses,* in *Teaching Economics to Undergraduates: Alternatives to Chalk and Talk,* edited by W. E. Becker and M. Watts, Cheltenham, UK and Northampton, MA: Edward Elgar.

Appendix: List of films

1. *Death of a Salesman* (Arthur Miller, 1949, US) – Choice of profession, sense of self-worth based on economic performance.
2. *Grapes of Wrath* (John Steinbeck, 1939, US) – Property rights, migration, trade unions.
3. *Oliver Twist* (Charles Dickens, 1838, UK) – Economics of crime, economics of charities.

4. *Rogue Trader* (James Dearden, 1999, UK)/*Wall Street* (Oliver Stone, 1987, US; C) – Psychology of financial markets, business ethics.
5. *Balkanizateur* (Sotiris Goritsas, 1998, Greece; C) – Efficiency of capital markets (with a touch of humour).
6. *La Terra Trema* (The Earth Will Tremble) (Luchino Visconti, 1948, Italy) – Poverty and the risks of entrepreneurship.
7. *Francis, God's Jester* (Rossellini, 1950, Italy)/*St. Francis* (Michele Soavi, 2002, Italy) – Choice between wealth and poverty.
8. *Mother India* (Mehboob Khan, 1957, India; C) – Rural financial markets in poor countries.
9. *Pride and Prejudice* (Jane Austen, 1813, UK) – Dowries, economics of inheritance.
10. *Ashani Sanket* (a.k.a. *Distant Thunder*, Satyajit Ray, 1973, India) – Economics of famines.
11. *Robin Hood* (author unknown, 1973, Walt Disney production recommended) – Morality of stealing from the rich/the state.

Note

(name of original author or film director in brackets, followed by date of release of original piece and the nationality of the author/director; a 'C' stands for caution as the film contains morally objectionable material such as violence, nudity, etc.)

Chapter 4

Fascinatin' Rhythm: Tapping into Themes of Leadership and Management by Making Music

Dave Griffiths
(London Metropolitan University)

Introduction

> ... 'And then we might ask [you] to make up a song.' The part about singing gives rise to a ripple of uneasy laughter across the class. 'Without words,' Heifetz adds, reducing the quiet laughter to something close to low-grade terror in some, fascination in a few. 'Because', he continues, 'leadership is about improvisation'.
>
> (Parks 2005: 104)

This is an account of how a session used an exercise in creating improvised music to aid reflection on specific aspects of leadership among participants on an innovative, work-based, MA programme in Leadership and Management in a post-1992 university. The author is one of a team of tutors who facilitate the learning on the programme.

The MA programme in question began in 2005 and it has been consistently popular not just for its form – six residential weekend blocks over a fifteen-month period – and its content – 'theory light and practice heavy' – but also because entry to the programme is not restricted just to participants with academic qualifications. On this programme, prior learning, particularly that of applicants experienced in leadership roles, is valued equally with formal qualifications in selecting participants for the programme. This valuing of their experience allows them, from the outset, to also value and take seriously their own experience (*cf.* Stacey and Griffin 2005). Since its inception, seven cohorts with approximately eighteen participants in each have undertaken the programme.

Each weekend residential block – residential in order to maximize both learning and social contact among staff and participants – is 'themed' to echo a number of the major themes in leadership. For example, there are blocks dedicated to 'Managing Change', 'Strategic Thinking' and 'Leading Groups and Teams', and it is in the context of that latter themed block that the activity described here takes place.

At the point when this session occurs, the participants will have already experienced two residential weekend workshops. The first of these, the general introduction to the programme, features an extended session where they are introduced to the Myers-Briggs Type Indicator (MBTI) model of personality traits and to their own personal Psychological Types. During the second weekend block, participants will have allocated themselves to Action Learning Sets (ALS) where they will work towards the completion of a self-selected, work-based

project supported through the ALS process and formalized through a personalized learning contract. In this block, too, the concept of 'reflective learning' is introduced and everyone is asked to begin writing reflective 'patches', which serve both as instruments of reflection and the basis for an assessed task that features in the final elements of the qualification. As a consequence of all this, by the time the third block is reached, everyone will have begun to work collaboratively and reflectively in many ways.

The 'zonals'

In each themed block, a range of activities is scheduled for participants – lectures, seminars, guest speakers, ALS – and on most residential blocks the participants engage in what are known as 'zonal' activities. That label is deliberately chosen because these particular activities have been created to place participants into a learning space outside their personal 'comfort zone'. Generally, they consist of activities that are unlikely to be part of participants' everyday routine and their engagement in which provides material for guided reflection. Each zonal activity is broadly configured to match the theme of particular residential sessions. Recent zonal activities have involved the cohorts in learning to play the didgeridoo, taking part in ballroom and Latin dance sessions, improvising scenarios with actors, experiencing the art of clowning and, in the example to be explored here, creating improvised music.

The zonal activities are not chosen simply for their novelty or because they provide 'an experience' – although they do offer both. They are, in fact, designed to dovetail with particular aspects of leadership and with the overall learning design of the programme, which is framed by an explicit set of values. These values are derived from particular pedagogical sources (e.g., Mezirow, Brookfield, Megginson) that inform the learning and development content and processes appropriate to adult students occupying a wide range of leadership positions in different organizations. Also, since one of the designers of the MA programme has particular views on, and has written scholarly and critical articles (to much acclaim) about, the nature and use of intended learning outcomes in learning encounters (Hussey and Smith 2002; 2003; 2008), the form and process of the programme is designed to allow for a 'spectrum' of learning outcomes to be realized by individual participants.

The design of the programme is also informed by *generic* pedagogical principles largely derived from Vygotsky's notions about the nature of effective learning spaces. In the context of this programme, these may be very broadly summarized as the criteria that (a) social interaction is required to develop high levels of communal knowledge and understanding among learners; (b) learning should 'take place in … contextualised, holistic [activities] that [have] relevance for them' (Grabinger and Dunlap 1995: 16 quoting Palincsar and Klenk 1992); and (c) movement towards higher levels of knowledge and understanding may take place when individuals are supported by a 'more knowledgeable other' – peers, more knowledgeable peers or teachers – across the 'zone of proximal development'. This is more formally described as

... the distance between the actual developmental level as determined by independent problem solving and the level of potential development as determined through problem solving under adult guidance, or in collaboration with more capable peers ...

(Vygotsky 1978: 86)

Since that process is integral to the programme, for that reason, too, the activities are called 'zonal'.

'Leadership' context

The literature on leadership is vast, and it is well beyond the scope of this chapter to consider even the most cursory of reviews of that literature. There are many genres and 'flavours' of leadership and many labels that describe composites and patterns of behaviour, concept, belief and values with which 'leaders' are observed to carry out their role. Excellent and succinct introductions to them may be found in, for example, Marturano and Gosling (2008) and in Nohria and Khurana (2010).

As mentioned earlier, this particular programme has been designed to be 'theory light and practice heavy', and so it is important for tutors/facilitators to explain, and for participants to note, that texts, whether supplied, recommended or self-generated, are envisaged as points of departure for the exploration of the nature of leadership in participants' own contexts. While the programme may be 'practice heavy' it is not 'skills heavy'. Clearly, there is a variety of high-level skills to be acquired and honed – the entire final weekend is an immersion in Strategy and 'strategizing' – but the emphasis is on the contextual character of those skills. Thus, while both cognitive and behavioural development is on the programme agenda from the outset, it is the nature of the contexts in which those cognitions and behaviours are deployed – their situation – that is equally important. For those reasons considerable time is devoted – through discussion and activity – to a critical examination of the nature of 'organizations'.

Choosing this particular developmental route, with its emphasis on leadership-in-context, presents an enormous issue with which participants and tutors alike must grapple. It is that organizations, no matter what their size, are just not rational entities that may be planned and ordered into tractability; they are also 'complex, adaptive systems' (Stacey 2002), they are 'turbulent' and create uncertainty (Emery and Trist 1975: 26) and because they are systems, their elements generate paradox and ambiguity (Senge 1990). All of this is part of the 'leadership terroir' – a term that more closely represents the dynamic and complex context of leadership than does the relatively static metaphor 'leadership landscape' suggested by Sheard and Kakabadse (2002). If it resists being caught in its entirety on a programme of this kind, then it must at least be approached if the values of the programme, that include 'challenging thinking and habitual ways of thinking and acting' and 'living with ambiguity and uncertainty' are to be honoured.

Metaphor, music and leadership

If you want to understand organizations, study something else.

(Weick 2002: 167)

Weick's invocation to metaphor as a route to understanding organizations is one to which the programme has responded. Metaphor provides an appropriate bridge, 'a kind of conceptual synesthesia [sic] in which one concept is understood in the context of another. The abstract is understood in the context of the concrete ...' (Geary 2011, loc 1585–1587).

What follows is, therefore, an extended metaphor. It is prefaced by a warning from Morgan (1997) in his classic work *Images of Organization* about use of metaphor in attempting to describe complex organization processes (and, by inference, the leadership processes involved):

'... All theories of organisation and management are based on implicit images or metaphors that persuade us to see, understand, and imagine situations in partial ways. Metaphors create insight. But they also distort. They have strengths. But they also have limitations. In creating ways of seeing, they create ways of **not** seeing. Hence there can be no single theory or metaphor that gives an all-purpose point of view. There can be no 'correct theory' for structuring everything we do.'

(Morgan 2007: 348)

The rationale for the musical form and content of the 'zonal' that takes place in residential block three rests on a number of conceptual links that have been made between leadership and music. This metaphorical bridge is well-used as the literature attests particularly to those metaphors that centre upon playing music, creating music and leading music (as conductors do in an orchestra). Kanter (1989), for example, describes how an orchestral conductor may be seen as a 'leader' and how the individual sections of the orchestra (brass, woodwind, strings, etc.) may be considered as 'teams' to be 'harmonized'. This same idea was later developed by Nierenberg (1995) into a highly influential experiential activity for organization leaders named 'The Music Paradigm'. Considerable literature also exists on metaphorical links between 'improvisation' in organizational settings and improvisation in music (particularly Jazz music) – see, for example, Weick (1993), the collection edited by Kamoche et al. (2002) and the variety of papers on similar themes that appeared in the special edition of the journal *Organization Science* (9: 5, 1998) dedicated to investigating such connections.

It is this latter metaphor-within-a-metaphor – organization complexity/leadership approached through jazz 'improvisation' – plus the accompanying metaphor of leadership as 'performance' that forms the rationale for the zonal activity. The fact that the zonal takes place in the block that deals with 'Teamworking' adds an extra dimension to the activity, as discussed later.

The music session

So what takes place in our zonal session? Although the format and content has differed slightly across the cohorts, the following is a general description of what takes place (and why) when participants return to the main meeting room in the afternoon of Day Two – a session that is labelled simply (and deliberately vaguely) as 'Exploring leadership concepts' on their agenda. It takes place after a morning's discussion about the nature of teams, groups and the role of the leader in developing their effectiveness.

The cohort returns from lunch to the main lecture room to find a variety of percussion instruments spread around the room together with a stage space on which is set a microphone connected to a Public Address (PA) system for amplification. There is a lot of speculation about what is going to happen – even some of the 'low-grade terror' that features in the opening quotation of this chapter. As the general facilitator of the session, it is my task to allay anxiety and to introduce what is about to happen as an opportunity for exploration connected with some of the themes of the weekend. I then introduce the two professional musicians who have now walked into the stage space and explain to the audience that they are about to see and hear a short (ten minute) completely improvised performance by the musicians and that they should simply watch and listen to the performance.

After the performance, discussion takes place at some length. I summarize this part of the proceedings by noting that the performance is part of an exploration of particular aspects of leadership and offer a quotation from Kamoche et al. (2002: 99) that defines (organizational) improvisation as '... the conception of action as it unfolds, by an organisation and/or its members, drawing on available material, cognitive, affective and social resources'.

The participants group is now 'handed over' to the two professional musicians who will conduct the remainder of the session, with occasional interruptions from myself to introduce elements of theory into the proceedings along with some observations on the process I am witnessing.

First, the group is formed into a large circle and the musicians lead a 'call-and-response' session where they call out phrases with varying tonal qualities, rhythms and complexity that the group is asked to repeat collectively – this is the 'warm-up' exercise.

Singing

The large group are now lead by the musicians in singing a 'round' (e.g., 'Frere Jacques', 'London's Burning' or 'Row, Row, Row Your Boat'). The four different parts of the round are rehearsed and sung in unison in the large group. The large group is then divided into four smaller groups (four or five individuals in each) and the round is sung again, this time with each of the small groups taking a voice in the round. The round is sung four times in this way.

Improvisation with sounds

The musicians allocate the same four small groups their own space in the corners of the room. The individual participants are given time to choose a 'sound of their own' – a nonsense syllable (or syllables), a song phrase, a hum, a whistle – something they can vocalize. They are then asked to perform their sounds in an improvised performance with the whole of their group. The brief performances will be made in a variety of 'styles' that the musician-facilitators will call out at random, for example, in the manner of 'a Shakespearean drama', 'a Rock Concert' or as if performing 'in front of the Queen'.

Improvisation with instruments

In the final and longest session, the large group are first introduced to the concept of 'bricolage'. In leadership contexts it may be exemplified by a leader 'mak[ing] things work by ingeniously using whatever is at hand, being unconcerned about "proper" tools and resources …' (Thayer 1988: 239).

The same four small groups are provided with a mix of simple musical instruments, either percussion instruments (e.g., drums, tambourines, maracas) or simple melodic instruments (e.g., kazoo, swannee whistle). To emphasize the nature of bricolage in this context, those without instruments are asked to find 'improvised' instruments, for example, empty water-cooler bottles or china mugs tapped with teaspoons or pencils to produce a variety of sounds. Under the guidance of the professional musicians the groups are coached through a series of rhythmic exercises designed to familiarize each individual participant with the potential of their 'instrument'.

The groups are now sent to 'break-out' rooms where they are asked, in the 30 minutes allowed, to compose a brief piece of music of between two and five minutes, using their given and 'found' instruments, to be performed in front of the whole class. The only constraint is that they must compose something that will allow the group to perform 'ensemble' and each member to perform 'solo' in the manner of a Jazz group (see Kamoche et al. [2002] for a detailed description of such processes). The musicians circulate to coach or facilitate the groups through the development of their piece during which the players experience a variety of approaches to their task.

Each group then performs their composition in front of the assembled group. Following the performances, a short discussion takes place. Then, to conclude, the musicians assemble the large group in the centre of the room. They sound a tone and the group is asked to sing that note encouraged by one of the musicians acting as a conductor. This continues with rising volume for about three minutes when the group is brought to a sudden halt by the conductor, and spontaneous applause breaks out from the group.

Undertones, overtones and echoes

The whole-group vocal performance signals the end of the session and the end of the residential weekend for the participants. Before leaving, they are handed a questionnaire, adapted from the work of Bourner (2003; 2011) that they were asked to complete and return to the author in postage-prepaid envelopes. Informed consent to the use of their information for this case study was sought within the structure of the questionnaire. Although the questions are reproduced in full in the Appendix, the findings set out below reflect only the responses to the questions relating to the musical exercise. Responses have been minimally edited to expand some shorthand comments that refer to particular activities, or to preserve the anonymity of named participants. A caveat underpinning the following thematic analysis of participants' comments is provided by Parks (2005):

> It is enormously difficult to trace reliably the direct cause-and-effect relationship between professional education and subsequent practice …
>
> (121)

Undertones

A number of comments revealed the feelings aroused, insights gained and challenges confronted in the activity.

Some struggled to make sense of it:

> I'm not a musician and I couldn't see what the point of the initial exercises was.
>
> (Participant B)

> I took a long time to 'get' what the point was.
>
> (Participant Q)

> I couldn't rationalize how people could play music and [how that would] compel me to be a better manager or leader.
>
> (Participant E)

Others felt intimidated or afraid, and some would have liked to withdraw from the activity:

> I was horrified about having to expose myself and what I believed were my limitations.
>
> (Participant A)

> I wanted to run away when I knew what was planned for the session.
>
> (Participant C)

However, without exception, all of them stayed on to face any fears they may have had and the related challenges:

> ... but although I wanted to run away, I stayed and I actually enjoyed creating something.
>
> (Participant C)

> Although I didn't know what was going to happen, I threw myself into the activities. As a leader you don't get to pick and choose so easily what you will or will not get involved in.
>
> (Participant D)

> I did something I've never done before and I don't usually get involved in anything that I haven't had experience of doing before. Here, I had no choice but to get involved.
>
> (Participant C again)

As a result of staying to face their challenges, they discovered not only something about themselves, but also about themselves in their roles as leaders:

> I tried to see what was behind each of the tasks. Now the notion that 'Leadership is a performance' seems more real to me.
>
> (Participant A)

> I thought of all the times I'd had to confront challenging situations and won through. ... That was just the first of a number of reflections that occurred during the session and afterwards that have helped me think about what kind of a leader I am – or might be.
>
> (Participant C)

Particular discoveries, for a number of the participants, were that they not only underestimate their particular talents but also that they have a tendency to compare themselves with others – to their own detriment:

> [Seeing] the professional musicians performing [and improvising] and wishing I had that kind of talent but then I thought, 'Hey! They wouldn't be as good at doing what I do as a day-job so maybe I do have that kind of talent!' (So not so negative, really ...)
>
> (Participant K)

> I was able to use my singing voice (which is quite good) with other people present – I haven't done that for a long time. I impressed myself!
>
> (Participant L)

I always tend to compare my work performance with others in the same position as me – usually to my detriment.

(Participant K again)

'I felt we hadn't used our initiative as other groups had done in using other [available instruments] and as a result my team's performance was 'ordinary' which in itself was not wrong but by comparison was not as good.

(Participant M)

Some of those same respondents had other and – potentially – more developmental realizations:

I can confront and challenge my instinctive desire to walk away from things I don't understand at first sight …

(Participant C)

That I can always find a good resource for my team to use.

(Participant L)

I can always find [appropriate] humour to help reframe challenging situations.

(Participant O)

I need to be able to stop 'jumping into the box' with others – particularly my team – and try to be a bit more detached. I might be more useful to them if I had a different perspective … My strength is that I can work collaboratively with others to get results against all the odds.

(Participant M)

These experiences echo what the literature has to say. As Palus and Horth (2002) observe:

Recognizing and producing musical sounds calls upon awareness of rhythm, harmony, silence and voice. Participants practice the risk taking of improvising in public. They explore what such risk taking might mean with respect to their own leadership and for eliciting others' leadership …

(218)

Overtones

Participants' comments also identified skills, knowledge and attitudes developed as a result of the activity.

Many respondents experienced a sense of shared challenge in the activity and that this had beneficial effects on their groups:

I realized that none of our large group had extensive musical experience and so we were all in the same boat ... after that realization I began to relax a bit and I just got into it, knowing I was on the same level as others.

(Participant B)

... we were all equals and we could make it up as we went along. It was real freedom.

(Participant K)

However, there were those – perhaps being more internally competitive – who failed to perform optimally:

I felt we hadn't used our initiative as other groups had done in using other [available instruments] and as a result my team's performance was 'ordinary' which in itself was not wrong but by comparison was not as good.

(Participant M)

The negative effects of competitiveness and bounded rationality – in this case assumptions that are made about 'boundaries' – are also evident:

... two of the groups strayed outside what I perceived to be the boundaries by using (a) a piano and (b) vocals to enhance their compositions.

(Participant G)

On the whole, though, the participants experienced affectively, cognitively and behaviourally the effects of the kind of alignment that emerges when challenges and situations are shared:

I made sense of what my group partners were doing and that we could (a) work together to produce something without words that was simple but meaningful to us and [we noticed] to others too.

(Participant K)

... our two musicians were able to play a piece that was totally unrehearsed ... because they had a huge understanding of one another and could develop a coordinated ... soundtrack [just] through the art of 'feel'.

(Participant M)

The ability to create a 'shared mental model' is felt to be one of the key roles ('disciplines') of leadership (Senge 1990). In groups and teams that act from such a model – when they

engage in 'macrocognition' – their task effectiveness increases greatly (Thylefors et al. 2005). 'Macrocognition' is also believed to be the key process that distinguishes high performance of the kind found in aviation, firefighting and surgical teams (Lensky et al. 2008).

Echoes

Subsequent ripples, ramifications and impact of the session became apparent in follow-up conversations. Having spoken to three of the participants eleven months after the event, they all tell me, looking back, that it was an 'enthralling' and 'very emotional' experience that has stayed with them. They say they have taken away 'a lot' from the experience, and when questioned about what this has meant in practice, each says that it has helped them to take a different perspective on their leadership roles and that they now actively look 'outside the obvious frame' – use other reference points – in order to help them understand options and strategies. They feel that as a result of the session, combined with their subsequent reflections and the supportive content and relationships of the programme, they also have some tools for (as they described it) 'taking things apart and putting them back together again in my own way'.

Conclusion

Although these informal findings may not seem particularly profound, they go to the heart of the intentions that framed the commissioning and briefing of the musicians who directly facilitated the workshop; the findings also go to the heart of what was intended through the writing of this chapter. More specifically, the session and the subsequent outcomes show that carefully crafted activities that combine elements of arts-based disciplines with other disciplines can, and do, have an impact.

The impact they have derives, arguably, from what Gregory Bateson (1979) calls 'double description'. Using Bateson's own metaphor for that process, double description may be approached through an understanding of 'binocular vision'. The left and right eyes receive different sets of information from the world and there is an area where both sets of information overlap. 'Seeing' is a neural process where the differences and the similarities are systematically compared and juxtaposed (by the visual cortex) to construct binocular sight in three dimensions – the eyes, individually, produce only two-dimensional sight. As Bateson says '[f]rom this new sort of information, the seer adds an extra dimension of seeing' (1979: 70). A more profound discussion of this metaphor and the concept from which it derives can be found in Hui et al. (2010: 80) and, as it relates specifically to arts-based activities of the kind described here, in VanGundy and Naiman (2007: 17–18).

Taking this further, the concept of double description generally suggests that by being presented with two different views of things – in this case, experiences of leadership and

music improvisation – an integrated view of both may be obtained if the 'seer' is able, in some way, to make sense of the 'overlapping areas'. Here, the facilitation of that process is the job of the tutors and musicians alike. However, this principle of double description may well be one of the epistemological foundations upon which the fusion of arts-based perspectives with other-discipline perspectives can rest.

What endures from such activities then, may be (as the participants have suggested) the ability to generate new perspectives (new ways of 'seeing') that are not confined to learning acquired from the same kinds of experience that gave rise to that ability originally. Ultimately, though, given the practice focus of both the MA programme and the activity described here, it is not seeing things differently – the cognitive change – that is the most important outcome, or even the affective accompaniments to those perceptions. The most important outcome from sponsoring such doubly describing activities will be if/when participants begin *doing* things differently – engaging in new forms of practice – not just doing different things. It is the difference between 'single-loop learning' (doing different things) and 'double-loop learning' (doing things differently) – see Bateson (1979) and Argyris and Schön (1974) – in responding to organizational or institutional challenges, which is the 'difference that makes the difference' (as Bateson puts it) in framing the most effective responses to such complex challenges. This is not a new idea, but it is the use of 'alternative' activities of the kind described here that makes the idea more concrete and, therefore, useable. And simply because these activities generate generativity, they offer a new kind of liberty – and how fascinating is that?

References

Argyris, M. and Schön, D. (1974), *Theory in Practice. Increasing Professional Effectiveness*, San Francisco: Jossey-Bass.

Bateson, G. (1979), *Mind and Nature: A Necessary Unity*, New York: E. P. Dutton.

Bourner, T. (2003), 'Assessing Reflective Learning', *Education & Training*, 45: 5, pp. 267–272.

—— (2011), *The Reflective Learning Revolution in University Education*, Address to BMAF/ UFHRD workshop – Reflective Learning: Facing up to the Challenges, Leeds Metropolitan University, 8 April 2011.

Emery, F. E. and Trist, E. L. (1965), 'The Causal Texture of Organisational Environments', *Human Relations*, 18, pp. 21–32.

Geary, J. (2011), *I Is an Other: The Secret Life of Metaphor and How It Shapes the Way We See the World* (Kindle Edition), HarperCollins e-books. Retrieved from amazon.co.uk.

Grabinger, R. S. and Dunlap, J. C. (1995), 'Rich Environments for Active Learning: a Definition', *ALT-J*, 3: 2, pp. 5–34.

Hui, J., Cashman, T. and Deacon, T. (2010), 'Bateson's Method: Double Description. What Is It? How Does It Work? What Do We Learn?' in J. Hoffmeyer (ed.), *A Legacy for Living Systems: Gregory Bateson as Precursor to Biosemiotics*, Dordrecht: Springer, pp. 77–92.

Hussey, T. and Smith, P. (2002), 'The Trouble with Learning Outcomes', *Active Learning in Higher Education*, 3: 3, pp. 220–233.

—— (2003), 'The Uses of Learning Outcomes', *Teaching in Higher Education*, 8: 3, pp. 357–368.

—— (2008), 'Learning Outcomes: a Conceptual Analysis', *Teaching in Higher Education*, 13, pp. 107–115.

Kamoche, K. N., e Cunha, M. P. and da Cunha, J. V. (2002), *Organizational Improvisation*, London: Routledge.

Kanter, R. M. (1989), *When Giants Learn to Dance*, New York: Simon and Schuster.

Lensky, M. P., Warner, N. W., Fiore, S. M. and Smith, C. A. P. (2008), *Macrocognition in Teams – Theories and Methodologies*, Hants, UK: Ashgate.

Marturano, A. and Gosling, J. (eds) (2008), *Leadership: The Key Concepts*, London: Routledge.

Morgan, G. (1997), *Images of Organization*, London: Sage Publishing.

Nierenberg, R. (1995), *The Music Paradigm*, BBC DVD Release (2000), FL 54.022 DVD, available from BBC Active, BBC Broadcasting House.

Nohria, N. and Khurana, R. (eds) (2010), *Handbook of Leadership Theory and Practice*, Boston, MA: Harvard Business Press.

Palincsar, A. S. and Klenk, L. (1992), 'Fostering Literacy Learning in Supportive Contexts', *Journal of Learning Disabilities*, 25: 4, pp. 211–225.

Palus, C. J. and Horth, D. M. (2002), *The Leader's Edge: Six Creative Competences for Navigating Complex Challenges*, San Francisco: Jossey-Bass.

Parks, S. D. (2005), *Leadership Can Be Taught: A Bold Approach for a Complex World*, Boston, MA: Harvard Business Press.

Senge, P. (1990), *The Fifth Discipline*, New York: Doubleday.

Sheard, A. G. and Kakabadse, A. P. (2002), 'Key Roles of the Leadership Landscape', *Journal of Managerial Psychology*, 17: 2, pp. 129–144.

Stacey, R. D. (2002), *Strategic Management and Organisational Dynamics: the Challenge of Complexity*, 3rd ed., Harlow: Prentice Hall.

Stacey, R. and Griffin, D. (eds) (2005), *Complexity and the Experience of Managing in the Public Sector*, London: Routledge.

Thayer, L. (1988), 'Leadership/Communication: a Critical Review and a Modest Proposal', in G. M. Goldhaber and G. A. Barnett (eds), *Handbook of Organizational Communication*, Norwood, NJ: Ablex Publishing Corporation.

Thylefors, I., Persson, O. and Hellström, D. (2005), 'Team Types, Perceived Efficiency and Team Climate in Swedish Cross-professional Teamwork', *Journal of Interprofessional Care*, 19: 2, pp. 102–114.

VanGundy, A. B. and Naiman, L. (2007), *Orchestrating Collaboration at Work*, San Francisco: Jossey-Bass/Pheiffer.

Vygotsky, L. S. (1978), *Mind in Society*, Cambridge, MA: Harvard University Press.

Weick, K. (1993), 'Organisational Redesign as Improvisation', in G. P. Huber and W. H. Glick (eds), *Organizational Change and Redesign*, New York: Oxford University Press, pp. 346–379.

Weick, K. (2002), 'The Aesthetic of Imperfection in Orchestras and Organizations', in M. Pina e Cunha, J. Vieira da Cunha and K. N. Kamoche (eds), *Organizational Improvisation*, London: Routledge, pp.166–184.

Appendix

Questionnaire (adapted from Bourner 2003 and 2011)

1. What did <u>you</u> experience at the workshop? (A brief description of how it was for you.)
2. What happened that most surprised you?
3. What, for you, was the most fulfilling part of the experience?
 Why do you think it was fulfilling?
4. What was the <u>least</u> fulfilling part of it?
 Why do you think it was not fulfilling?
5. What does the experience suggest to you about your strengths?
6. What does the experience suggest to you about your limitations or things you might want to develop?

Now … thinking about the music workshop in the context of the last few months of the MA (the lectures, the discussions, the social time, your action learning sets and maybe specific items such as your initial icebreaker activity 'The Leadership Secrets of Attila the Hun', the MBTI, your Belbin Team Role Inventory) …

7. What patterns can you recognize in your workshop experience?
8. What have you learned during the MA so far that helps you make more sense of the workshop experience?

Finally a few short(er) questions to help you turn your reflections into actions:-
As a result of the music workshop I will:-
Start doing (say what specifically)
Stop doing (say what specifically)
Continue to do (say what specifically)
Take time out to (say what specifically)
Talk to about
Do nothing because

Chapter 5

A Dramatic Approach to Teaching Applied Ethics

Craig Duckworth
(Anglia Ruskin University)

Introduction

This chapter describes a module in Applied Ethics that places drama, and dramatic techniques, at the heart of its pedagogical design. The module was developed in response to the perceived demand for ethically literate graduates, and has been offered as an option across all disciplines at London Metropolitan University, where the author was working at the time. In what follows, I present the rationale for the use of drama as a teaching device in Applied Ethics, and describe the ways in which drama is employed on the module. An appendix includes an original script that has been devised for use in teaching the climate ethics aspect of the course.

The rationale

Applied Drama

The use of drama on the Applied Ethics module is an example of Applied Drama. This is a general term for the use of drama, and dramatic techniques, for educational, research and political purposes.

There are many examples of applied drama. Forum theatre, for example, grew out of the work of Augusto Boal (2000), and offers the audience the opportunity to determine the course of dramatic events. This form of applied drama strongly influenced the design of one of the assessment instruments on the module, and we will return to it below. Other prominent examples of the application of theatrical techniques include the Theatre in Education movement in the United Kingdom (Wooster 2007), so-called invisible and guerilla theatre (Kohtes 1993), the Verbatim/Polemical theatre of, for example, David Hare (2009; 2005), and the rights-focused plays of Ice and Fire Theatre Company (iceandfire.co.uk). In addition, dramatic techniques are used in 'socio-drama', a participatory form of research that is used in the social and human sciences (e.g., Conrad 2004). Inspired again by Boal (especially Boal 1998), applied drama has also been used to generate public discussion about social and economic policy (Howe 2010).

In the context of Higher Education, Michael Watts has long advocated the use of novels and plays to teach economic principles (Watts 2003). In Ethics, the revival of interest in the moral dimension of literary texts (Nussbaum 1990; Adamson et al. 1998) has revived the view that novels and plays are appropriate tools for exploring the nature of morality. Prominent here has been the work of Martha Nussbaum, for whom an important part of the value of literature and drama in education is its capacity to promote empathy (see especially Nussbaum 1998; see also Stow 2006).

What these various uses of drama recognize is its power to facilitate group exploration of a given topic or issue. This insight is not new. As Nussbaum has noted, the ancient Greek conception of drama emphasized its social, exploratory character: 'To attend a tragic drama (in ancient Greece) was … to engage in a communal process of inquiry, reflection, and feeling with respect to important civic and personal ends' (Nussbaum 1990: 5). The capacity that drama has to facilitate group-based exploration is, however, distinctive. As the next section points out, drama facilitates a *special kind* of group exploration.

Critical engagement

Drama-based discussion, in which students discuss issues arising from a piece of recorded or live theatre, is unlike other collective fora in that it encourages discussants to occupy a particular kind of intellectual space. Audience members are simultaneously involved in the fictional events, they occupy the world of the fictional characters, and are also aware of themselves as spectators, as onlookers. They are, as Boal put it, 'spect-actors' (Boal 2000: xxi), alive to the possibilities of synergy and tension between the perspectives of the fictional characters and the spectator's point of view, the point of view that is available only to the audience.

There are two pertinent interpretations of the relationship between the spect-actor and the dramatic performance. Bertolt Brecht saw in Epic Theatre a means to stimulate dispassionate, critical reflection on contemporary social conditions. To achieve this, Brecht thought it essential to make the audience aware of the artificiality of the drama they were watching. Too much unreflective emotional engagement would, he believed, destroy the play's capacity to encourage 'distanced' critique.

Martha Nussbaum takes a different view. For her, the power of drama to stimulate reflection lies in its ability to carry the observer into the world of the play, to view things from the perspectives of the characters. What is on display from this perspective is, according to Nussbaum, the lived emotional and factual complexity of moral issues (Nussbaum 1990: Introduction, *passim*). The importance of Boal's notion of the spect-actor is, on Nussbaum's reading, that it makes possible critical reflection that is informed in a rich way by the emotional, lived intensity that characterizes moral issues as they unfold. It is the reading of the spect-actor that is implicit in Nussbaum's work, rather than Brecht's, that more directly inspires the use of drama on the Applied Ethics module.

The spect-actor and ethics

Why is this vision of drama as a means to critically engage the spectator important for the teaching of ethics? One way to answer this is to note a distinction that is commonly made between principle-based moral philosophies (Kantian and Utilitarian) and an approach to ethics that allies itself with Aristotle's emphasis on moral character.

Kantian and Utilitarian moral theories identify principles for action that are intended to determine what we ought to do in specific circumstances. For those who follow Aristotle's lead, moral action flows not from a reasoned grasp of general principles, but from possession of the relevant virtues. A benevolent, loyal, courageous person is primed to do the morally right thing.

It will be helpful to consider two interpretations of virtue ethics. What a person ought to do, in given circumstances, might be viewed as *the act that a virtuous person would perform*. One might ask what a generous or loving person would do faced with a given dilemma. Alternatively, on a reading that takes us closer to Aristotle's own view, the virtuous person can be viewed as one who is appropriately sensitive to the morally relevant features of a specific situation. The sophistication with which a person exercises this *perceptual* capacity (McDowell 1979) will reflect the extent to which he or she possesses the relevant virtues: commitment to friendship, recognition of the importance of family loyalty and so on. What importantly follows from this is that an appreciation of the character of a morally charged situation requires an imaginative grasp of how things appear to the agents involved. At the same time, in order to critically appraise agents' behaviour, we need to adopt the stance of the detached spectator. This dual perspective, the perspective of one who is at once emotionally engaged and dispassionately critical, is the perspective that Boal attributes to the spect-actor.

It should be noted that the point of encouraging students, through the use of drama, to adopt the point of view of the spect-actor, is not to suggest that principle-based moral philosophies ought to be viewed as redundant. A central aim is to bring into vivid relief the contrasting characters of alternative approaches to moral philosophy and how they might inform our response to applied issues.

The module

Armed with the rationale for the use of drama in Applied Ethics, I want now to outline the different ways in which drama has featured in the module.

Before I Call You In: Euthanasia and double effect

The first piece of drama that the students were introduced to was a monologue – *Before I Call You In* (Blick 2008) – in which a woman recounts episodes from her life as she prepares for her assisted suicide. The seminar session that followed this explored the 'trolley

problem' (Foot 1978; Thomson 1976), a thought experiment that explores the role of consequences in moral thinking. In a standard version of the trolley problem, a runaway trolley (or tram) will kill five people for sure but will kill only one person for sure if a switch is pulled that diverts it. The question is whether it is morally permissible to pull the switch. One way to approach this is to draw on the doctrine of double effect. According to the doctrine, it is permissible to cause bad consequences if the consequences, while foreseen, are not intended.

The parallel with the case of euthanasia is that the person who helps a person to die need not be viewed as intending to kill their loved ones by their actions. The death is a foreseen consequence, but the primary intention is, arguably, to enable a loved one to exercise his or her will. Towards the end of the monologue, close to the point at which she takes the fatal poison, the woman says to her husband, 'I love you, I love you'. It was pointed out by a student that this gives us a moving insight into her husband's motivations and intentions. The session illustrated for me the power of drama to engage students with subtle ideas.

The View From the Bridge: Moral character

The second use that I made of recorded drama was Arthur Miller's play, *A View From the Bridge* (1955/2009). In the play, the central character, Eddie Carbone, is giving shelter to two illegal immigrants in 1950s New York. One of the immigrants becomes romantically attached to Eddie's niece. Eddie disapproves of his niece's relationship with the immigrant, and, to stymie their plans to marry, Eddie informs the authorities of the illegal immigrant's whereabouts.

As with many of Arthur Miller's plays (see also *All My Sons* 1947/2000), *A View From the Bridge* is rich in moral complexity. The play's plot was outlined and central, particularly significant scenes were shown to the students. Little attempt was made to channel the students' reactions to the play other than to encourage an exploration of Eddie's motives. Following student-led and then lecturer-led discussion, a standard consequentialist way of evaluating Eddie's actions was introduced. This was then contrasted with the complexity of motivations revealed by the students' comments in order to explore the contrast between virtue-based and principle-based ethics. The drama was an ideal way to bring out the kinds of complexities that consequentialist theories are ill-equipped to deal with.

Group assessment using Boal's Forum Theatre

For the assessed presentation, students were organized into groups of approximately ten members. The presentation was designed to draw on the actor-audience interaction that is characteristic of Augusto Boal's Forum Theatre.

Step 1: Each group formulated a question relating to a general topic, such as terrorism and torture or abortion. At first, the groups worked cooperatively to develop key issues. Then each group was split into two groups: one group was tasked with developing an argument in favour of a particular point of view. The other group was asked to prepare counter arguments.

Step 2: Each group nominated one of its members to represent its position. Using notes, the two delegates sat at a small table and argued their cases.

Step 3: Following this initial discussion the delegates returned to their respective groups. The delegates were given ideas and fresh ammunition with which to challenge the opposing side.

Step 4: The two delegates returned to the table. During the ensuing debate, members of the delegates' groups were able to shout 'Stop!' and replace their group's delegate if they thought they had a more powerful contribution (delegates could also shout 'Help!' and be replaced if they wished).

At the end of the debate, the audience (other class members) asked questions to help them, and the lecturer, to come to a consensus as to which team had been the most persuasive.

This assessment method involved a rehearsal in week three in order to make sure that the students understood what was expected. For the rehearsal, a topic was chosen on which the students were expected to have quite strong views (I used the ethics of illegal music downloads). They were also given newspaper articles to help them to formulate arguments.

Climate ethics: A rehearsed reading

Over a two-week period the students were given lectures on climate ethics. Central considerations were discussed. The students were also given a script that I had written to illustrate and explore central moral issues relating to climate change. The ethics of climate change are commonly dealt with in a way that strips out any emotional content. This can alienate students from the issues by making them seem remote. The dialogue is called *Now We Are Dead* and as in, for example, Sartre's *No Exit* (1944/1989), the characters are deceased. One of them (Harry/Claire) represents the present generation, while the other (Dominic/Sarah) represents the not yet born.

During the two-week session on climate ethics, lecture material is delivered that highlights and explains the issues that will be covered in the dialogue. Students also read through the dialogue in small groups to familiarize themselves with it. In the second week of this aspect of the module two students are selected to perform the dialogue. There is a very simple staging. Floor sheets are used to cover a table and to create a stage beneath it. A small picture frame is also needed for the table. The students perform the dialogue and are then asked, in small groups, to address a number of set questions. A plenary session is then used to consider students' reactions. The dialogue is included below as an appendix.

Conclusion

There is a central conflict in moral philosophy between principle-based approaches and those that emphasize the importance of context. A further distinction can be made between contextual information viewed as the spectator sees it and how things appear for the agents involved. From the perspective of the agents, the open-ended, lived emotional and factual complexity, and uncertainty that characterize moral experience are in view. This tension among approaches to moral philosophy can be explored in a vivid and meaningful way by an approach to teaching moral philosophy that uses drama. Recorded and live drama through rehearsed readings place the student in the position of what Boal called the spect-actor. The spect-actor occupies an intellectual space that makes possible engaged critique, a form of critical reflection that is at once outside and inside other agents' moral experience. In this way, drama has the power not only to deliver knowledge of moral principles, but to transform students' moral sensitivities.

References

Adamson, J., Freadman, R. and Parker, D. (1998), *Renegotiating Ethics in Literature, Philosophy, and Theory*, Cambridge: Cambridge University Press.

Blick, H. (2008), *Before I Call You In*, The Last Word Monologues, BBC DVD.

Boal, A. (1998), *Legislative Theatre*, London: Routledge.

—— (2000), *Theatre of the Oppressed*, 3rd ed., London: Pluto.

Conrad, D. (2004), 'Exploring Risky Youth Experiences: Popular Theatre as a Participatory, Performative Research Method', *International Journal of Qualitative Research Methods*, 3: 1, available from http://www.ualberta.ca/~iiqm/backissues/3_1/pdf/conrad.pdf (May 2011).

Foot, P. (1978), 'The Problem of Abortion and the Doctrine of the Double Effect', pp. 19–32 in P. Foot, *Virtues and Vices and Other Essays in Moral Philosophy*, Berkeley, CA: University of Berkeley Press.

Hare, D. (2005), *Stuff Happens*, London: Faber & Faber.

—— (2009), *The Power of Yes*, London: Faber & Faber.

Howe, K. B. (2010), 'Adapting Boal's Legislative Theatre: Producing Democracies, Casting Citizens as Policy Experts', Ph.D. Thesis, available from http://repositories.lib. utexas.edu/bitstream/handle/2152/ETD-UT-2010-05-1186/HOWE-DISSERTATION. pdf?sequence=1.

Kohtes, M. M. (1993), 'Invisible Theatre: Reflections on an Overlooked Form', *New Theatre Quarterly*, 9: 33, pp. 85–89.

McDowell, J. H. (1979), 'Virtue and Reason', *Monist*, 62, pp. 331–350.

Miller, A. (1947/2000), *All My Sons*, London: Penguin.

—— (1955/2009), *A View From the Bridge*, London: Penguin.

Nussbaum, M. (1990), *Love's Knowledge*, Oxford: Oxford University Press.

———— (1998), 'The Literary Imagination in Public Life', in J. Adamson, R. Freadman and D. Parker (eds), *Renegotiating Ethics in Literature, Philosophy, and Theory*, Cambridge: Cambridge University Press.

Sartre, J. P. (1944/1989), *No Exit & Three Other Plays*, New York: Vintage.

Stow, S. (2006), 'Reading Our Way to Democracy', *Philosophy and Literature*, 30: 2 (October), pp. 410–423.

Thomson, J. J. (1976), 'Killing, Letting Die, and the Trolley Problem', *Monist*, 59, pp. 204–217

Watts, M. (ed.) (2003), *The Literary Book of Economics*, Wilmington, DE: ISI Books.

Wooster, R. (2007), *Contemporary Theatre in Education*, Bristol: Intellect Books.

Appendix

If you find this dialogue helpful, you are welcome to use it for non-profit, educational purposes.

Now We Are Dead

Scene: Two people are sitting at a table. They appear to have been arguing. There is a small, simple photograph frame on the table. The gender of the characters can be changed. Alternative names are Claire/Harry and Sarah/Dominic.

HARRY (CLAIRE):	You would have done exactly what I did. You sit there and judge me but you would have done exactly what I did. Had you been me.
DOMINIC (SARAH):	What you did? You 'did' nothing. You sat on your hands and did nothing!
HARRY (CLAIRE):	And you would have done the same, had you been me – I am sure of it.
DOMINIC (SARAH):	Had I been you – I mean 'you', Harry (Claire), then of course I would have done nothing, because you, Harry (Claire), did precisely … nothing!
HARRY (CLAIRE):	You miss my point.
DOMINIC (SARAH):	I do not miss your point, Harry (Claire). You think you are so sophisticated to view things impersonally, but it was you, Harry (Claire), who did nothing – you can't spin this table and speak with my voice – that is not possible, I'm afraid. No, forever, for eternity, Harry (Claire), you will be you, and I will be me. It's a fact.
HARRY (CLAIRE):	Well, had you … Had you been alive when I was alive you would have been as sceptical as me, as sceptical as most of us were, and that's the truth.
DOMINIC (SARAH):	But you had all the information, Harry (Claire), all the information you needed. You knew the possibilities, what could happen … what happened …

HARRY (CLAIRE):	It was all so uncertain – no one could predict genuine catastrophe with any confidence – things were merely probable.
DOMINIC (SARAH):	You knew the possibilities, Harry (Claire) – you knew the basics of what was going on. You didn't need to be a leading climate scientist. It was in your newspapers, on your TV, you read it with your breakfast – you knew what might occur and, listen, the merest probability of human disaster on that scale imposed a moral duty on you to take action – whatever was in your power to do – it was your duty to take action.
HARRY (CLAIRE):	Tell me, how did you die?

2

DOMINIC (SARAH):	It was St. Petersburg. St. Petersburg became the centre of everything. Supply routes from North Africa and China were heavily policed, food and energy supplies kept the great St. Petersburg alive, while we, on the outside, we starved – we starved, Harry (Claire), and we froze in winters more deadly than anything you ever experienced in your lifetime. No, you wouldn't want to swap places with me, Harry (Claire), you wouldn't want my memories – they watched us die, with regret, in our millions – the Gulf Stream collapsed, just as your scientists said it would, the 'thermohaline' currents, the ocean currents, that carried heat around the globe, they collapsed, and we froze, we froze to death, and we starved – in Eastern Europe, and all across Western Europe, where you lived all your life, that's what happened.
HARRY (CLAIRE):	I … we didn't know that this would happen. As I said, we didn't know for sure.
DOMINIC (SARAH):	Do you think I had rights, Harry (Claire)? Do you think I had a right not to be exposed to that kind of risk? I wasn't at risk of grazing my shin, of scratching my skin on a rose thorn – I, and millions like me, we were at risk of losing everything, of leading blighted lives, of losing the ability to feed ourselves, we risked disease, continuous upheaval, and painful, lingering death, in our millions. To know that you could do something to prevent that kind of vulnerability and, knowing that, do nothing, was morally wrong, Harry (Claire) – it was your duty to act in whatever way you could – to help me. My memories, they are torturers. When I close my eyes they shove me awake.
HARRY (CLAIRE):	I didn't cause the catastrophe … you didn't have any rights!

3

DOMINIC (SARAH):	Now we're getting somewhere, starting to peel back the skin – so come on, Harry (Claire) – now that we are dead we can say what we really think.

HARRY (CLAIRE):	You didn't exist. You weren't yet born. How could you have had rights? The idea is preposterous – you had no more rights than Mickey or Minnie Mouse have rights – you were a fiction, more than that you – 'you' – couldn't even be imagined.
DOMINIC (SARAH):	You have a poor imagination, Harry (Claire). What did you expect? That I might have two heads? Or bullet-proof skin? That I might not need to eat or be safe from the cold? You knew that I would have needs, Harry (Claire), whoever I turned out to be, you knew that I would have needs.
HARRY (CLAIRE):	But you were merely possible.
DOMINIC (SARAH):	My name is Dominic (Sarah). Do I look like a possibility? That's not how it feels to me.

4

DOMINIC (SARAH):	We can be calm now, now that we are dead. No need for fireworks. I want to ask you something, and I want your honest opinion. I know that you suffered, Harry (Claire) – everybody does – loss, grief, anxiety, depression, fear. Do you think that my suffering mattered less than yours because it happened later in time? That's what some of your most eminent minds thought, Harry (Claire), what some of your policymakers believed.
HARRY (CLAIRE):	I do not. How could I? Here we are, after our deaths – our harms, our sufferings, and our joys, are of equal value, of equal worth – but you *were* likely to be wealthier than me – your generation was likely to be wealthier than mine.
DOMINIC (SARAH):	Yes, my *generation* – but I was a poor man (woman), and powerless. There was never any guarantee that money, or sufficient money would be spent wisely – and, of course, when our time came it was too late – war, conflict, brutal suppression were the only means left, to make the few secure and the rest …
HARRY (CLAIRE):	I never did defend discounting. Future harms are no less harms because they occur in the future, and it was always crazy to think that your generation's greater wealth would somehow protect you. I accept that.
DOMINIC (SARAH):	Then what is your defence, Harry (Claire), for doing nothing? Do you have one? I am accusing you of being morally at fault – you, Harry (Claire), not your generation, not your politicians, not your ancestors – you. Do you have a defence? You see, it's not about my rights. What you did was to fail to treat me as a person. You say you don't defend discounting, but you discounted 'me', not my welfare, not my harms, not my rights, you discounted me – you

83

saw me as less important than you – you knew that you could have helped to reduce my vulnerability, and you did nothing. (Angrily) I am a person! I am as important as you! You should have done something!

5

HARRY (CLAIRE):	I didn't harm you, Dominic (Sarah). You believe that I did, but it's not true. I did not make you worse off through my lack of action.
DOMINIC (SARAH):	How so?
HARRY (CLAIRE):	Had I, had we all done everything that was needed to prevent catastrophic climate change you, Dominic (Sarah), would not have existed. Your grandfather would not have become a climate migrant. He would not have met your grandmother and you, in short, would not have been born. So, you see, Dominic (Sarah), I didn't make you worse off – had I done otherwise, had my generation done all that you say you wanted them to do, then there would have been no you. And tell me, Dominic (Sarah), you had a terrible, tragic end, but was your life worth living? Would you rather not have been born?
DOMINIC (SARAH):	I cannot regret knowing the people I knew, the people I loved. I am glad that I lived, if that is what you are asking.
HARRY (CLAIRE):	Then you have me to thank for that.
DOMINIC (SARAH):	This is repugnant! It was wrong to expose me to such serious risks.
HARRY (CLAIRE):	Had I done all the things that you would have liked me to do, I wouldn't have helped you, Dominic (Sarah). I would have helped to prevent your very existence – would you have wanted that? You said your life was worth living.
DOMINIC (SARAH):	What you did was morally wrong.
HARRY (CLAIRE):	You're on weak ground, Dominic (Sarah).

6

| DOMINIC (SARAH): | You did not cause me to exist. Neither what you did nor the actions of your generation caused me to exist. What your generation chose to do did not cause my grandfather and my grandmother to fall in love. The idea is ridiculous. Similarly, I might have existed even had the Gulf Stream been prevented from collapsing. My grandfather might have left Hampshire, he might have migrated east anyway. I might or might not have existed irrespective of your |

	actions, Harry (Claire). The thing is, your inactivity made it more likely that, were I to be born, my existence would be blighted by life-threatening vulnerabilities – me and literally millions like me. It was your moral duty to do everything you could to prevent my basic needs from being endangered. And you did nothing.
HARRY (CLAIRE):	You are trying to hold a dead man (woman) accountable for things that he (she) didn't do. I died a long time ago, Dominic (Sarah). A few charred bones, that's all that's left. I'm a pile of bones. You can't blame bones, can you?

7

(If the gender of the characters is changed then there are adjustments to be made in this section)

DOMINIC (SARAH):	Do you know why we're here? I mean why you and me? You don't know do you?
HARRY (CLAIRE):	Now you come to mention it, no I don't – do you?
DOMINIC (SARAH):	Here (passes the photograph that has been on the table all along). What do you see?
HARRY (CLAIRE):	You are much younger, but it's clearly you?
DOMINIC (SARAH):	And the woman?
HARRY (CLAIRE):	I don't know her … of course … how could I? She was your wife?
DOMINIC (SARAH):	Can you see a family resemblance? She is one of yours, Harry (Claire). She was your blood. She lived because you lived. Yes, you guess right, she was my wife … would you like to meet her?
HARRY (CLAIRE):	I would like to meet her … is it possible?
DOMINIC (SARAH):	It is possible, but I must warn you, Harry (Claire) … she will be hostile … she died with me … we died together … she died first, thankfully … I need to know. Will you apologize to her? Will you say that you are sorry?
HARRY (CLAIRE):	… No … I will not say that I am sorry – I have nothing to be sorry for … I didn't do anything … You have said it yourself, I did nothing.

PART III

Using Poetry

Chapter 6

Using Poetry to Create Conditions for Dialogue in a Postgraduate Course on Managing Diversity

Christina Schwabenland
(University of Bedfordshire)

As the module was accredited by the CIPD [...] higher level course, as the CIPD no longer [...]

I structured the module into twelve weeks of teaching [...]

Introduction

Recently I have begun to use poetry in my teaching, and in this chapter I will describe the way in which I have incorporated poems into the curriculum, what I hope to achieve from doing so and some of the results, as evidenced by follow-up interviews with students and comments in reflective diaries and reports. The context is that of a postgraduate module in Managing Diversity offered within a business school. Many of the subjects that are covered in this module touch on issues that are potentially both contentious and emotionally confronting, such as racial and religious discrimination. In particular, I have found that the topic of sexual orientation can be especially challenging. Not only are some students profoundly uncomfortable with this subject, their initial resistance can create a real barrier to learning. It is in this context that I have begun to use poetry as a means of transcending this resistance and developing the conditions for greater receptivity. I have drawn here on recent theoretical developments in the area of social poetics (Ramsey 2008; Cunliffe 2002) in management education and also on literary commentary, which points to the potential for the 'aesthetic imagination' to achieve a 'felt change of consciousness' (Barfield 1999: 20).

Background

Seven years ago I started teaching a postgraduate module on Managing Diversity and Equality. The module was offered in a business school and was a recommended elective for students taking degrees in Human Resource Management (HRM), several of which were accredited by the Chartered Institute of Personnel and Development (CIPD). It was also a popular choice for students taking a variety of other degrees including the MBA, MAs in management, international business, public administration and community organizing. A substantial number of students in any given year would be international, coming from Eastern Europe, the Middle East, Africa and Asia.

As the module was accredited by the CIPD (this is no longer the case, as the CIPD no longer accredit learning), it was essential that the curriculum introduce students to the United Kingdom's anti-discriminatory legislative framework, and this, of course, includes legislation to prevent discrimination on the basis of a number of factors including sexual orientation. I structured the module to include twelve weeks of teaching input arranged

around a core of six weeks in which we covered each of the main diversity 'strands': gender, race, disability, sexual orientation, religion and belief and age. Coming from a background of working in the voluntary sector, I anticipated that the most sensitive subject would be race. To my (perhaps naïve) surprise, I have never found talking about race discrimination in a classroom of predominantly black students (I am white) to be particularly difficult, but talking about sexual orientation is. Many of my students belong to particular faith communities that take a very strong position on the sinfulness of homosexual activity. Some students come from countries such as Iran or Uganda where to openly come out as gay or lesbian is to risk the death penalty. For some of these students it can be profoundly disorientating to find themselves in a classroom where equality between people of different sexual orientations is not only taken for granted but positively encouraged by the law.

In my second semester, disaster struck. I was working my way through the lecture slides with a group of about twenty students. At the back of the room were a small sub-group of African Christian women from Nigeria and Ghana, full-time students taking MAs in International Business or International HRM. At the front were a group of (mostly) white women, part-time students, already working professionally in HRM and taking one of the CIPD accredited qualifications. I was aware of a certain restlessness from the back of the room as I was going through my talk but as I reached my slides on the Civil Partnerships Act and its implications for HRM there was an eruption from the back of the room. All at once everyone in the back sub-group started talking vehemently and all at once. Intermingled in the collage of comments were such themes as sin, the destruction of family life, the unnaturalness of homosexuality, the immorality of the West. I waded into the melee wittering about the social construction of the concept of family and the proven incidence of homosexual activity among animals ('we're better than animals' was the response) to little effect. At this point the students in the front of the room started to retaliate. 'If your religion tells you homosexuality is wrong, then it's a crap religion', said one.

Everyone did, of course, quieten down after a while and the session got back on track. But all of us, including the students from both sides of the debate, were quite shaken by the experience. It seemed to me that the boundary had been crossed between encouraging challenging academic debate, on the one hand, and allowing comments that were hurtful and offensive, on the other. The effect of this experience was not of encouraging debate and dialogue, but of shutting it down, and I resolved to do better next time.

The next few times I taught the module, I experimented with setting ground rules. This is a common enough technique on training programmes. But it seemed artificial in the university context. Explaining why such rules were necessary disconcerted the students who had not expected to encounter homophobia in a module on Managing Diversity. Other students would arrive late and miss the discussion. It wasn't particularly effective.

Meanwhile, in my research I had been exploring the notion that metaphor, and in particular, metaphorical thinking, might be relevant to managing diversity. Edwards elegantly posed the fundamental question at the heart of diversity management when he asked: '[W]hich of a multitude of differences between people justify us in treating them differently and which

similarities justify similar treatment?' (Edwards 1987: 45). A metaphor can be conceptualized as presenting a theory about similarity and difference. Aristotle famously wrote that metaphor 'implies an intuitive perception of the similarity in dissimilars' (Aristotle, in the *Poetics* cited by Ricoeur 2007: 227). Building on this notion that metaphorical thinking may be of relevance in navigating this terrain between similarity and difference, I had begun to experiment with a small programme of 'warm-up' exercises, such as getting students to come up with metaphors for diversity, at the beginning of each session. I decided that for the week focusing on sexual orientation, I would create the exercise around poetry.

Experimenting with poetry

Stop this day and night with me and you shall possess the origins of all poems,
You shall possess the good of the earth and sun,
(there are millions of suns left,)
You shall no longer take things at second or third hand, nor look through the eyes of the dead,
nor feed on spectres in books,
You shall not look through my eyes either, nor take things from me,
You shall listen to all sides and filter them for yourself.

<div align="right">(Lines 33–37, 'Song of Myself', from Leaves of Grass, Walt Whitman)</div>

This is one of five extracts from poems that I gave my students at the start of the session. Each of the poems was written by a poet who was known, or generally regarded, as having been gay or lesbian. The poets included Sappho, Walt Whitman (the extract above), Audre Lorde, Wu Tsaio and Oscar Wilde (in this case, using work not too erotic in nature). However, in the sheet I gave out to the students, the poems were unattributed. The task I gave them was to work in pairs or small groups and see if they could work out in what century and part of the world was each poem written. My main aim was to get them to actually read and experience the poems – the stated task was of secondary importance. Very few students were able to guess many, if any, of the attributions. However, when we went through them together, discovering that the poems spanned such a wide range of time and space did serve to demonstrate that homosexuality as a human experience is as ancient as any other experience that people have thought important enough to record in symbolic form.

Poetry and management education

Why did I choose to use poetry for the opening exercise rather than some other art form? Using poetry in management education is not unique; Ramsey, for example, has experimented with asking students to write poems as well as providing poetry of her own

to stimulate what she calls the 'social poetics of a polyphonic classroom'. Social poetics, writes Cunliffe, 'carries the assumption that sensemaking is an embodied, relational and dialogic process of making connections' (Cunliffe 2002: 135). Poetry is 'about multiplicity not specificity' (Cunliffe 2002: 133), it 'disturbs certainties' (Ramsey 2008: 549). In structure and in content, poetry tells us that there is always more, there is always a surplus of meaning. The very act of providing poems for students to read at the beginning of a session on sexual orientation can be seen as suggesting in a gentle, rather than a confrontational way, that there may be more than one possibility for understanding human experience. 'Poetry should be great and unobtrusive, a thing which enters into one's soul, and does not startle it or amaze it with itself but with its subject' (Keats 2009: 493).

Secondly, the process of engaging with poetry draws us out of ourselves and into the poem.

> Poetry is more a threshold than a path, one constantly approached and constantly departed from, at which reader and writer undergo in their different ways the experience of being at the same time summoned and released.
>
> (Heaney 1989: 108)

This experience of being drawn in, or 'summoned' by a poem bears a certain affinity to the first stage of what Jung (cited in McIntosh 2010) described as engaging in the active imagination. Samuels describes this initial stage as a 'temporary suspension of ego control, a "dropping down" into the unconscious' (Samuels 2008: 6). This requires us to find a way of circumventing, or stepping aside from the ego, to temporarily suspend judgement. In his exegesis on Keats, Bate suggested that the reason Keats believed that poetic truth was more valid that rational truth was because 'poetic truth is grasped intuitively' while 'consequitive man [sic] contemplates the world through a logical pattern and imposes an artificial order and arrangement on what he sees' (Bate 1939: 16–18). In giving my students these poems at the very beginning of the session my intention was that they would experience a little of this sense of being summoned into the heart of the poem and in so doing might 'leapfrog' over the pre-existing cognitive frames for understanding that they bring to the session.

Thirdly, poetry changes us.

> Poetry enables the world to speak, to enter human language while remaining itself: it draws the world towards us, as it draws us towards the world. And in doing so it changes the world, or changes the way we perceive it … It seems to me that the one universal effect of poetry is this modification of reality, whatever the worldviews of the poets concerned.
>
> (Edwards 2011: 12)

Fourthly, poetry promotes empathy; a 'momentary identification of the imagination with its object' (Bate 1939: 25). Kohn (1990) suggests the capacity for empathy is an essential

requirement for living well in a plural society. Empathy can be promoted in many ways, but Scarry specifically links it to the experience of beauty. She argues that in an encounter with the beautiful *'we undergo a radical decentring'* (Scarry 2006: 111; emphasis added by author), a process that Iris Murdoch described as 'unselfing'. Murdoch wrote that 'the appreciation of beauty' is 'an entry into the good life since it *is* the checking of selfishness in the interests of seeing the real' (Murdoch 1970: 65), 'as though one has ceased to become the hero or heroine of one's own story' (Scarry 2006: 113). Hopfl suggests that poetry touches 'the shared experience of grief, joy, weariness, wonder and so on' (Hopfl 1994: 470).

D'Addelfio suggests that our capacity to experience empathy, 'intelligent feeling' (D'Addelfio 2006: 8) can be *deliberately* nurtured through narrative and poetry. So, to sum up so far, poetry is relevant to the teaching of diversity, because in its structure and form it resists closure and promotes a more relativist worldview. Experiencing poetry draws us into an intuitive encounter with another and through that encounter we are changed, at least in some small way.

Observations from the field

I really enjoyed the innovative way in which subjects were introduced by the tutor each week. For example the piece of music by Dame Evelyn Glennie at the start of the week on disability and the poetry (especially as I am a fan of both Sappho and Oscar Wilde) in the lecture on sexual orientation.

(Student)

I used a number of different methods to evaluate the impact of the exercises. These included my own observations, which I noted down each week in a reflective diary, reflective reports that I asked the students to write at the end of the semester (the quotation above comes from one such report) and a series of follow-up interviews that I carried out with students about six months after they had completed the module.

Although I nurtured a hope that the module might promote some Damascene moments of transformation for my students, my more prosaic aim was to create set conditions for dialogue within the classroom itself so that we could discuss difficult and contentious issues but in a way that would not cause harm or offence. 'First do no damage', doctors are extolled on taking the Hippocratic oath. Generally, this aim was achieved, although sometimes at the expense of there being any debate at all. My diary records my feelings after two quite different sessions:

AM group
Major disappointment! At 10am only one student there. Started exercise at 10:05 but only 3/4 students participated.

Overall session quite subdued – some of the more 'noisy' members of the group are not here. I found myself falling back on my more didactic role. Felt let down – had really been

looking forward to this session (with a lot of trepidation …). Very hard to predict effects of different exercises.

PM group
Much better! Some interest in the poetry and even some right guesses! Presentation group started their presentation with an interactive exercise (getting people to talk about gay people they knew) … Atmosphere quite light and friendly.

There was also evidence that reading the poetry had indeed allowed some students to 'suspend judgements' and to bypass their ego, the process that I referred to earlier as 'leapfrogging' over the initial barriers that their resistance erected. One of the excerpts is not, strictly speaking, a poem; it is a portion of a letter that Oscar Wilde wrote in 1897 when he was in prison serving a sentence for homosexuality, which was then illegal. This letter has been turned into a monologue entitled *De Profundis* and is occasionally performed as a play. The excerpt includes the following lines:

When first I was put in prison some people advised me to try and forget who I was. It was ruinous advice. It is only by realising what I am that I have found any comfort of any kind … and that those things that are meant for me as much as for anybody else – the beauty of the sun and moon, the pageant of the seasons, the music of the daybreak and the silence of great nights, the rain falling through the leaves or the dew creeping over the grass – would all be tainted for me and lose their healing power, and their power of communicating joy. To regret one's own experiences is to arrest one's own development. To deny one's own experiences is to put a lie into the lips of one's own life. It is no less than a denial of the soul.

(Wilde 1897)

On a number of occasions when I have asked students to guess the origin of this extract several of them have suggested that the author is Nelson Mandela. This is a very interesting guess. The excerpt is a profoundly moving soliloquy about the experience of being imprisoned for what you are. But Nelson Mandela is not gay, at least not as far as his public persona suggests. When I point this out the students generally react with shock. It seems as if they have become so drawn into the beauty of the piece that they have forgotten what the topic of the week is, even though I have already opened up the powerpoint slides and projected the lecture's title page on to the screen in front of the room.

The excerpt cited below is particularly interesting because the student specifically comments on the way in which the structure of the sessions did make it possible for the more contentious issues to be addressed. She noted the relationship between the first half, during which the exercises and the formal lecturing input occurred, and the second half where students would prepare a group presentation:

I realised a specific pattern, that when the tutor delivered the topic there used to be positive emotions reflected and so many of the groups, when they presented the same topic later in the day they were more likely to focus on case [studies] and hard aspects of the topic.

This student is the only one who specifically drew a connection between the different parts of the session. However, she does highlight exactly the experience that I wanted to achieve, that of creating the conditions for dialogue.

Many other students commented more generally as in the example cited below:

How could I do a reflective report without mentioning the lecture on sexual orientation. The poetry was brilliant.

The following two excerpts are important because they draw a link between the exercises, including the poetry, the more formal input and the implications for their own management practice. The first is quite general:

The metaphorical exercises at the beginning of the lectures were amazing. It has had a profound effect on the way I look at things. The way of looking at subjects (whether controversial, sensitive or difficult) from a symbolic perspective that was not confrontational I felt was very powerful in its subtlety. The different mediums such as poetry, music and quizzes show the complexities of forms and ideas that make up the quest for philosophical thinking around diversity and equality and, policy and practice. I will definitely use this in training and presentations whenever I am able to.

The second of these examples is worth quoting at length because it is specifically concerned with this session:

In week eight of the course we looked at sexual orientation and organisations and I remember very vividly the exercise that we undertook at the beginning of the lecture. We were given a list of five poems and asked to decipher what century they were written in and in which part of the world. I remember reading through them several times over ten minutes or so and still having no idea what they were about. After having a quick break and going back to read the first poem again with a fresh take I started to read it more slowly and intensely and all of a sudden I spotted words that were significant clues like 'Aphrodite' and 'myrrh' in the first poem. As I read the other poems with the same level and depth of intensity I realised that I could understand them and decipher where they were written. Admittedly the century they were written in was very difficult to guess, nor did I understand every poem thoroughly, but what I learnt was to take a step back from what I was doing and not to take things in such a literal sense. Once

I had moved away from looking at the face value of the poems I could see that the words had deeper meanings and understandings. This exercise really made me realise that whatever situation I am in as an HR practitioner I need to focus solely on that to be able to understand it thoroughly, and I realise that things can have a much deeper, significant meaning once interpreted fully.

All of the evidence I have presented above relates specifically to the use of poetry. The following example is less strictly relevant as the student cited does not make any specific comments about the way in which the module was taught. However, I am including it here because it is a powerful testament to the importance of including this topic:

I have always been confused about my sexuality. I was in denial since I was not sure about society acceptance and for fear that I will put myself at a disadvantage at employment I always kept it to myself. This module has made me fully understand the Discrimination Act 2003 [Employment Equalities Act (Sexual Orientation)] that protect gay lesbian and bisexual people. I now know that employers are required to protect employees against bullying and harassment in the workplace. And protect against the violation of individual dignity ...

These examples (save the last) all demonstrate that the use of poetry in the session on sexual orientation had some positive impact. It is worth noting, however, that these comments make up a small proportion of the material generated through the students' reflective reports and the other forms of data that I gathered. The more common response was silence – the poems were rarely referred to at all. The most frequently cited session was one on disability, which I introduced with a few minutes of percussion music played by Dame Evelyn Glennie, a musician who has been profoundly deaf since childhood. Perhaps having one's preconceptions about disability challenged is 'safer' than those about homosexuality.

Discussion

Fine (1989) writes that within a pedagogy that 'encompasses multiple views it is, quite often, difficult to manage the truly racist, sexist, elitist or homophobic student without privileging some position over others, thereby subtly silencing' (Fine 1989: 171).

Diversity in general and sexual orientation, in particular, are difficult topics to address in the classroom. They are, in Bielby's (2003) words, 'highly contentious' and raise a number of difficult ethical issues for the teacher. To what extent is it acceptable to impose one specific ethical framework on students who come from very different cultures? Or is it hopelessly utopian (perhaps even undesirable) to create a pedagogy that really 'encompasses multiple views'? These are, of course, not new questions. However, in business schools in the United Kingdom, these issues may be achieving greater salience as UK universities are becoming

more culturally and internationally diverse. Increasing numbers of students are arriving from cultures and countries where very different social norms are in operation, with little preparation or adjustment time before embarking on courses where they are expected to demonstrate critical thinking skills and a preparedness to embrace challenges to underlying assumptions and values. This is hard.

Perhaps one of the most valuable uses of poetry in circumstances such as these is that it allows the unsayable to be said. Poetry expresses complex, multilayered ideas and experiences but in such a way that some space is provided when it is needed. Poetry is challenging, but it is gentle. My students who mistook Oscar Wilde for Nelson Mandela had clearly been deeply moved by the poetry of Wilde's words. They did not need to have the implications of their mistake spelled out for them. Using poetry in this way provides them with some privacy.

Poetry also offers another route to participation. Social poetics 'draws on language as ontology to emphasise relationally engaged dialogic experience' (Cunliffe 2002: 133) and are embodied in 'the moment-by-moment activities of the tutor and manager-students in creating a polyphonic "classroom"' (Ramsey 2008: 544). I would like to think that every student's experiences are somehow interwoven into the polyphony. Each student's reactions to the poetry, their guesses, right or wrong (usually wrong whichever culture or background they come from) combine to create a dialogical space in which not all contributions need to be fully graspable or explainable to be nonetheless apprehended.

References

Barfield, O. (1999), *Fundamentals of Poetry,* New Delhi: Shubhi Publications.

Bate, W. J. (1939), 'Negative Capability: The Intuitive Approach in Keats', Harvard Honours Theses in English no.13, Boston: Harvard University Press.

Bielby, P. (2003), 'Courting Controversies: Using Insights from a Legal Philosophy Course to Develop Practical Recommendations for Realising Pedagogical Objectives in Teaching Morally Contentious Issues', *Teaching in Higher Education,* 8: 3, pp. 369–381.

Cunliffe, A. L. (2002), 'Social Poetics as Management Inquiry: A Dialogical Approach', *Journal of Management Inquiry,* 11: 2, pp. 128–146.

D'Addelfio, G. (2006), *The Educative Value of Empathy Within the Capability Approach,* available from www.capabilitiesapproach.com/publist/php?pubtype+research. Accessed 26 February 2008.

Edwards, J. (1987), *Positive Discrimination, Social Justice and Social Policy,* London: Tavistock.

Edwards, M. (2011), 'Believing in Poetry', *Literature and Theology,* 25: 1, pp. 10–19.

Fine, M. (1989), 'Silencing and Nurturing Voice in an Improbable Context: Urban Adolescents and Public School', in H. A. Giroux and P. McLaren (eds), *Critical Pedagogy: The State and Cultural Struggle,* Albany: SUNY Press.

Heaney, S. (1989), *The Government of the Tongue,* London: Faber and Faber.

Hopfl, H. (1994), 'Learning By Heart: The Rules of Rhetoric and the Poetics of Experience', *Management Learning,* 25: 3, 463–474.

Keats, J. (2009), 'Bright Star' The Complete Poems and Letters of John Keats, London: Vintage.

Kohn, A. (1990), The Brighter Side of Human Nature: Altruism and Empathy in Everyday Life, New York: Basic Books.

McIntosh, P. (2010), Action Research and Reflective Practice: Creative and Visual Methods to Facilitate Reflection and Learning, London: Routledge.

Murdoch, I. (1970), The Sovereignty of Good, London: Routledge and Kegan Paul.

Ramsey, C. (2008), 'Managing to Learn: The Social Poetics of a Polyphonic "Classroom"', Organization Studies, 29, pp. 548–558.

Ricoeur, P. (2007), The Rule of Metaphor, R. Czerny (trans.), London and New York: Routledge.

Samuels, A. (2008), 'New Developments in the Post-Jungian Field', in P. Young-Eisendrath and T. Dawson (eds), The Cambridge Companion to Jung, Cambridge: Cambridge University Press, pp. 1–18.

Scarry, E. (2006), On Beauty and Being Just, London: G. Duckworth and Co.

Whitman, W. (1928), Leaves of Grass, J. Valente (ed.), New York: Macmillan.

Wilde, O. (1897), De Profundis, available from http://upward.com/wilde/de_profundis.html. Accessed 19 April 2011.

Chapter 7

Teaching and Using Poetry in Healthcare

Clare Hopkinson
(University of the West of England)

The meaning of a work is not what the writer had in mind at some moment during composition of the work, or what the writer thinks the work means; the work means what it is intended, but rather what he or she succeeded in embodying in the work.

(Culler 1997: 66)

This chapter first provides an overview of how poetry has been used in healthcare settings, before describing the role of the facilitator, and demonstrates its use as a teaching process for professional development with nurses. Several exercises will be offered that can be used in the classroom to create different types of poems such as haiku, list poems and group poems. Using examples from my own poetry and teaching practice, I will focus on the power of experience reflected through language, image and metaphor for practice-based professions. I argue using poems for reflecting on my nursing experiences unleashed embodied practice knowing. The multi-layered nature and complexity held in poems can encourage reflexive insight in the writer and reader, which can inform a reflective conversation or enquiry in the classroom. In my experience, professionals in using poetry to reflect critically on their practice, gain an emotional distance that encourages empathy and may lead to an appreciation or understanding of the emotional exposure, contradictions and dilemmas faced in their day-to-day work. In turn, this knowledge offers the potential to create emotional resilience. Consequently, poetry may provide a space to reflect upon and re-connect practitioners to their underlying practice values, which sometimes are forgotten during the hurly-burly of practice.

Introduction

Poetry is one of the oldest ways of transferring knowledge, but definitions of it are contentious and difficult to pin down (Grisoni 2008). The word 'Poetry' is derived from Greek and 'means to compose, to pull things together, to shape, to create' (Harthill 1998: 47). Poems are written for the page and thus for the eye or for the ear – to be heard, so that how the poem sounds connects the audience making it memorable. Poetry comes from human experience, and through the use of language, form, rhythm, rhyme, metre, metaphors, images, themes, an evocation of the senses and feelings it 'reveals' the experience in new ways rather than describing it explicitly. As Culler (1997) suggested:

> The meaning of a work is not what the writer had in mind at some moment during composition of the work, or what the writer thinks the work means after it is finished, but, rather, what he or she succeeded in embodying in the work.
>
> (Culler 1997: 66)

But of course this is for published poems; poetry for personal and professional development may use published poems to discuss aspects of practice, for example, poems written by the practitioner's client group, or the purpose could be for practitioners to write their own poems. Published poems can give insight into the patient's and carer's journey in a synthesized format, bringing that experience to life and producing an emotional response in the listener or reader of the poem. In facilitating practitioners to write about their professional practice, the learning focuses on the reflexive insights gained and not the actual 'product' or quality of the poem. Yorke (1997), writing about the work of the poet Adrienne Rich, described writing poetry as:

> Writing poetry above all involves a willingness to let the unconscious speak – a willingness to listen within for the whispers that tell of what we know, even though what we know may be unacceptable to us and sometimes, because we may not want to hear, the whispers may be virtually inaudible. But to write poetry is to listen and watch for significant images, to make audible the inner whisperings, to reach deeper inward for those subtle intuitions, sensings, images, which can be released from the unconscious mind through the creativity of writing. In this way a writer may come to know her deeper self, below the surface of the words.
>
> (Yorke 1997: 22–23)

Consequently, how a person sees the imagery and metaphor in a poem depends on their unique experience, which will be different from the writer's. This ensures the audience or reader will make their own interpretations and connections (or none at all), so that in sharing these ideas in the classroom meaningful group discussions can be created. Writing can be a process of discovery; it can be re-visited or re-drafted potentially providing different insights and connections over time. Writing may bring a focus and clarity to an experience that was not present before. Nevertheless, poetry is not a dominant discourse in the healthcare literature, although it is becoming more prevalent in the social sciences and action research fields (Jones, 1997; Barrett 2011; Grisoni 2008; Richardson 2003).

Poetry in healthcare practice and education

Several themes emerge from the poetry healthcare literature: firstly, the claim that poetry is a spiritual, educative or healing process; secondly, poetry as a process for 'personal insight', liberation or empowerment; thirdly, as a process for developing empathy and connection with others; and finally poetry as a form of knowing that is described variously as aesthetic, imaginative or artistic ways of knowing practice. All of these ways of knowing can be regarded as embodied knowing.

In the limited healthcare literature, much of it describes poetry's use for aiding the well-being of, improving the mood of and reducing stress in clients, rather than for use with

hospital staff in a deliberate reflective or inquiry process. Poetry has been used in a variety of clinical settings with clients in areas such as learning disabilities (Logan 2002), psychiatry (Tischler 2010; Olson 2002; Harthill 1998), cancer and palliative care (Jarrett 2007; Robinson 2004; Roy 1999), midwifery and parent education (Davies 2008), elderly home care (Rice 1999) and with dementia clients (Hayes 2006; Killick 2004). Finally, hospital poetry projects have used poems in the environment to improve the general well-being of patients (Harthill et al. 2004; Macduff & West 2002) and in 'waiting room' settings (Philipp & Robertson 1996).

Poetry's prolonged use in psychotherapeutic practice and counselling is well documented where it is seen as a therapy in its own right (Chavis 2007; Hedges 2005; Shapiro & Rucker 2003). Furman (2003) a psychotherapist, used his own poetry as personal therapy, extolling the healing and curative power of poems. He argued poetry enables people to come to terms with the reality of their existence, thus connecting them to the emotional impact of experiences, which he found empowering.

There are some examples of using poetry during professional education: in humanities and ethics courses for medical students (Shapiro & Rucker 2003; Pickering 2000; Wellbery 1999), with general practitioners (Bolton 2005), in nursing and midwifery education (see, e.g., Tischler 2010; Davies 2008; Searle & Sheehan 2008; Hurlock 2003; Olson 2002; Anthony 1998), and specifically for assessing, synthesizing and evaluating learning (Olson 2002; Peck 1993). For the most part, nurses were encouraged to read and write poetry with the aim of gaining greater understanding of their nursing experience and promoting empathy with their clients (Bolton 2005; Olson 2002; Hunter 2002; Holmes & Gregory 1998). Hurlock (2003) proposed poetry helped student nurses to remember why they wanted to nurse, and this re-connection facilitated nurses to value the complexity of their role. These authors all promote the importance of personal insight gained through poetry, suggesting it has a reflexive quality.

Less overt was the suggestion that poetry could enable nurses to cope with the challenging experiences, contradictions and tensions in their work. Hurlock (2003: 7) proposed poetry could be seen as a 'poetic pedagogy', arguing the 'surprise' from poetry and the multiple meanings about nursing practice provides a useful medium for exploring nursing experiences. Through poetry, nurses can appreciate the 'art' of practice or aesthetic knowledge of nursing deepening their understanding of their practice (Hunter 2002; Olson 2002). Holmes and Gregory (1998) suggested poetry encourages the art and meaning of nursing to be made visible through rich, symbolic and metaphorical language that deconstructs and reconstructs images of nursing experience. Finally, Macduff (1998) proposed poetry could convey the spiritual dimension of nursing care while Gadow (2000) claimed it is an imaginative narrative that encourages nurses' emancipation.

It is clear from this literature that poetry can be a powerful and creative teaching strategy for deconstructing and reconstructing professional practice. Consequently, I have used it as a medium to stimulate reflective conversations and enquiry in the classroom as a catalyst for examining difficult aspects of practice while at the same time providing some psychological distance. Nevertheless, as Paley (2004) counters, poetry is not a panacea for transformative learning, liberation or emancipation because it can also be used to oppress. Indeed, I have

found many students are reluctant to engage initially in sharing their views about poems or to write their own because they have had difficult past school experiences. Pickering (2000) further warns that because poetry is a vehicle for holding paradox, paradoxically using it with a specific purpose in mind may actually inhibit its usefulness in healthcare education. I have found introducing poetry as a way of learning for professional practice requires careful facilitation, as students working with poetry can encounter unpredictable and emotional responses.

Using poetry in the classroom

First dalliances with poetry

I have used poetry in the classroom for nearly twenty years with nurses. In the beginning this was as a fun exercise to evaluate modules or students' programmes in order to facilitate their memories of their time as student nurses. In small groups, students were asked to take a familiar rhythm such as the '12 Days of Christmas' to produce a poem or a 'rap' to be shared later with the larger group. Fenton proposes (2003: 22) 'the handling of rhythm and form is instinctive', as we learn this from nursery rhymes at an early age, but we usually find it difficult to articulate what we know about a poem's form. This light-hearted, creative and collaborative group exercise gave students an artefact as a remembrance of their programme or module and the performance and process often produced much hilarity, a sense of achievement and closure for the group.

My own poetry writing began accidentally. It took me by surprise when I started to write poems in my diary during my Ph.D. Up to that point I had only written poems at school, a long time before. I had no training in poetry reading or writing nor had I studied English beyond school, so my knowledge about crafting a poem was intuitive. As a facilitator of reflective practice for over fifteen years, I kept a professional reflective diary about my teaching practice at the university, but these had not included poems. The poems were inspired by a mixture of events. On reflection I think the discipline of writing for ten minutes nearly every day encouraged me to become more creative. Some poems arose from my observations of returning to work as a hospital nurse where I was engaged in an action research inquiry that focused on nurses' reflections in the ward (Hopkinson 2009). Some were from student stories of practice re-processed as poems. Some were based on my past and personal experiences that were re-stimulated by working in a hospital ward, and later others were inspired by creative-writing workshops where the exercises and the space to reflect on my practice enabled the early drafts of poems and ideas.

Ageism
Old lady 80 years or more
Alone and still with this open sore

She shifts about just a tiny bit
Tired skin rub sheets that don't quite fit

The nurses say she's not in pain
The student says look how she's lain
Who makes the time to sit and listen?
Or notice the beads of sweat that glisten

Look at the doctor, a tired man
Ask him what's the care plan?
Just a bed blocker left to die
Frustration makes the student cry

Old lady in the hard ward bed
Her life story now left unsaid
Her leg wound open to the air
Hospital staff, do you really care?
Clare Hopkinson

The poem 'Ageism' above and 'All in a Day's Work' below came from two powerful student stories shared during two emotionally intense reflective practice sessions at the university. Both students had voiced their frustrations, anger and tears during the sessions about their challenging ward experiences. At the next session, a fortnight later, I gave each student a copy of the poem based on their story. Surprisingly, I was asked to read them to the group. This was the first time I had shared any poetry with anyone, not even my family. Thus, sharing my own poems and using them in the classroom as a deliberate learning process happened by accident. After the reading, the quality of the classroom discussion changed. Both groups talked about the conflict they experienced in the ward from patients and staff. They discussed the difficulty of not liking patients and having to sometimes put up with bad behaviour while outwardly still respecting the patient. They focused on wanting to give time to patients to talk but how this was challenged by staff asking them to do other tasks. Further stories were told about the challenging nature of nursing work. I could see a shift during these sessions, which I put down to sharing the poems; the students were not justifying their practice but were starting to raise powerful questions about it and the values underpinning it. On subsequent sessions where I have shared my own poems, the quality of the conversation has always changed like this.

The 'Ageism' poem has many layers; it was also about my experience some years earlier when my mother was hospitalized and subsequently died. It highlights the emotional labour of nursing and questions the politics and language of elderly care. I have learnt that when the poems are inspired by others' stories, there is usually a resonance with my own experience, emotions or values. Therefore, the poems are both my personal experience and the experience of the student nurse; they represent first (personal) and second person (relational) reflexive

inquiry and may even represent wider cultural aspects of nursing that can be regarded as third person or organizational reflexive inquiry (Hopkinson 2009; 2010).

> All in a Day's Work
> He touches her breast
> Chirpy, swallow, she isn't sure
> His black eyes undress her
> She becomes a dead bird
>
> He grabs her bum
> Easy prey swooped upon.
> Now she's sure, imagine
> How can she nurse him as before?
>
> It's only a bit of fun. Fair game
> Part of the job
> Shower, scrub, soap away confidence
> Down the drain
> *Clare Hopkinson with thanks to Elaine*

I felt very vulnerable reading my poems, just as Elaine had in telling her story of sexual assault by a patient, in 'All in a Day's Work'. Later, I discovered an important part of the process was being honest about how I felt in the moment and telling the students this. Now looking back, I can see this helped to make the relationship between myself as facilitator and the students more equitable; it helped reduce the power differentials while also creating an atmosphere of trust. I suggest these are key aspects of facilitating any creative process.

On reflection, I am still surprised by the powerful effect the poems have in sparking a meaningful reflective conversation. Mostly, they show my nursing values and interests that I was not aware of at the time of writing. For example, in 'Ageism' I express the assumptions of the dominant discourse by referring to the doctor as a man, but of course, she could just as easily be a woman. This is not an easy observation to make when I consider myself a feminist! So we learn who we are by noticing our responses to what we have written or read. It is interesting to also notice what we choose to omit or not say as another way of finding out more about ourselves.

Before starting writing: The role of the facilitator and group agreements

In academic writing, we are often 'schooled out' of writing from all our five senses of taste, smell, touch, sight and sound. There is arguably a sixth sense of context and memory

that sometimes lies just outside our awareness and may need stimulating. However, encouraging students to return to these senses helps release their imagination and forms the building blocks for creating poems. The first problem to overcome when engaging students in any form of creative writing is that of the 'internal critic' or voice that invariably surfaces; and this may be so for the facilitator as well as the students. The internal critic does not like uncertainty, undervalues what we do and tells us that 'we won't be good enough to write'. This requires the facilitator to consider the safety of the group: too safe and the students' creativity and imagination may not be inspired to reflect on their practice, too unsafe and the students will not enjoy the process and will refuse, subvert or resist taking part.

Professional practice groups can be more challenging to facilitate than 'creative-writing groups' where participants have chosen the course. In the latter case, there is usually a commitment to the process, but this cannot be assumed with professional practice groups. Established group dynamics may surface in creative-writing sessions that require addressing because trust among group members is essential in this kind of work. The facilitator may need to be aware of unconscious processes, such as group dynamics, transference and counter-transference that can be played out. Distressing experiences may be triggered by writing, therefore facilitators need to be comfortable with emotions, know when to refer students for counselling or other appropriate services and may require supervision after sessions.

Students sometimes perceive poetry as turgid, as an academic exercise or something that is serious whereas it can be a pleasurable and enjoyable activity. Consequently, encouraging 'playfulness' and establishing there is no 'right answer' or 'perfect writing' are key facilitation processes. Moreover, establishing group agreements, or 'boundaries', or 'ground rules' formally or informally, are usually helpful, to clarify the purpose and expectations of the session or sessions. Group agreements usually include:

- 'no put downs'
- silence when someone is reading their work
- listening and responding with respect to each other
- it not being compulsory to read out your work or receive feedback from others
- maintaining confidentiality
- it being alright to get emotional
- one person speaking at a time – no interrupting or talking over each other
- the process and not the quality of the writing being the focus
- starting and finishing on time

Students do not always appreciate 'group agreements', but they help to create safety and trust in groups. However, this is only the case if the facilitator reminds the group of the agreement if they are transgressed.

Writing exercises

Creative writing is, it seems to me, a mixture of invention or imagination alongside recollection or autobiographical experiences. This mixture can allow students some emotional distance and reframing of their experience and thus, make the writing more interesting by freeing up their thinking in a way that reflective models may not do. It is often helpful if the facilitator also joins in the writing exercises. 'Warm-up' exercises can be useful in getting students in the mindset for writing.

Exercise 1: Free-fall writing

As Flint (2007: 31) noted, writing fast can 'assist us to sidestep the restrictions our minds place around our creativity'. Free-fall writing involves a stream-of-unconscious writing. The pen is not removed from the page, and no attention is paid to grammar, spelling, etc. Stopping to think or re-read the writing is not permitted; the key is to keep writing continuously, repeating words on the page if necessary.

Sometimes it is useful to provide a trigger, such as 'the journey here', 'today I will', 'I remember when', 'I feel' or 'write to the internal policeman in your head'. An alternative can be to read a poem or passage and then engage the students in free-fall writing. This can stimulate free associations, which might provide some personal and professional insights. The time spent on this activity can be flexible, but I usually spend at least ten minutes on writing. Processing the activity can also take many forms. Students can read out a section they were pleased with, or more general comments can be invited by asking them 'what surprised you?' or 'what did you notice?'

Exercise 2: Word-storming feelings

Write down a word you are feeling right now. Repeat this three times. Each person contributes a word on to the 'word board' or flipchart. Choose an emotion to write from.

Or do the same as above, and write down something you might find in a drawer at work or at home. Repeat three times. Then select a creature or place or aspect of nature. Repeat three times. Select three words from your list of nine. Write on these three ideas. Or alternatively, pass the three words on to your partner and write from their list of words.

Exercise 3: Memory and Imagination (Manjusvara 2005: 2)

Describe a recent journey/experience include all the sights, sounds, smells and your thoughts and feelings. Invent one small detail that did not happen. Then share your story with a partner. Can your partner detect what is untrue?

This exercise is useful for showing different perceptions and how people notice different things. It can be applied to clinical practice and adapted to encourage students to write from the perspective of a patient or colleague. Inventing a detail can help provide some emotional distance and acceptance of a difficult experience.

Exercise 4: List poems

These are poems that begin with the same words for each line, such as 'Nursing is …' , 'I used to … but now …', 'I am …', 'Because …', 'If only …'.

List poems are really useful for collaborative or group poems. Students can write a line each before passing on the poem with the line turned over so the next person does not know what has been written before. This often produces some powerful work and the connections can be the focus for the plenary discussion.

Exercise 5: Writing from an object or photograph

Household objects or objects from nature, pictures or photographs can stimulate memories and recollections and are often used to encourage students to write from the five senses or create a fresh image. An alternative can be to produce an object when students have their eyes closed so they only feel or smell it. Writing begins when the object has been removed so that the writing focuses on what the object evoked (Bolton et al. 2006: 91). Students can be asked to imagine they are the object and write from that perspective. For example, what is it like to be the curtains in a hospital ward?

Exercise 6: Writing as a place or animal

If you were a place or animal what would you be? Using all your senses write from that perspective. Asking questions to evoke the senses may encourage writing.

Exercise 7: Haiku, less is more

Haiku is a poem with a specific form containing seventeen syllables set out in three lines of five, seven and five syllables, respectively. It captures an experience succinctly and attempts to establish the essence of that which is being written about. It usually involves nature and the closeness of the self to that experience. For example,

up from the valley
gold larch needles edge the lane
stitching back my heart

(Bolton 1999: 41)

Grisoni (2008) used haiku for gaining insight about what really happens in organizations. However, I have found it difficult to engage students with this kind of poetry writing as some students get distracted with the form and structure to the point where it interferes with their creativity.

Conclusion

This chapter has addressed poetry's versatility as a teaching process for professional practice development. Poems may stimulate and paradoxically encourage emotional distance thereby allowing for the emotional nature of practice, the values and contradictions in practice to be safely examined. Poetry may capture the complexity of practice through its multi-layered nature, developing empathy and providing new insights over time. It incorporates conscious and unconscious experience to reveal a different way of knowing that is embodied and reflexive. The interactive nature of poetry, as an individual and social process, can produce powerful reflexive conversations and purposeful inquiry to further reveal embodied practice wisdom.

References

Anthony, M. (1998), 'Nursing Students and Haiku', *Nurse Educator*, 23, pp. 14–16.

Barrett, T. (2011), 'Breakthroughs in Action Research through Poetry', *Educational Action Research*, 19: 1, pp. 5–21.

———— (1999), *The Therapeutic Potential of Creative Writing Myself*, London: Jessica Kingsley.

Bolton, G. (2005), *Reflective Practice: Writing and Professional Development*, 2nd Ed., London: Paul Chapman, Sage.

Bolton, G., Field, V. and Thompson, K. (2006), *Writing Works: A Resource Handbook for Therapeutic Workshops and Activities*, London: Jessica Kingsley.

Chavis, G. (2007), 'A Poetry Therapy Experience', in W. Field and Z. Ansari (eds), *Prompted to Write*, Truro: fal publications, pp. 5–10.

Culler, J. (1997), *Literary Theory: A Very Short Introduction*, Oxford: Oxford University Press.

Davies, L. (2008), 'Rhyme and Reason – The Use of Poetry in Midwifery Practice and Education', *New Zealand College of Midwives Journal*, 38, pp. 17–19.

Fenton, J. (2003), *An Introduction to English Poetry*, London: Penguin.

Flint, R. (2007), 'A Writing Workshop in the Garden of Dreams', in W. Field and Z. Ansari (eds), *Prompted to Write*, Truro: fal publications, pp. 31–38.

Furman, R. (2003), 'Poetry Therapy and Existential Practice', *The Arts in Psychotherapy*, 30, pp. 195–200.

Gadow, S. (2000), 'Philosophy as Falling: Aiming for Grace', *Nursing Philosophy*, 1, pp. 89–97.

Grisoni, L. (2008), 'Poetry', in M. Broussine (ed.), *Creative Methods in Organizational Research*, London: Sage, pp. 114–133.

Harthill, G. (1998), 'The Web of Words: Collaborative Writing and Mental Health; Poetry and Healing Project, Wales', in C. Hunt and F. Sampson (eds), *The Self on the Page: Theory and Practice of Creative Writing in Personal Development,* London: Jessica Kingsley, pp. 47–62.

Harthill, G., Low, J., Moran, S., Purse, M., Ryder Richardson, E., Sampson, F. and Sandbrook, C. (2004), 'A Case Study: The Kingfisher Project', in F. Sampson (ed.), *Creative Writing in Health and Social Care,* London: Jessica Kingsley, pp. 92–118.

Hayes, K. (2006), *The Edges of Everywhere: Poetry by People Living with Memory Loss,* Bristol: City Chameleon.

Hedges, D. (2005), *Poetry, Therapy and Emotional Life,* Oxford: Radcliffe.

Holmes, V., and Gregory, D. (1998), 'Writing Poetry: a Way of Knowing Nursing', *Journal of Advanced Nursing,* 28, pp. 1191–1194.

Hopkinson, C. (2009) *More than A Good Gossip? An Inquiry into Nurses' Reflecting in the Ward* Ph.D., University of the West of England

—— (2010), 'Personal and Professional Development', in D. Sellman and P. Snelling (eds), *Becoming A Nurse: A Textbook for Professional Practice,* Harlow, UK: Pearson, Prentice Hall.

Hunter, L. P. (2002), 'Poetry as an Aesthetic Expression for Nursing: a Review', *Journal of Advanced Nursing,* 40: 92, pp. 141–148.

Hurlock, D. (2003), 'A Kinship of Nursing and Poetry: Creating a Poetic Pedagogy', *Organization Development Journal,* 21: 3, pp. 31–43.

Jarrett, L. (2007), *Creative Engagement in Palliative Care,* Oxford: Radcliffe.

Jones, A. (1997), 'Death, Poetry, Psychotherapy and Clinical Supervision (the Contribution of Psychodynamic Psychotherapy to Palliative Care Nursing)', *Journal of Advanced Nursing,* 25, pp. 238–244.

Killick, J. (2004), 'It's Mine! It's Mine! Writing and Dementia', in F. Sampson (ed.), *Creative Writing in Health and Social Care,* London: Jessica Kingsley.

Logan, E. (2002), 'Springfield: Education for Adults with Learning Disabilities', *British Journal of Learning Disabilities,* 30 (1), pp. 43–46.

Macduff, C. (1998), 'Poetry and the Spirit Level in Nursing: Seeing with Burns and Whitman', *European Nurse,* 3 (3), pp. 197–206.

Macduff, C. and West, B. (2002), 'Developing the Use of Poetry within Healthcare Culture', *British Journal of Nursing,* 11 (5), pp. 335–341.

Manjusvara (2005), *Writing Your Way,* Birmingham: Windhorse Publications.

Olson, T. (2002), 'Poems, Patients and Psychosocial Nursing', *Journal of Psychosocial Nursing,* 40 (2), pp. 46–51.

Paley, J. (2004), 'Gadow's Romanticism: Science, Poetry and Embodiment in Palliative Care, Loss and Bereavement', *Nursing Philosophy,* 5 (2), pp. 112–126.

Peck, S. (1993), 'Monitoring student learning with poetry writing', *Journal of Nursing Education,* 32, pp. 190–191.

Pickering, N. (2000), 'The Use of Poetry in Healthcare Ethics Education', *Medical Humanities,* 26 (1), pp. 31–36.

Philipp, R. and Robertson, I. (1996), 'Poetry Helps Healing', *The Lancet,* 347, pp. 332–333.

Rice, R. (1999), 'A Little Art in Home Care: Poetry and Storytelling for the Soul', *Geriatric Nursing,* 20, pp. 165–166.

Rich, A. (1995), *What is Found There: Notebooks on Poetry and Politics,* London: Virago.

Richardson, L. (2003), 'Poetic Representation of Interviews', in J. R. Gubruim and J. A. Holstein (eds), *Post-Modern Interviewing,* Thousand Oaks, CA: Sage, pp. 187–201.

Robinson, A. (2004), 'A Personal Exploration of the Power of Poetry in Palliative Care, Love and Bereavement', *International Journal of Palliative Nursing,* 10 (1), pp. 32–39.

Roy, D. (1999), 'Why We Need Poets in Palliative Care', *Journal of Palliative Care,* 15 (3), pp. 3–4.

Searle, R. and Sheehan, D. (2008), 'Innovative Reflection on Nursing Practice: Introducing the Art of Reflective Poetry into the Curriculum of a Graduate Nurse Program', *Focus on Health Professional Education: A Multi-disciplinary Journal,* 10 (1), pp. 71–75.

Shapiro, J. and Rucker, L. (2003), 'Can Poetry Make Better Doctors? Teaching the Humanities and Arts to Medical Students and Residents at the University of California, Irvine, College of Medicine', *Academic Medicine,* 78 (10), pp. 953–957.

Tischler, V. (2010), *Mental Health, Psychiatry and the Arts,* Oxford: Radcliffe.

Wellbery, C. (1999), 'Poetry and Medicine', *The Journal of the American Medical Association London,* 281: 24, pp. 2286–2287.

Yorke, L. (1997), *Adrienne Rich, Passion, Politics and the Body,* London: Sage.

Chapter 8

Gaining a Wider Perspective on Life in Medical Education

Mark Rickenbach
(Wessex Deanery for Medical Education)

Introduction

'*Teaching is a short cut to the acquisition of experience*' (personal communication from D. Rowlands). Within medical education there is much more to consider than the factual science if doctors are to achieve holistic and effective care (McNamara 2010; Saunders 2000). Holistic medicine deals with spirituality, sexuality, mental well-being and physical well-being (Myss 1996). Doctors need to consider the personality, life stage and family context for each patient if they are to maximize the impact of their medical treatments. To widen the understanding of this concept, those doctors in training within the general practice vocational training scheme at the Wessex deanery were introduced to the song 'Everybody's Free (to wear sunscreen)' by Baz Luhrmann. Also known as 'The class of 99 from William Shakespeare's Romeo and Juliet' this song was written using the exact words published by Mary Schmich in the *Chicago Tribune* on 1 June 1997 (Schmich 1997).

This song was played to the trainees and a copy of the words were provided to facilitate discussion and reflection. Trainees were aged between 25 and 30 years, and the intention was to introduce them to the viewpoint of their patients over the age of 40 years. This was undertaken as a short activity as part of a biannual meeting for all trainees on the vocational training scheme. After a short discussion trainees were encouraged to reflect on the song and lyrics after the meeting ended.

Words of Mary Schmich later used in the song 'Everybody's Free (to Wear Sunscreen)' by Baz Luhrmann (Schmich 1997)

Wear sunscreen
Enjoy the power and beauty of your youth
You will only understand the power and beauty of your youth when they have failed
You are not as fat as you imagine
Don't worry about the future
It is as effective as trying to solve an algebra equation by chewing bubble gum
Do one thing every day that scares you
Sing
Don't be reckless with other people's hearts
Don't put up with people who are reckless with yours

Floss
Don't waste your time on jealousy
Sometimes you're ahead, sometimes you are behind
The race is long and in the end it is only with yourself
Remember compliments you receive, forget the insults
Keep your old love letters and throw away your old bank statements
Stretch
Don't feel guilty if you don't know what to do with your life
Get plenty of counselling
Don't congratulate yourself too much or berate yourself either
Your choices are half chance so are everybody else's
Enjoy your body
Use it every way you can
Don't be afraid of it or what other people think of it
It is the greatest instrument you will ever own
Do not read beauty magazines they will only make you feel ugly
Get plenty of calcium
Be kind to your knees
Get to know your parents
You never know when they will be gone for good
Be nice to your siblings
They are the best link with your past
And the people most likely to stick with you in the future
Friends
Work hard to bridge the gaps in geography and lifestyle
Because the older you get
The more you need the people you knew when you were young
Travel
Accept certain inalienable truths
Prices will rise, politicians will philander
You too will get older
Respect your elders
Don't expect anyone else to support you
Don't mess too much with your hair
Or by the time you are forty it will look 85
Be careful whose advice you buy
Advice is a form of nostalgia
Trust me I'm the sunscreen

Everybody's free

After the song was played there was a silence of contemplation and then discussion about the different perspectives that come with age. Themes that emerged were consideration of people's current perspective, and making the most of opportunities that were open to younger people before the frailties of old age crept in to limit a person's options and choices.

After the discussion the organizers reflected on the session. It was concluded that the song did lead to a wider perspective than that set by the subsequent agenda of the day. More time would have allowed a longer more in-depth discussion and this was suggested for future training opportunities. Whether more time would have had a greater impact was uncertain. Also more time would have constrained the remaining events of the day.

This song could be viewed as a brief intervention, which would nudge people towards considering the perspectives of other age groups and life in general – helping to nudge the trainees from pre-contemplation stage to contemplation stage or even a change in behaviour (Prochaska et al. 1994; Rickenbach 2003). Unlike other brief behaviour, such as stopping smoking, alcohol or drugs (Prochaska & DiClemente 1986; Prochaska et al. 1992), the thought processes started could be reinforced by hearing the song again on the radio or elsewhere.

In terms of learning theory, hearing the song on future occasions, in other media, could move superficial learning, that was soon forgotten, to a deeper learning and greater understanding of the underlying issues (McNamara 2010). However, a formal evaluation of impact was not undertaken in this setting, because any small changes in self-perception, insight and behaviour change would be hard to demonstrate set against the other activities of the day. The focus of the subsequent meeting was on administration of the training scheme that the trainees were involved in.

The session and subsequent hearing of the song did reinforce my own personal learning about patients and increased my desire to share the content of the song in other settings. It had opened my eyes to issues I had a sense of, but which had not crystallized in my mind. The intention had been to use a combination of sensory media to enhance learning and encourage recall – auditory being the predominate sense, both via the song and speaking of the lyrics, and also visual, with the written word. By anchoring the messages to a song there was an increased likelihood of recall.

The hope was that medium of music and song would stimulate a deeper motivation to consider the subject of seeing other people's viewpoint, and help the trainees reflect on and enhance each person's own professional practice (Schon 1987, 1983). This particular topic was not driven by surface motivation to complete the course or a strategic motivation to pass exams, approaches common among medical students, so it needed a different approach (McManus and Richards 1999) – one focused on building up a perception of the relevance and value of learning about other people's perspectives (Miller et al. 1998).

The messages of the song are to enjoy life and hold a positive approach to what happens to you during life. Achieving this is a developmental stage for many people and some people never reach this stage in their own life. A preoccupation with appearance, materialism and an assumption that life should be perfect can lead to crisis later in life when these goals usually become unachievable. There is also an important realization to be made that each person's perceptions about their own life are within their own control (Briers 2009). External agents such as magazines and words can influence people's perceptions, but the inner belief of each person is a key factor.

These points could have been made clearer after the discussion following the song, but there is a balance between being told and reaching relevant conclusions by personal reflection. Personal reflection and ownership of concepts can produce deeper practice-based learning that may be more likely to be applied.

Art has been used to illustrate concepts in medical education and there is an overlap between the artistry of medicine and the science of medicine. The current drive towards scientific thinking, technology and targets has overshadowed the fact that there is considerable uncertainty in medicine and that the art of individualized medical care remains. The human body itself is a source of hundreds of years of artistic endeavour and there is a beauty in the anatomy of humans that has spawned artistic work from Leonardo Da Vinci through to *Gray's Anatomy* book and the plastinized body sculptures of Gunther von Hagens. In addition, art forms have served a range of educational and health care purposes.

Poetry and song have been used in health care education to raise awareness of issues (Janowiak 1995; Emah 1993; Muszkat et al. 2010), to disseminate information (Keller 1997; Emah 1993), to reinforce learning (Keller 1997; Capen et al. 1994), see the perspectives of others (Muszkat et al. 2010; Savishinsky 2007) and to help reflect on learning (Canby and Bush 2010). These media have often been used to educate the general population. A recent example of this relates to control of HIV infection by adequate barrier contraception (Keller 1997). Songs on this topic were shared in the community and led to significant increase in contraception and reduction in HIV infection (Keller 1997). Poetry and song have been used to reflect on the gift of life after anatomy sessions (Canby and Bush 2010) and to help trainees understand the life of those in rest homes (Muszkat et al. 2010) or overcoming drug abuse (Janowiak 1995). Poetry has helped doctors discuss the perspectives of other ethnic, income, age and social groups as part of structured training (Muszkat et al. 2010; Savishinsky 2007). Song has been used to educate children about managing their asthma (Capen et al. 1994) and educate populations about contraception (Emah 1993).

It is through the various media of art that people relax, open their minds and become motivated to learn (Gifford and Varatharaj 2010). Art can contribute to and enhance the learning of both doctors and patients in all aspects of medical care. Art is an integral part of medical care (Saunders 2000) supplementing and augmenting the scientific core of medicine in the twenty-first century.

Acknowledgements

Permission was granted by PARS International on behalf of *The Chicago Tribune* for the use in full of Mary Schmich's column; 'Advice, Like Youth, Probably Just Wasted on the Young'. Chicago Tribune, 1997 © 2013 Chicago Tribune. All rights reserved. Used by permission and protected by the Copyright Laws of the United States. The printing, copying, redistribution, or retransmission of this Content without express written permission is prohibited.

References

Briers, S. (2009), *Brilliant Cognitive Behavioural Therapy,* Edinburgh: Pearson Education.

Canby, C. A. and Bush, T. A. (2010), 'Humanities in Gross Anatomy Project: a Novel Humanistic Learning Tool at Des Moines University', *Anatomical Sciences Education*, 3 (2), pp. 94–96.

Capen, C. L., Dedlow, E. R., Robillard, R. H., Fuller, B. M. and Fuller, C. P. (1994), 'The Team Approach to Pediatric Asthma Education', *Pediatric Nursing,* 20: 3, pp. 231–237.

Emah, E. (1993), 'Singing about Family Planning', *Nigeria's Population Health Education Research,* 10: 2, pp. 38.

Gifford, H. and Varatharaj, A. (2010), 'ELEPHANT Criteria in Medical Education: Can Medical Education Be Fun?' *Medical Teacher,* 32: 3, pp. 195–197.

Janowiak, J. J. (1995), 'Drug Education in Tune', *Journal of Drug Education,* 25: 3, pp. 289–296.

Keller, S. (1997), 'Media Can Contribute to Better Health', *Network International Communications in Library Automation,* 17: 3, pp. 29–31.

McManus, I. C. and Richards, P. (1999), 'Intercalated Degrees, Learning Styles and Career Preferences: Prospective Longitudinal Study of UK Medical Students', *British Medical Journal,* 319: 542, pp. 542–546.

McNamara, D. S. (2010), 'Strategies to Read and Learn: Overcoming Learning by Consumption', *Medical Education,* 44: 4, pp. 340–346.

Miller, J., Bligh, J., Stanley, I. and Al Shehri, A. (1998), 'Motivation and Continuation of Professional Development', *British Journal of General Practice,* 48: 432, pp. 1429–1432.

Muszkat, M., Yehuda, A. B., Moses, S. and Naparstek, Y. (2010), 'Teaching Empathy through Poetry: a Clinically Based Model', *Medical Education,* 44: 5, p. 503.

Myss, C. (1996), *Anatomy of the Spirit,* New York: Harmony Books, pp. 1–294,.

Prochaska, J. O. and DiClemente, C. (1986), *Treating Addictive Behaviour: Processes of Change,* New York: Plenum.

Prochaska, J. O., Diclemente, C. G. and Norcross, J. C. (1992), 'In Search of How People Change. Applications to Addictive Behaviours', *American Psychology,* 47: 9, pp. 1102–1114.

Prochaska, J. O., Velicer, W. F., Rossi, J. S., Goldstein, M. G., Marcus, B. H., Rakowski, W., Fiore, C., Harlow, L. L., Redding, C. A., Rosenbloom, D. and Rossi, S. R. (1994), 'Stages of Change and Decisional Balance for 12 Problem Behaviours', *Health Psychology,* 13: 1, pp. 39–46.

Rickenbach, M. A. (2003), 'Medical education, professional learning and action research in the health service: assessment, interventions and future models for general practice vocational training of senior house officers', Bournemouth: Ph.D. thesis, pp. 292–298.

Saunders, J. (2000), 'The Practice of Clinical Medicine as an Art and as a Science', *Med Humanities,* 26: 1, pp. 18–22.

Savishinsky, J. S. (2007), 'Poetry to Express Ideas about Age. Lighting the Match: Using Haiku to Teach about Aging', *Gerontology & Geriatrics Education,* 28: 3, pp. 55–68.

Schmich, M. (1997), 'Advice, Like Youth, Probably Just Wasted on the Young', *Chicago Tribune,* June 1.

Schon, D. A. (1983), *The Reflective Practitioner: How Professionals Think in Action,* New York: Basic Books.

—— (1987), *Educating the Reflective Practitioner: Towards a New Design for Teaching and Learning in the Professions,* San Francisco: Jossey-Bass.

PART IV

Using Imagery

Chapter 9

Beyond Words: Surfacing Self in End-of-life Care Using Image-making

Sue Spencer
(University of Northumbria)

Introduction

Over the last seven years my work as an educator in health care practice has been increasingly influenced by my own personal exposure to the use of poetry and other expressive arts in health and well-being. During this time I have begun to understand how I can reconcile my own development as an artist with my role in education and explore the uses of expressive arts in the education of health care professionals.

As an educator I have always sought to develop reflection and self-knowledge within students. My own experience of education demonstrated how education can be both empowering and also lead to perspective transformation (Mezirow 1981). In the past I have found that students resist high challenge in the classroom and become defensive and do not welcome a critical companion on their professional journey.

As health care delivery becomes increasingly technologically driven there is a danger that the education of health care professionals will be seduced by this same technology. At the same time there are increasing demands being placed on practitioners, and as the scope of practice and the range of therapeutic interventions increase, the human side of caring can be overlooked. I also believe that nursing has defaulted back to an overly task-orientated profession. This stance privileges practical competence over a deeper theoretical understanding of the emotional and psychological impact of nursing interventions and nursing's role. This approach overlooks the emotional impact health care delivery can have, either on the individuals themselves as practitioners or on their patients. This is often reflected in how nurse education content is provided and structured.

Lest we forget, human beings are still the recipients of care delivery and within my educational practice I want to ensure that nurses and other health care professionals are able to communicate effectively with people and recognize that they need a balance of knowledge within their nursing practice.

This chapter explores the complexity of end-of-life care and how a creative arts exercise within a service development enabled practitioners to go beyond simply developing competence in their practice but gave them permission to make room for felt emotions within the delivery of care. End-of-life care inevitably exposes emotional layers, and, if this is not heeded, can inhibit practitioners in their work as they 'block' discussion about death and dying (Lawton & Carroll 2005). From an educational and professional development

point of view, this latter issue necessitates that practitioners recognize and work with their own perspectives and experiences of death and dying. For practitioners to feel confident in their ability to discuss death and loss with patients and families requires them to actively manage their emotions and also have confidence in their own approach (Walshe & Luker 2010; Burt et al. 2008).

There is also a need, in any educational activity – as a moral obligation – to provide practitioners with ways of supporting themselves in their work in the future and sensitizing them to when they may be overburdened and likely to be emotionally challenged in their work. Reflexivity and self-awareness are crucial if practitioners are to continue to work within an increasingly demanding and complicated care environment (McIntosh 2010: 67).

The challenge educationally is in how to engage in such potentially deeply affective work in safe, creative and developmental ways that enables professional development for practitioners working in this field. In order to do this, I would like to share with you my experiences and reflections of implementing an educational strategy that draws on the arts to open up and support learning in areas that have potential for profound change in care provision and professional practice.

Issues in end-of-life care for professionals and services

End-of-life care provides a unique challenge to health care practitioners, as therapeutic interventions extend life expectancy and the choices offered to patients become increasingly bewildering. This array of choice leads to potentially complex and emotionally volatile conversations about what happens when we die, and they become more difficult to tackle (Lawton & Carroll 2005). The UK health service policy over the last ten years has sought to raise the profile of end-of-life care and also increase patient and family involvement in decisions about where, when and how we die (DOH 2008).

Advance care planning has become the key motif in the end-of-life policy (Royal College of Physicians 2009), and although not fully understood, the majority of commentators agree that this is more than planning for the future: it is also about understanding past and present selves. Simplistically, it can be seen as the writing/recording of living wills, conversations about treatment options, treatment withdrawal, funeral arrangements and also about where people would like to die – at home or at a care provider's (hospice or similar). However, the reality of planning in advance is that it exposes layers of uncertainty and anxiety. All of these discussions also need to be considered within the context of the person themselves and the life they have lived. As health care providers seek to enable their practitioners to engage with these conversations, it is an equal pedagogical challenge in relation to a learning strategy that might both challenge and engage practitioners in thinking about how they approach this particular aspect of care delivery.

Creating an approach for learning and reflection

In preparing a course for senior community practitioners it was decided that a mix of learning strategies would be need to be implemented. Role play would be used to explore how practitioners might begin conversations with patients and families. We employed professional actors for this exercise and they were asked to play the role of couples who had been given recent diagnoses and prognoses from health professionals that required a consideration of future planning and understanding. Role play has been extensively used in end-of-life education and has proved to be a very useful starting point to guide practitioners, particularly in relation to identifying areas of high challenge (Jackson & Back 2011). Through supportive and imaginative use of role play, practitioners can receive feedback from the actors and a facilitator that helps address strengths in communication skills as well as areas that might need attention. However, my experience of the use of role play is that is often greeted with high resistance, and participants may just go through the motions to ensure that they get through the session – endure rather than engage. Seasoned professionals know what is expected and can see what performance is needed and not engage at any deeper level.

The greater challenge in delivering this development workshop was engaging practitioners in an activity that would address the issues of self-awareness and reflexivity and, crucially, how this insight might be the key to the practitioners' understanding of where and how they might be approaching these difficult and emotionally charged conversations within their own practice (Skilbeck and Payne 2003).

I felt that the practitioners' understanding of themselves and their attitudes to death and dying were pivotal to how they might approach these issues with their patients. Much of the literature around community nursing suggests that district nurses are the key people to initiate these emotive and difficult conversations. However, my own experience as a district nurse led me to believe that practitioners have a wide repertoire of skills available to them that enabled them to avoid these conversations, often delaying discussions while patients and families were waiting for an opening (Griffiths et al. 2010).

Given this particular challenge, my colleague who had initiated the project with the local trust agreed that this might be an ideal arena 'for some of that creative stuff you do'. Once I had permission to try out some of that 'creative stuff', I explored an approach that might surface feelings and emotions in a safe and supportive way.

Creative and expressive approaches to subjects can often uncover otherwise suppressed or hidden attitudes and beliefs, and it was with this intent that I approached the workshop. The idea was to engage practitioners in some reflection about their own attitudes and beliefs about death and enable them to develop some insight into this and how it might impact on their capacity and willingness to have conversations with patients and families about death and dying.

Arts and palliative care

There is a growing acknowledgement that a range of artistic interventions can have a very positive impact on people's experiences of death and dying (Watts 2009). This positive impact can be in terms of coping mechanisms, planning for the future or expressing emotions. The hospice movement has been at the forefront of integrating a range of artistic endeavours into end-of-life care that both enriches the care people receive and provides support for patients and carers through increasing their resilience and self-efficacy. Artists who have worked in this field are either influenced by their own experiences of health care and/or in their belief in the positive effects of art on well-being. It was with this background that I felt it was appropriate to utilize a creative/expressive arts exercise that drew on imagery as a way of exploring personal issues that might impact on a person's practice.

I also have had experience of engaging community nurses with poetry in the past. I was fairly confident that, although challenging, creative/expressive arts can be very effective in reaching emotional depths, and as it takes a more lateral approach, can often 'trick' participants into not just being creative; but this creative activity also uncovers previously hidden emotional issues that might impact on how they approach emotionally difficult conversations/decisions with patients and families.

The exercise

Before the session began, I explained what I intended to do and the activities I was asking them to engage in. I also warned them that, given the reason we were all there, some of us may have heightened emotional responses to issues and that, if people felt too vulnerable, they should say so, and I would make sure they felt safe and supported. Without any further preamble or too much explanation or justification I invited participants to draw a picture that meant something to them emotionally, related to their thoughts, feelings or beliefs about the end of life. I stressed that it was important that is was not within their professional life but within their personal sphere. Participants were offered oil pastels, crayons, felt-tip pens, tissue paper, embellishments from card making, glue, etc. Participants were advised that they should not think too much about what they were doing and that artistic merit was not an important criterion – more importantly, the image they created should be personal and meaningful to them. Much protracted discussion then ensued about artistic ability and most participants declared that I was asking them to do the impossible and none of them believed they were capable of generating any meaningful images. This delaying tactic was common at the start of this exercise in the workshops, but after about ten minutes, most of the participants in the five workshops engaged with the exercise. I gave participants 30 to 40 minutes and nearly all the sessions became silent and intense after the first foray of anxiety.

All participants, who took part, created a very clear image that was recognizable to others and required little explanation. These images ranged from intimate interior scenes from

childhood homes to expansive landscapes of windswept coastlines, to more abstract mark-making images. All contributing participants found value in the activity, and a number found that they became emotional during the session and tears were commonplace. This response was welcomed, and I allowed discussion to develop about how inevitably we are sad and cry at this time but that there is nothing wrong with that and that one of the outcomes of creative exercises is often an emotional one. After the visual images were shared with each other, we then explored some of the language we might ascribe both to the images and to their role in end-of-life care and how that might relate to their own life experiences. A summary of this discussion and subsequent reflection is in the table below (Table 1).

Undertaking this exercise was challenging and developmental in many ways. Emotions ran high during the session, and in a follow up session four weeks later, some of the participants were very angry with me; one participant suggested that I was irresponsible and unsafe in

Table 1: Reflections on visual images created by health care practitioners

Example of Images drawn	Issues raised	Reflection
Front room of family home	Childhood	How place evokes memory
	Age	What age is it OK to die? Places jog memory
	Memories	Role of reminiscence in sense making at end of life
	Family and relatives	Competing needs in end of life care
Beach	Place	How discussions about important places might lead to permission to talk about choices about funerals etc
	Holidays	Times in life when really happy and relaxed might help symptom control and reduce anxiety – role of psychosocial support
	Memories	How important it is to pay attention to people's life story
Church	Religious faith	Spirituality and how important paying attention to identity
	What if not religious	Are there alternatives to religious ceremonies
Abstract images	using colour to communicate feelings	Often words are not enough role of music
	Mark making	We can all make images – that they mean something to the individual is as important as them conveying meaning to anyone else

asking them to undertake the exercise as it made her feel very vulnerable. I did point out that as registered nurses we all had a responsibility to understand our own emotional responses to issues. I also suggested that protecting our emotional selves was commonplace and that surfacing these issues raised questions about the availability of clinical supervision. It also raised questions about reflective practice and how clinical supervision ought to be about supporting and encouraging engagement with reflective practice, increased self-awareness and development within their practice. Some participants felt that the creative exercise ought to be used in clinical supervision.

Other participants have felt so positive about the exercise that they have invited their patients and families to engage with a similar exercise – words are often difficult to find at this time, and they have found that images can stimulate insight and understanding.

Personal reflection

My previous experience of working with experienced community nurses in relation to reflective practice suggested I needed to take a different and more lateral approach to engaging these practitioners in reflecting on their own practice. In previous sessions I have been met with resistance and resentment. Resistance occurred at the beginning of discussions, particularly in that those about examination of practice issues tended to be superficial and clichéd. Discussion always veered away from any meaningful input from the practitioners about attitudes and beliefs related to emotional aspects of practice. Anger and frustrations are glossed over and the 'there is nothing we can do about it' response was commonplace, and these loud and protracted discussions blocked problem-solving and insight. Issues that became topics for discussion were aimed at the organization or the management and included time, lack of resources and the conspiracy of the system to derail their best intentions. Further examination of these issues in relation to what ideal practice might look like often resorted to phrases like 'patient centeredness' but without any tangible ways of making that become a reality or any emotional link to that reality.

Not everyone offered the opportunity to rediscover their creative self or their inner-most soul will embrace it positively and gratefully. During these workshops I have met resistance and anger. Experienced practitioners guard themselves within their 'emotion work' and present to the world a particular way of undertaking their practice, and they wish to preserve this and for their own safety do not wish to delve into its meaning or significance (Frank 2009). Appreciating this response made a significant difference to the way the workshops were undertaken. After the first workshop, the order of activities were changed so that the policy context of the workshops was delivered first in order for the active learning sessions to be delivered next to each other, and in that way the visual arts session could then inform the role play. I also discovered that as a facilitator I needed to disclose much more about my own personal experiences of death and dying to underpin the issues we were trying to communicate. This was particularly important in

relation to enabling the participants to recognize the link between personal experience and professional expectation. If demands in professional practice remind us of personal loss and grief, then we are at our most vulnerable and our responses to the needs of the patient and their family might be a result of transference and projection rather than the true needs of the individual and their family (Woo et al. 2006). Our needs or previously unmet needs, both emotionally and psychologically, impact on how we 'make up and mend' in practice (Tester 2008).

I also found that sharing my own reflective journey of discovering creative arts in my practice enabled participants to look beyond my educational role and also see how important I felt it was for them to view their practice differently. This led to disclosures of artistic practice and artistic endeavours that included creative problem-solving and relationship building in practice (Fish 1998). Sharing anxieties and insecurities about what constitutes legitimate artistic work also developed during image-making, giving permission to then discuss preferences and attitudes about art in general as well as sharing experiences of art teachers who successfully suppressed creative endeavours as they were 'not good enough'.

These discussions provided a safe and supportive space that enabled participants to be less protective about their fears and hopes about end-of-life care. Most participants were also really surprised at their own ability to communicate visually and were very proud of their art making and their artistic ability.

My experience during these workshops has stayed with me over the years since I delivered it, and subsequently, I have used similar exercises with postgraduate pre-registration students when exploring values and beliefs in their beginning practice. Permission to go beyond words and the rational self has enabled students to access clear and articulate ways of expressing themselves that have welcomed and surprised them. I believe that going beyond words and embracing image-making can yield significant insight into professional practice within the classroom, and it is one I intend to further develop in the future.

References

Burt, J., Shipman, C., Addington-Hall, J. and White, P. (2008), 'Nursing the Dying within a Generalist Caseload: a Focus Group Study of District Nurses', *International Journal of Nursing Studies*, 45, pp. 1470–1478.

Department of Health (2008), *End of Life Care Strategy: Promoting High Quality Care for All Adults at the End of Life*, available from www.dh.gov.uk/publicationsandstatistics. Accessed 20 July 2011.

Fish, D. (1998), *Appreciating Practice in the Caring Professions*, Oxford: Blackwell Publishing.

Frank, A. (2009), 'The Necessity and Changes of Illness Narratives, Especially at the End of Life', in Y. Gunaratnam and D. Oliviere (eds), *Narrative and Stories in Health Care Illness, Dying and Bereavement*, Oxford: Oxford University Press.

Griffiths. J., Ewing, G. and Rogers, M. (2010), 'Moving Swiftly on: Psychological Support Provided by District Nurses to Patients with Palliative Care Needs', *Cancer Nursing*, 33: 5, pp. 390–397.

Jackson, V. A. and Back, A. L. (2011), 'Teaching Communication Skills Using Role-Play: An Experience-Based Guide for Educators', *Journal of Palliative Medicine*, 14: 6, pp. 775–780.

Lawton, S. and Carroll, D. (2005), 'Communication Skills and District Nurses: Examples in Palliative Care', *British Journal of Community Nursing*, 10: 3, pp. 134–136.

McIntosh, P. (2010), *Action Research and Reflective Practice*, Abingdon: Routledge

Mezirow, J. (1981), 'A Critical Theory of Adult Learning and Education', *Adult Education*, 32: 3–23.

Royal College of Physicians (2009), *Advance Care Planning National Guidelines*, available from http://bookshop.rcplondon.ac.uk/details.aspx?e=267. Accessed 21 July 2011.

Skilbeck, J. and Payne. S. (2003), 'Emotional Support and the Role of Clinical Nurse Specialists in Palliative Care', *Journal of Advanced Nursing*, 43: 5, pp. 521–530.

Tester, C. (2008), 'Keeping going – as staff', in K. M. Boog and C. Y. Tester (eds), *Palliative Care: A Practical Guide for the Health Professional*, Edinburgh: Churchill Livingstone.

Walshe, C. and Luker, K. (2010), 'District Nurses' Role in Palliative Care Provision: a Realist Review', *International Journal of Nursing Studies*, 47: 9, pp. 1167–1183.

Watts, J. H. (2009), 'Illness and the Creative Arts: a Critical Exploration' in S. Earle, C. M. Bartholomew and C. Komaromy (eds), *Death and Dying: A Reader*, London: Sage Publications., pp. 102–108.

Woo, J. A., Maytal, G. and Stern, T. A. (2006), 'Clinical Challenges to the Delivery of End-of-Life Care Primary Care Companion', *Journal of Clinical Psychiatry*, 8: 6, pp. 367–372.

Chapter 10

Fashion Students Engaging in Iconic Designs in a Business World

Ruth Marciniak
(London Metropolitan University)

Debbie Holley
(Anglia Ruskin University)

Caroline Dobson-Davies
(Hull York Medical School)

Introduction

The significance of fashion as part of modern popular culture is well acknowledged through the media. In turn, its growing sense of respectability has been taken up by academia through studies that have examined fashion in terms of its social, cultural, political and economic history. In addition, universities have acknowledged its importance in the global economy and as a consequence the number of fashion business courses has increased over the past decade in order to meet both the demands of industry and also students looking to study this subject in Higher Education. The challenge for those delivering such courses is to ensure that the needs of industry are met and, in doing so, ensure that students understand that the subject, which is informed by aesthetics, anthropology, psychology, linguistics, sociology, and cultural as well as business studies, is given the gravitas that it deserves as opposed to something that is merely frivolous and fun wherein enthusiasts are only informed about fashion through the pages of *Vogue, Elle* and other glossies. In short, the subject is understood to be academic and one that draws upon multiple disciplines.

The purpose of this chapter is to describe and evaluate a study that employed web-based technologies blended with both classroom activities and a field visit to the Victoria and Albert (V&A) Museum as part of teaching and learning the subject of fashion. The particular focus of the study was on the field visit. More specifically, the study drew upon first-year undergraduate students, who typically, as they make the transition from school or college to university, are faced with problems including the move from small class sizes in school to very large class sizes in university, from structured study plans to independent learning. Such problems can be compounded by a potential misinterpretation of the subject area, which in the case of fashion can easily arise in that, for the reasons outlined above, students may perceive the subject to be something quite different to what both academia and industry understand it to be. In all, the purpose of the study was to encourage students to engage with the subject matter in a scholarly manner, using the stimulus of a coursework assessment, which revolved around the field visit to the V&A. Together with increasing the students' understanding of the concept of fashion, the educational visit also aimed to encourage students to work together in small teams, and thus 'make friends' to develop a sense of belonging; provide a forum for students to engage with their subject matter more and to develop their academic skills through writing a carefully scaffolded set of 'patchwork texts "stitched"' together by a reflective commentary of their learning during the module.

In all, the chapter reports findings arising from an evaluation of teaching and learning implemented during this study. In doing so, this chapter draws upon field notes made by the lecturing staff accompanying students on their visit, and of the assessment (a presentation) where students presented their 'product' in small groups. Issues raised by the literature review, as well as the site visit, were incorporated into a pilot questionnaire, which was completed by approximately two-thirds of the students. This pilot study was followed up by two subsequent data collections, one prior to the visit to the V&A and one post-visit. Selected extracts from this data, consisting of students' reflective commentaries, are included in the chapter to illustrate perceptions on their learning experiences.

Encouraging engagement with the subject

The purpose of museums is to facilitate access to knowledge that the museums themselves hold (Mencarelli et al. 2010). In recent years, it has become the norm that museums accept the constructivist view of learning, that is, the focus is on what the museum contributes to the visitor's existing knowledge. Taken to the extreme, Fritsch (2007) identifies that there is 'no museum knowledge except for that which the visitor constructs in his or her head' (2). Hence, the role of the curator is not about producing instructional materials about an object, but rather to facilitate the learner in exploring and discovering. Generally, museums are acknowledged as places for learning, however, it is the learner who constructs their own learning. This view is summed up by Bayne et al. (2009) who state:

> the phenomenal presence and status of the collected artefact remains important, but less so than the ability of the individual museum user-learner to access and make meaning from it.
>
> (112)

It can be determined therefore that museums encourage visitors to engage with the artefacts through inspiring the visitor to explore them within the context of their own personal histories, that is, their experiences and previous knowledge.

Encouraging engagement with peers

Traditional education understands learning to be a largely secluded relationship between the learner and the material to be learnt. The only other being in this relationship is the teacher who is in control, whilst the learner is both compliant and passive. Constructivism rejects this view and holds that learning is a social activity. Hein (1991), writing on museums, supports this notion. Indeed, in acknowledging this, museums strive hard in being identified as social environments wherein experiences may be shared, for example, through the

provision of restaurants, shops and cafes. Albeit, these facilities contribute to the overall profits of the organization, nevertheless they are designed to extend the experience of the museum visit and facilitate social interaction and are now commonplace in both small and large museums alike (Mencarelli et al. 2010).

Closely linked to social activity is the concept of entertainment in museums that further extends the opportunity for engagement and that Stephen (2001) identifies, along with education, is also an objective of museums. Evidence of such educational objectives is presented in V&A museum's 'Ten Commandments for Learning at the V&A', for example:

Our belief is that learning at the V&A can develop talent and creativity in our visitors, through looking, thinking and making.

(V&A 2009: 1)

Whereas, in addition, the V&A's mission states that it aims:

To be the world's leading museum of art and design; enriching people's lives by promoting knowledge, understanding and enjoyment of the designed world.

(Frampton & Davies 2011: 1)

Museums give rise to the notion of 'edutainment', wherein initiatives have been undertaken in order to blur educational and enjoyment and social interaction functions. Examples of such initiatives include, firstly, V&A's Summer Camp in 2010, which was a two-day celebration of design with the purpose of sharing design and knowledge skills. It combined live entertainment, creative workshops and a communal campfire tent. Secondly, in 2006 Tate Modern erected 'Test Site' by the artist Carsten Holler, which was composed of five giant slides, the object of the art being a 'playground for the body and the brain'. Whilst such initiatives have met with criticism, for example, accusations of the 'spectacularisation' of art (Barnes 2011), nevertheless such creative and inventive events provide productive environments for sharing ideas, discussion, learning and reflection.

The study

The module through which this assessment was delivered – titled 'Studying Marketing and Operations' – is a 'higher education orientation' module in that it provides an introduction to the learning strategies that students need to successfully study in Higher Education. Further, it introduces students to researching subject material from a wide variety of sources and provides them with a framework for the development of a range of skills, contributing to a reflective portfolio of personal development. The objectives of the module are identified in the learning outcomes listed below.

On successful completion of this module students will be able to:

1. Understand how to build upon their previous learning and develop strategies for individual success at Certificate, Intermediate and Honours level study;
2. Demonstrate their ability to work in a group with other students, using written, oral and interpersonal skills;
3. Use evidence from a range of sources and critically use information gathered to reflect and solve problems creatively within an appropriate ethical framework.

Assessment

Fashion students need to be equipped with knowledge of key people in the profession, together with these key peoples' values and judgements, in order to understand how these particular individuals' work has been promoted over that of others. In order to facilitate this understanding, the students were set a project focused on a field visit to V&A Museum. The V&A has an international reputation as a museum showcasing art and design. Students were tasked to devise a new product inspired by the V&A collection and present ideas for merchandising it. To scaffold student learning, the students had access to a bespoke interactive website (Figure 1) that introduced the task, and guided the students through a set of practical and reflective exercises designed to support their final portfolio. Through its collection of fashion and accessories from the seventeen century to the present day, the V&A museum furnished students, via a choice of artefacts, with the opportunity to demonstrate innovation and business flair by devising a new product that would be appropriate to sell in the museum shop. An example of this is the design of earrings and other accessories such as handbags that would complement the concept of the original Katherine Hammett 1980s slogan T-shirt. In this way, the curriculum design is matching up students' creativity with the sharp business acumen demanded by employers in the competitive fashion industry. Specific areas covered through the website resource were the theory behind teamwork, with a self-test task to profile the students' preferred role in a team setting; sections providing guidance on research and presentation skills; and a final gallery where their final products could be showcased, that is, the 'style gallery'.

In addition, the free wetpaint wiki (www.wetpaint.com) was used to encourage students to develop their thoughts and written progress through their first semester at university. The commercial aspect of this website (wetpaint is free to use but is funded by commercial advertising) was seen as a beneficial aspect, relevant to students studying fashion marketing in that the wetpaint wiki provides a learning opportunity with regards to public relations, advertising and communications. Using this website exposed students to targeted media and, indeed, this was part of the in-class discussions too. In the subject specific module, also studied by this student cohort, 196 of 198 students opted to join the Fashion Marketing

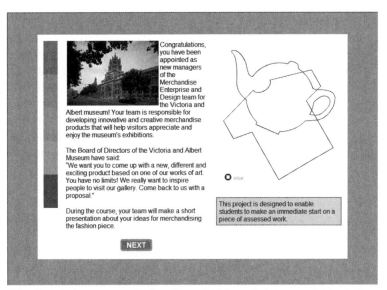

Figure 1: Introductory image for the website, which hosts the learning activities. Source: website: http://learning.londonmet.ac.uk/LMBS/fashion.

lecturers' Facebook group, where he posted regular blog links and information about contemporary fashion and design. Thus the students were introduced to the different business models offered by the advances in the Web 2.0 world.

Iconic design

The students needed to incorporate both business acumen and design skill to successfully market their product during the assessed team presentations. To familiarize the students with iconic design, a set of activities were scheduled the week prior to the visit to the museum, whereby students were shown an image of *Marilyn,* by Andy Warhol, and asked to work in pairs to define exactly why *Marilyn* has iconic status. This original Warhol is a silk screen on canvas piece that originates from a multi-image diptych (pair) format produced in 1962. The painting is based on a photograph of the actress Marilyn Monroe taken by Gene Korman in 1953 for *Niagara* (1953), the film that propelled Monroe to star status (www.webexhibits.org 2010). This particular double artefact, *Marilyn Diptych,* is housed at Tate Modern, London.

After the discussion, students were able to access a two-page document from the Virtual Learning Environment, prepared by an expert tutor, which set out to deconstruct the types of writing about art and design that students, many from a widening participation background, had not previously accessed. Its purpose was to provide a model for academic writing.

Process of the data collection

Data were collected, in the first instance (December 2009), in the form of a pilot questionnaire, which was distributed to all first-year Fashion Marketing students who took the 'Studying Marketing and Operations' module. The timing of this data collection occurred after the V&A visit and after students had completed their presentation. The purpose of the pilot study was to elicit initial impressions of the learning experience and the assessment students were asked to undertake. The design of the questionnaire consisted of predominantly closed questions, with three opportunities to add free text. A total of 47 responses were elicited, approximately two-thirds of the module cohort.

Subsequent data collections took place, both with the aim of collecting open and reflective statements from students. The first data collection took place in September 2010 at course induction, that is, at the very start of students embarking upon a university education. Students were asked to identify whether they visited museums and what was 'good' and what was 'bad' about them. All Fashion Marketing students who attended the induction produced reflective statements. This totalled 56 students; these students were a different cohort than those who completed the pilot questionnaire. The final data collection took place (March 2011) using the same students who had attended induction. This totalled 21 students. All reflective statements were anonymous.

Student reflections

Engagement with museums

The students surveyed were all Fashion Marketing students – the subject they had chosen to take at university. Given the creative nature of the course, as might be expected, many of the students, at induction, stated in their reflections that they visited art galleries and museums. For example, many mentioned that they had visited the V&A. However their interests were broad, that is, beyond matters of art. This is evident in the reflections presented below, which are representative of the numerous comments made by individual students. It is clear there is an engagement and interest in museums.

> My favourite museum to visit in London is the Science Museum as I find it the easiest to interact with and the most interesting'. ... 'Favourite museums – Science Museum, Moma (Museum of modern art), Tate Modern and V&A' ... 'The best thing about museums are that you can concentrate on anything you like.

Whilst a number of students stated that they had visited museums as part of school trips, that is, not on their own initiative, others made reference to museums they had visited independently whilst travelling to countries such as Singapore and India. In addition, some

mentioned specific museums, for example, 'FOAM' photography museum in Amsterdam; the Shoe Collection in Northampton; Leopold museum in Austria. In addition to this, some students reflected on specific exhibitions, for example, 'Grace Kelly' and also the 'Golden Age of Couture', both of which were at V&A. Those students had visited these exhibitions prior to coming to university.

Purpose of a museum

Students comments reflect the museum literature, discussed above, that is, the purpose of a museum is about both education and enjoyment (Stephen 2001). Illustrative comments included the following:

> If people want to learn new things, for most, it is easier when looking at paintings or 3D objects rather than reading books, so it is a practical way of learning.… Museums show you past and present pieces of art, help you gain inspiration or are just a fun day out.… first hand experience of learning something.… learning and understanding other cultures.… makes you think imaginatively.… Benefits of museums [are] that they educate, inspire and fascinate me.

A minority of students had never visited a museum and some had only visited whilst on school trips. Nevertheless, for a number of these students reflections expressed positive anticipation to museum visits – as one stated:

> I would like to visit the V&A now that I live in London.

Overall, the majority of students were fully engaged with museums as places of education and enjoyment. It was only the very minority who had no interest.

Engagement with the subject

Limited reflections focussed on how or to what extent the assessment helped the students to better engage with their subject. However, what limited offerings there were, were positive. The reflections below are representations of statements made:

> [F]un to come up with product ideas and pitch it … broaden my knowledge … interesting way of learning.… fun way of learning.… it was extremely inspiring and evoked excitement.

There was a hint, too, that students were starting to develop a sense of the substantive, scholarly nature of the subject area. As one student observed: 'I have learned numerous things … firstly, fashion marketing isn't about drawing pictures and designing.'

Engagement with peers

It is evident from the large number of reflections made on working in groups that this aspect of the assessment was of much interest to many students. The comments indicate that there is some anxiety associated with working in this way. A number of negative comments were evident. However, despite negativity, some also offered reflections relating to learning that had taken place despite an adverse experience, such as poor communications within a group. In all, some students were able to rise from the experience. Common amongst the reflections on group work was the acknowledgement that attaining a successful working group is very important. A number of students reflected that the interpersonal skills required to do this is important in terms of employability.

> My previous groupwork experiences have not been very satisfactory as I had uncommitted members in the group before and was very anxious as to whether it would occur again. However I had formed a group with two very trustworthy and hard-working people. We were determined to be successful in our presentation and get excellent grades.
>
> I think groupwork is a very important skill to be able to perform … it is needed throughout the whole of life, whether in work or social activities.
>
> I learned that working within a team is not a simple task as it requires a balanced input from each member of the team in order to succeed. For the next time, I will try to engage and motivate the people in my group to achieve our common goal.
>
> I unfortunately had to perform the group presentation on my own due to lack of communication within other group members.
>
> … good to do in a group as we all have different opinions and ideas.
>
> I gained knowledge about forming relationships and choosing groups effectively.
>
> I gained a strong sense of comaraderie [*sic*].

Whilst the idea of students sharing their learning and working together in groups is often understood to be something of value, it is evident from the above reflections that a number of issues can arise thereby making the student experience, both positive and negative. Gunn (2007) identifies some negative issues, for example, one being freeloading whereby students may interpret other students who seemingly are not contributing being rewarded marks whilst their hard-working peers do all the work. Other identified issues include vocal dominance by a minority or just one person. Dealing with these kinds of issues demand well-developed interpersonal skills. Exposing students to group work from the start of their university life helps to better equip them in these skills.

Interestingly, the results of pilot questionnaire indicated that none of the students visiting V&A used the café or other social areas such as the shop. The prohibitive prices for food and drink in the café could be a probable reason.

Skills development

Initially, most students found the idea of having to create a product from an existing fashion artefact very daunting. Overall skills called upon to undertake the assessment were varied, many of which were commented upon in the reflections, including

Communication and presentation skills:

The presentation was extremely beneficial in improving my presentation skills. ... It helped me with my timing.
 improving oral communication skills through group working and the presentation. ... built more on my communication skills.
 In general, this module has helped me by giving me the opportunity to develop my writing, observational skills as well as working in a group, presenting in a group and working with new people.

Teamwork and employability skills:

I knew this [team work] was a must and I wouldn't get far in my career without this skill.
 Negotiating, dealing with conflict, motivation strategies are all very important and I had opportunities to apply them.

Discussion and conclusion

In this chapter we have sought to capture student reflections on their learning experiences of a first-year assessment, which specifically aimed at orientating students into Higher Education. The assessment, which required students to work as a group, put students at the centre of their learning. In essence students took on the role of ethnographers through developing products that were of interest to them as a group. It was not the artefact per se that was at the centre of the learning, for example, acquiring an understanding of the relationship between politics and fashion in the 1980s. Rather, it was the student and their learning and development, putting them in the position of acquiring and developing skills through undertaking the project.

Skills gained, as identified by the students included working in groups, undertaking oral presentations and time management. In particular, it was working in groups that students chose to focus their reflection upon. Group work provided the opportunity for the lecturer to increase the complexity of the assessment. In turn, whilst there were some negative experiences evident in their statements, overall students reflected that they understood the benefits of group work for future employability.

Reflecting on the learning process, Falk and Dierking (2011) point out that learning is 'transformative' in nature, in the sense that it involves learning to reflect on the past and occurs over the long term. Therefore, in order for deep learning to occur, visitors of museums need reinforcing experiences long after the museum visit has taken place. Discussions taking place in the classroom, post the museum visit, allow for the opportunity for this to occur. In addition, student presentations further allowed deep learning to occur. The museum's website can also promote on-going ('transformative') learning. However none of the students referred to the V&A website as a place that they went to in order to learn further about the artefact that they had chosen. Indeed, one student identified that visiting the museum itself was an attractive alternative to learning in the library or learning online.

A number of previous studies (e.g., Tyler 2010) have explored museum pedagogy, but have predominantly focused on school children. Our study shows that museums can also encompass university-level learners to productive effect, stimulating inspiration and imagination through direct encounter with artefacts.

Our findings indicate that adopting an innovative and creative approach to learning, using museums as educational spaces to support project-based, small-group learning, can encourage students to engage with both business acumen and broader skills development and develop a sense of belonging.

References

Bayne S., Ross J. and Williamson Z. (2009), 'Objects, Subjects, Bits and Bytes: Learning from the Digital Collections of National Museums', *Museum and Society*, 7: 2, pp. 110–124.

Barnes, D. (2011), 'Radical Aesthetics: The Art of Spectacle', *Ceasefire*, available from http://ceasefiremagazine.co.uk/arts-culture/radical-aesthetics-2/. Accessed 4 April 2011.

Hein, G. E. (1991), 'The Museum and the Needs of People', *International Committee of Museum Educators Conference*, Jerusalem, Israel, available from http://www.exploratorium.edu/IFI/resources/constructivistlearning.html. Accessed 1 April 2011.

Falk, J. H. and Dierking, L. D. (2011), *The Museum Experience*, Walnut Creek, CA: Left Coast Press.

Frampton, L. and Davies, J. (2011), *V&A UK Strategy April 2011–March 2015*, London: The V&A UK Group.

Fritsch, J. (2007), 'The Museum as Social Laboratory: Enhancing the Object to Facilitate Social Engagement and Inclusion in Museums and Galleries', available from www.kcl.ac.uk/content/1/c6/02/37/02/Fritsch.doc.pdf. Accessed 1 April 2011.

Gunn, V. (2007), 'Approaches to Small Group Learning and Teaching', University of Glasgow, available from www.gla.ac.uk/media/media_12157_en.pdf. Accessed 5 April 2011.

Mencarelli, R., Marteaux, S. and Pulh, M. (2010), 'Museums, Consumers and On-site Experiences', *Market Intelligence and Planning*, 28: 3, pp. 330–348.

Stephen, A. (2001), 'The Contemporary Museum and Leisure: Recreation as a Museum Function', *Museum Management and Curatorship*, 19: 3, pp. 297–308.

Tyler, W. (2010), *Schooling the Museum: Pedagogy and Display in the Information Age*, The Sixth Basil Bernstein Symposium, Griffith University, Brisbane, available from http://www.griffith.edu.au/__data/assets/pdf_file/0005/226544/Schooling-the-Museum-2-Tyler.pdf. Accessed 4 April 2011.

V&A (2009), 'Ten Commandments for Learning at the V&A', V&A, available from media.vam.ac.uk/media/documents/legacy_documents/.../66899_file.doc. Accessed 4 April 2011.

www.webexhibits.org (2010). Accessed 18 October 2011.

Chapter 11

Storytelling and Cycles of Development

Karen Stuart
(University of Cumbria)

If you want to know me, then you must know my story, for my story defines who I am.

<div align="right">(McAdams 1997: 11)</div>

Introduction

This chapter describes an inter-professional learning workshop that I used when teaching a Masters programme in Leading Integrated Children's Services. The workshop is creative in its use of storytelling and the cycle of development. When used together, and structured around the experiential-learning cycle, the stories promoted reflection and metaphors for change, and the cycle of development offered self-awareness and clear developmental tasks to complete. This chapter will explain some of the context and theoretical choices for each tool before going on to describe the pedagogical approach.

My story – part 1

There was once a girl who loved exploring the woodlands around her home. She would stray further and further away seeking some treasure, wonderment or love. Each weekly foray took her further and further away, deeper and deeper into the woodland. One day she came across a huge stone house. Its walls were roughly hewn and the garden thick with brier. On entering the house she found cool and damp air and a number of doors. Pushing each heavy door open in turn revealed lush rooms draped with thick brocade, carpeted with plush rugs and adorned with gilt ornament. Kitchen, drawing room, bathroom, bedrooms, dining room - all fantastic, all empty, all pristine. One door, however, was locked. The girl was perplexed and returned for another wander around the rooms. She entertained herself with a return visit to all the other rooms, but she kept finding herself outside that door again. Curiosity finally overcame her – if that room was that nice, then what would be behind this door? She searched the house for the key to the door and finally found it in an inlay box on the hearth. She stood in front of the locked oak door with a cool heavy key in her hand. The lock turned heavily and gave onto a flight of stairs leading down into a dark cellar. With trepidation she stepped down onto the first stair. Each step was colder than the last, the walls increasingly damp and wet – yet at the bottom she could see a dim glow of some kind. It pulled her on. At the bottom there was

almost complete gloom, the doorway above a small slot of light. The glow came from a golden ball that reflected the light coming from the doorway. It was perfectly formed, smooth and shiny, she could not resist picking it up. As soon as she touched the ball it darkened, her fingers leaving brown tarnished fingerprints. The ball was exquisite, dense, cool, perfect metal … until she had picked it up. Now it was dull and tarnished, finger marks dulling it as she turned it in her hands. She tried to clean the ball with her skirt, but the marks would not come off …

This is my story – a metaphorical story that I have constructed as it reflects aspects of how I experience myself in the world – it speaks to me about my professional identity. I have used a three-part developmental story process in my work as a leadership consultant in the children's workforce and as an MA tutor.

The context

From 2007 to 2010 I validated and taught a Masters pathway called Leading Integrated Children's Services at the University of Cumbria in the United Kingdom. The MA was designed in direct response to the new requirements in the UK Children Act 2004 for professionals who work with children (the children's workforce) to work together across professional boundaries. One of the main obligations laid down in the Children Act (DCSF 2004) in England, was a clear requirement for all services to work together. I also worked for the University of Cumbria as a leadership consultant, going into newly integrated teams in the children's workforce and facilitating their collaborative practice. The reconfigurations of inter-professional agencies and multi-agency teams meant they had to simultaneously learn how to work together while continuing to deliver services for children and young people. This was problematic for some, as backgrounds, assumptions, working practices and terms and conditions varied. McKimm and Phillips's (2009) model of professional identity was a useful framework for conceptualizing what was happening. This showed that professional identities sometimes clashed due to the 'enculturation' that they had experienced in joining their profession. Teaching people to lead in this context in a multi-agency MA required a pedagogical approach that would allow them to understand and work with these difficulties.

The approach needed to value individuals and their professions, and that would help create a new enhanced 'multi-professional' identity, transcending professional boundaries. Wenger (2006) described the value of single-profession communities of practice but in this circumstance the need was for the creation of a new 'multi-professional' community of practice, where they could navigate new forms of practice themselves through action research in situated contexts. Winter et al. (1999) had demonstrated the use of reflective writing to promote professional development, and this inspired me to use narratives or stories.

The developmental storytelling process

There were four parts to the storytelling process that I developed. The first was to elicit stories about an individual's experience (for instance, of being in the new team, of experiencing change, of working collaboratively, of a changing professional identity – whatever was appropriate). The personal example that I used above has lots of description and detail in it – this could be because I moulded it into a workable example that appeared to flow spontaneously in a session with other participants. Some people had equally embellished and descriptive stories, while others used a simple storyline – this would depend, I would suggest, on the familiarity and comfort that the individual had for figurative speech. When I first used the process I thought that professionals would baulk at creating 'stories' and that they would prefer to recount the narrative of what really happened, but in three years of using the technique, I have only had two people who did not want to use metaphor. The technique does require trust, however, and as a tutor or facilitator I would need to build a rapport and establish a safe working environment before introducing the exercise.

How? Part 1

I create a magical scene for people to walk into – story books, props, mystical music, soft seating, powerpoint flicking slides of book covers.

When people enter I tell them that we are going to work with stories and metaphors in a purposeful and developmental way.

I tell the first part of my story (as above) and invite them to decode it, giving their own interpretations of it. This shows that there are multiple interpretations depending on the perceptual filters of the individual and that no-one can know the meaning that I intended when I encoded it.

I remind the participants of the issue that we are working on together.

I ask them to quietly think of a story (any story happy, sad, drama, tragedy) that they can recall on the issue that we are working on.

I give them five or ten minutes to quietly think.

Next I ask them to turn it into a metaphorical story – they can invent it, base it on a known story, or use a real story, tale, fable.

(Continued)

(Continued)

I give them another five – ten minutes to complete this.

I ask them to then find a partner that they would be happy to tell their metaphorical tale, and partners exchange tales.

I do not ask them to share the stories in the whole group setting.

So why use story and metaphor? The theory of narratives (spoken accounts of a personal experience) and stories (experiences encoded in symbolism, myth, metaphor and magic) shows them to have three benefits for this context. They are identity-forming, socially constructed and situated learning tools and forms of experiential learning.

Throughout the chapter I will refer interchangeably to narratives and stories but I recognize that there is less fictional intentionality in a narrative and ask the reader to be aware of this. I have adopted Gabriel's (2000) description of a story as having the following features:

> [they have] plots and characters, generating emotions in narrator and audience through a poetic elaboration of symbolic material. This material may be a product of fantasy or experience, including an experience of earlier narratives. Story plots entail conflicts, predicaments, trials, coincidences and crisis that call for choices, decisions, actions and interactions and purposes.
>
> (Gabriel 2000: 239)

Stories for identity formation

Humans have told stories for centuries, using them to pass on and reinforce aspects of culture. As individuals we experience stories from childhood. Most of us are told stories; as children at home and school, and as adults among peers and colleagues and by popular culture (i.e., TV and radio). We use stories as 'sense-making' tools. Boje (in Simpson 2008: 106) describes storytelling as 'the preferred sense making currency of human relationships'. I attribute this to our cultural experiences of stories, as they are 'intrinsic parts of being human' (Macguire 1998: xiv). Individuals use stories to represent and to make sense of who they are. As we read stories we relate to different characters and situations, exploring how they represent who we were, who we are and who we might be. The stories that we choose to read tell us something about who we are.

Gabriel (2000: 120) highlighted that cultural stories can be purposive: 'Individual stories may be attempts to proselytise, neutralise and bolster organisational control'.

This conception of stories as political tools is supported by the early work of Vladimir Propp (1968: 14) who thought folklore was the genre of the oppressed classes and could be a tool to understand oppression and suffering. This highlights the use of stories to describe organizational cultures and norms and to expose tacit rules. As such, narratives are growing in credence in leadership literature, as Denning (2005: xv) writes, 'storytelling already plays a huge role in the world of organisations and business and politics today', and there are a growing number of workshops, tools and books on the use of narratives, stories and metaphors available today.

The stories we listen to, create and tell can generate change. 'People live stories, and in their telling of them, reaffirm them, modify them, and create new ones. Constructions of experience are always on the move. Stories, when well crafted, are spurs to the imagination, and through our imaginative participation in the created worlds, empathetic forms of understanding are advanced' (Koch 1998: 1183). Stories are not fixed; they are developmental, so changing the events or ending in a story can metaphorically open new ways of thinking and new possibilities to individuals and groups, helping to create personal and professional development by further understanding of self and circumstances. Stories can, however, oppress as they perpetuate grand narratives of, for example, 'heroic deeds'. These need to be countered with non-dominant narratives or at the very least critical commentary.

Bettelheim (1976) first wrote of the developmental scope of enchanted stories for children: '[T]he fairy tale speaks softly and subtly to the child, promoting psychological growth and adaptation, the fairy tale encourages the child to face the world with confidence and hope.' Stories thus legitimize early childhood emotions and experiences (understanding feelings of hatred towards our own mother as hatred and fear of the evil stepmother, for example). This links to early work by Freud on the metaphors that the unconscious mind uses to represent unresolved issues – a starting point for psychoanalysis. Transactional analysis (TA) holds that at an early age we develop a life story or 'script' (Steiner 1974) that we then endeavour to live out – this may explain some of our repetitive life patterns. Narrative authors have had a similar perspective. Denning (2005), for example, states that:

Just as the tiniest sample from your living body can reveal the DNA of your whole biological person, so a brief, well chosen story can shed light on your entire life history. When you tell a story about an apparently trivial incident, it exposes the entire fabric of your character.

(Denning 2007: 82)

Life scripts are used in psychoanalytic, developmental and organizational TA to surface the unconscious 'script' that is being lived out to enable awareness and autonomy (Berne 1976). On the basis of this, individuals or organizations might choose to 're-parent' themselves (Illsley-Clarke and Dawson 1998), re-writing a new ending to the story. Awareness of these life scripts can allow us to alter the pre-determined path. While I did not intend to work

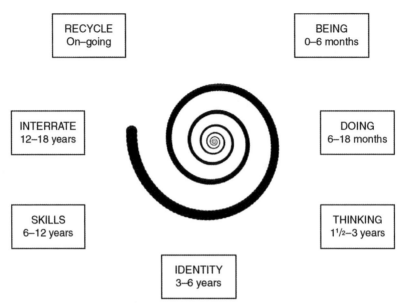

Figure 1: Based on Pam Levin's (1982) Cycle of Development.

'therapeutically' with stories, I was aware of the 'therapeutic' benefits possible. The implications for this are the need for a safe learning environment and careful facilitation of story work.

My story – part 2

My little girl is lost and alone, she has explored beyond safe boundaries. With no guides or travelling companions, she is out of her depth. Despite finding gold, she has also trespassed and the owner of the house will know that she has been there because she cannot clean the ball. She needs permission to explore and discover the world rather than doing it covertly, and she needs safe boundaries. She needs support to become who she can be, and she needs protection now from whoever owns the house.
How were these developmental needs identified?

In the second part of the developmental storytelling process, I 'teach' the students or delegates about the cycle of development. The 'Cycle of Development' (Levin-Landheer 1982: 34, see Figure 1) is a TA model that accounts for the process of developing from child to adult. The concept is cyclical rather than linear. It shows childhood progression through six developmental stages. A significant life event (new job/illness/change of home, etc.) may also restart the cycle or cause us to revisit stages at any point in our future

lives. The cycle is shown in figure 1 below, and the developmental actions associated are shown in Table 1:

Table 1: The Stages and Permission of the Cycle of Development (Clarke and Dawson 1998)

Stages	Age	Needs	Permissions
Being	0–6 months	Nurture	Its OK to be here, make my needs known and to be cared for.
Doing	6–18 months	Stimulation	Its safe for me to explore and to try new things and to trust what I find out.
Thinking	1½–3 years	To test limits and ask questions	It is Ok for me to learn to think for myself.
Identity	3–6 years	To test power and explore identities	Its OK for me to be who I am a unique individual and to learn the consequences for my behaviour.
Skilful	6–12 years	Skill development	It is OK for me to build the technical and social skills I need to live in my culture.
Integration	12–18 years	Integration	It is Ok to become a separate person with my own values, to be independent and responsible.
Recycling	Rest of life	Relationships	It is Ok for me to do what I need to in order to complete the meaning of my life and prepare to move on.

This conceptualization of development is powerful and solution-focused, enabling adults to locate their personal and professional development on a cyclical, developmental spectrum. It accounts for how people are in different stages developmentally in different circumstances – they may, for example, be fully integrated at work, but in a phase of being less integrated in their private lives due to a recent divorce. The model allows reflection on the self and others in different contexts.

The model not only signals what might be going on for individuals personally and professionally, but also offers a clear guide to interventions and roles of caregivers (who may be literal parents or line managers). In the workplaces, the cycle of development has been used to plan induction processes as it shows what new employees might be thinking and feeling about the tasks that they need to complete and what their managers need to do to enable this to happen. It can guide personal, professional and organizational development, and connect the logical with the affective domains, is useful in offering a way for people to anticipate the reactions of themselves and others to change, and the actions to take to move through these (Illsley-Clarke and Dawson 1998).

How? Part 2

I walk into the centre of the circle and explain that I am now going to teach them a developmental model that is TA or psychodynamic in origin.

I explain that it is a spiral and that I am going to recreate it on the floor.

I place each card in turn, slowly.

With the first card I offer an explanation of the developmental stage in terms of child development and ask them what the care givers role is at that stage of development.

With each subsequent card I ask them to describe the stage and the needs of the child, and to identify the role of the care giver.

Once the cycle is completed, I walk around it explaining how it reoccurs in adult life, and what I might mean for us then.

I use my personal experience of having unresolved issues in 'being' as an example of how we can sometimes need to revisit stages.

I ask them in their pairs to identify the developmental stages, needs and caregivers role for each of their metaphorical characters. They work on them jointly in metaphor.

Stories as socially constructed situated learning

Denning (2005: 178) argues that stories are a concrete form of knowledge (contrasted to abstract and tacit understanding) and as such are repositories of situational experience; he claims that cognitive scientists have proved that this is how we encode and make sense of experience. Polkinghorne (in Clandinin and Connelly 2000: 15) noticed that stories are used by practitioners (in medical settings) to make sense of their work, sharing both clients' narratives and practice narratives. Story in these contexts do not supplant the analysis of practice but enable new ways of thinking, which support ways of articulating change and encouraging innovation (Denning 2005). As a professional tool, stories then yield powerful shared understandings in the workplace, and the possibilities of overcoming professional barriers.

Situated learning occurs when co-workers acquire knowledge through the dynamics of everyday learning and interaction (Wenger and Lave 1991). An important part of situated learning is the construction of knowledge within the social and cultural circumstances in which the learning occurs. Wenger (2006) noted that in some situated learning, the learning was

explicit and steered by a common interest or passion in developing practice. This (still informal and situated) group of people were termed a 'community of practice' (Boud and Middleton 2003). Narratives are the quicksilver of these communities of practice; both the historical stories and the day-to-day stories create norms of 'how things are done here' and help practitioners make shared sense of dilemmas and problems in the work context. This socially constructed learning, I recognized, could be the root for the development of inter-professional education, as professionals from different backgrounds come together to create new ways of working.

My story – part 3

... [T]he little girl hears a noise on the stairs. She gasps, drops the ball and looks up in terror. Coming down the stairs is a large black outline, slow steps and heavy breathing. ... [S]he looks for somewhere to hide but can find nowhere in the damp empty cellar space. ... 'Now what do we have here?' booms the voice a step above her. ... A sharp sulphur smell announces the lamp light, and the girl is gently illuminated. As her eyes adjust she looks up into the lined face of an old man. His eyes are twinkling, his mouth is curved into an ironic smile, his clothing as rich and decadent as the furnishings in the room above. 'Come with me my girl, I have some more things that might entertain you – bring the ball, you'll need my special solution to get those grubby marks off ... what do you think to my anti-theft elixir? Effective isn't it? Chip chop, up you come ...' The old man turned and climbed the stairs taking the light with him. The little girl picked up the ball and dashed after him, into a whole new world of potions, inventions and magic.

Having identified the needs of the characters in the story, I then ask the students or participants to re-create these metaphorically by adding a new ending. Part of the joy of a story is that the ending can always be re-written, developed and go on to another chapter or volume. We do not always have this view of real life.

My story – part 4

What my story revealed for me was that I had often felt like a fraud in the professional roles that I had worked in. Whilst I logically knew that I was capable, and whilst I performed to or above standards in each role, I found it hard to shake an internal sense that one day I would be 'found out' as incapable, named and shamed as an imposter. This internal dissonance often led me to overwork, over-perform and create my own work stress as I endeavoured to ensure people could not detect any weakness in what felt like a façade. Identifying this pattern has allowed me to seek feedback from colleagues and students that my work is of standard, to soothe myself that 'good enough' is indeed good enough, and to feel more grounded in my new academic identity.

The fourth and final stage of the developmental story process was to identify the meaning from the new endings that they had created, and to transfer that learning into the current work situation. Kolb's (1981) experiential-learning cycle offers a pedagogical structure that draws from past experiences to inform future situations. As such it is appropriate to enable multi-professionals to draw from their past 'mono professional' experiences when moving into their new integrated settings. The experiential-learning cycle places importance on reflective practice (Moon 1999; York-Barr et al. 2006), this reflection 'in action' and 'on action' (Schon 1983) is an approach to professional development adopted across the children's and young people's workforce in the United Kingdom. The ability to reflect on past actions and to decide on future actions may provide a more resilient approach to the development of services for children and young people. The stages of the cycle offers a framework for the thinking and feeling areas of the experiential-learning cycle, the perceptual continuum and the tasks and permissions indicate developmental activities for the processing continuum. The experiential-learning-cycle approach and the cycle-of-development model are mutually reinforcing and can create deep insight and learning for individuals at cognitive and affective levels. The cycle of development presents the opportunity to take responsibility for meeting their own needs, or for asking for them to be met by others, allowing integration. This in experiential learning terms will allow them to observe and reflect on their life pattern, forming abstract concepts, and in planning the next steps they will test out new conceptualizations of themselves in new situations.

The action research cycle (McNiff 1998) bears a resemblance to the learning cycle in its cyclical phases of planning, researching, analysing and doing something different as a result. As such, engaging professionals or young people in an experiential, or action research process (sometimes known as practitioner research) would allow them to identify the current situation, the desired changes that they wanted to make, and the ability to carry out those changes. This use of narratives and or stories when linked to the experiential-learning cycle and action research cycles offered a structure for development. This led me to consider narratives and stories as research tools in their own right.

How? Part 3

In the final part of the process I would ask the delegates / participants to work individually again.

I asked them to reflect on the story endings that they had created, and the needs that had prompted the new ending.

I asked them to identify what the meaning is from the metaphorical story that they can apply to their personal or professional situations.

What were the lessons?

(Continued)

(Continued)

What would that ending look like in real life?

What were the needs in reality?

How could they meet them?

Finally I asked them to write down the action points that emerged on index cards that we would share as a group.

In a plenary setting we shared actions and insights (but not any of the literal or metaphorical stories).

We then shared our experiences and views on the developmental story telling process.

The process could be called a 'narrative inquiry', especially as I aligned it to action research in the previous section. Narrative inquiry is a research technique in its own right, and Broussine (2008: 19) identifies that creative methods allow insight into human experience as they are; 'rich and multifaceted', they 'enhance our capacity to find different expressive forms', and they are well suited to collaborative approaches to inquiry. When accepted as auto-ethnographic accounts (Anderson 2006; Ellis 2004; Sparkes 1996), stories can provide genuine insights into personal and collective experiences and understandings.

Stories are not reality, they contain exaggeration and embellishment. This 'levelling' and 'sharpening' (Denning 2005: 181) adds meaning to the experience rather than robbing it of validity. Broussine (2008: 169) argues that stories allow us to recognize different forms of knowledge from multiple participants, 'accessing dimensions of experiential knowing that are not represented in predominant presentational forms, and they offer processes of sense making for generating new propositional and practical knowing', which is vital for this type of generative practice. So my developmental storytelling process drew on experiential learning scaffolded onto a psychodynamic framework to create practitioners narrative-action research. This blend of disciplinary approaches was effective and appropriate (if irreverent!) in this multi-agency context.

What I learned from the practice

The narratives that were told by people across both contexts showed real personal insight, a journey, and a change in personal identity. Four themes have emerged out of my use of narratives that I had not conceptualized at the start of the work: disclosure, self-realization, psychological depth and solution focus. The use of metaphor often gave the individuals

(whether professionals or young people) the opportunity to deal with difficult situations confidentially. This opened up subjects that they might not otherwise have discussed – it facilitated disclosure. This in turn then allowed greater learning as more was 'up for grabs'. Self-realization preceded change. This was of crucial importance, and individuals and groups needed the time to make the self-realization 'oh that's what I've been doing!' before they could move on to make any lasting change. The individual realizations led to group realization. The more individuals disclosed, the more others did, and the more learning occurred as a result. A positive learning environment and strong enough group rules or group trust was therefore vital, even when working metaphorically.

I found that work at the narrative level can surface unconscious thoughts into consciousness. One professional spontaneously 'encoded' their organizational experience into the story of Cinderella. This surfaced the realization that unconsciously he felt put upon by the rest of the staff and was treated as a dog's body. This in turn explained his external resentful behaviour and offered new possibilities in changing his behaviour or tackling the issue. This facilitation experience substantiates Gabriel's view that

> a story can at the same time express the individuals deeply private and personal desires (e.g. for revenge, justice or recognition), a group's shared fantasy (e.g. of salvation or domination of another group), and deeper structural and political realities (e.g. a groups experience of long term exploitation, insecurity, or privilege). Stories carry personal meanings, cultural meaning as well as personal meanings.
>
> (Gabriel 2000: 91)

As a result, deep psychological material was surfaced into the conscious mind.

Use of an experiential or action research process alongside the stories allowed change. The uniqueness of stories in facilitating this change is that everyone believes that they can write a new ending to a story. Re-authoring their personal stories gave them the open-mindedness and the permission to identify the steps or resources that they might need for a successful ending. The experiential use of stories also offers individuals a sustainable approach to lifelong learning and provides a 'narrative map' (White 1987).

How does it create development and change? There are at least four ways in which change occurs that arose from studying the feedback from 40 participants:

- Validation
- Reframing
- Unconscious connect
- 'New'

By validation, I reflect that telling a story and being listened to can be a validating experience, especially in the busy lives of professionals. Having someone listen to, and play back a story ('I heard that ...') can validate the listeners' experience. This alone can create therapeutic

change. This validation can be transformational, and '[t]hrough transforming our negative, painful or chaotic experiences into stories, we take responsibility for them, and we bring them to bear more constructively on our lives' (Maguire 1998: 17).

A story can often reframe the experience that an individual or group has had. It may be reframed by the 'moral' of the story, by the events of the story, or through listening to and comparing others' stories. A huge obstacle may seem less significant in the light of others' stories or other perspectives. Once reframed, a change can then occur. Narratives allow us to conceptualize something in a new way, adding shades of meaning – a well told metaphorical story about teamwork can help a corporate team identify with how they function, leading to development, and a story with subtle meaning is more palatable than being told you are 'dysfunctional'. Metaphor may reframe experience, and by using metaphor to encode our stories, we can be offered the safety and distance to share events that would otherwise remain private. This has been my experience of using stories in multi-professional settings – it is easier to talk about the difficulties of the prince trying to get to Snow White than of the endless hurdles of collaboration. As Broussine (2008: 26) states, 'metaphor provides a description of something by reference to another object that is different to, but analogous to, the "something" originally described'. This is particularly useful when researching personal and practice experiences as metaphors can operate as an emotional receptor for unconscious feelings.

So, 'an appropriately told story had the power to do what rigorous analysis could not, that is to communicate a strange new idea in a meaningful way and to motivate people quickly into enthusiastic action' (Denning 2005: xii). This reminded me of Dadds (2008) concept of empathetic validity, where the measure of the story is how much it moves the readers, rather than whether it is reliable and generalizable.

This is a single point in the ongoing journey that I have begun with stories and other creative teaching and research techniques. I invite you to step on the road with me, taking our tales as worthy travelling companions.

References

Anderson, L. (2006), 'Analytic Autoethnography', *Journal of Contemporary Ethnography,* 35: 4, pp. 19–50.

Berne, E. (1976), *Beyond Games and Scripts,* New York: Grove Press.

Bettleheim, B. (1976), The Uses of Enchantment: *The Meaning and Importance of Fairy Tales,* New York: Knopf.

Boud, D. and Middleton, H. (2003), 'Learning from Others at Work: Communities of Practice and Informal Learning', *Journal of Workplace Learning,* 15: 5, pp. 194–202.

Broussine, M. (2008), *Creative Methods in Organizational Research,* London: Sage.

Clandinin, D. and Connelly, F. (2000), *Narrative Inquiry,* San Francisco: Jossey Bass.

DCSF (2004), *Children's Act,* London: DCSF.

Dadds, M. (2008), 'Empathetic Validity in Practitioner Research', *Educational Action Research,* 16: 2, pp. 279–290.

Denning, S. (2005), *The Leaders Guide to Storytelling,* San Francisco: Jossey Bass.

Ellis, C. (2004), *The Ethnographic I,* Walnut Creek: AltaMira.

Gabriel, Y. (2000), *Storytelling in Organizations: Facts, Fictions, and Fantasies,* Oxford: Oxford University Press.

Illsley-Clarke, I and Dawson, C. (1998), *Growing Up Again,* Minnesota: Hazleden.

Koch, T. (1998), 'Story telling – is it really research?' *The Journal of Advanced Nursing,* 28: 2, pp. 1182–1190.

Kolb, D. (1981), 'Learning Styles and Disciplinary Differences', in A. Chickering (ed.), *Responding to the New Realities of Diverse Students and a Changing Society,* San Francisco: Jossey Bass.

Lave, J. and Wenger, E. (1991), *Situated Learning: Legitimate Peripheral Participation* Cambridge: Cambridge University Press.

Levin-Landheer, P. (1982), 'The Cycle of Development', *Transactional Analysis Journal,* 12: 2, pp. 129–139.

Maguire, J. (1998), *The Power of Personal Storytelling: Spinning Tales to Connect with Others,* Thousand Oaks, CA: Sage.

McAdams, D. P. (1997), *The Stories We Live by: Personal Myths and the Making of the Self,* New York; London: Guilford Press.

McKimm, J. and Phillips, K. (2009), *Leadership and Management of Integrated Services,* Poole: Learning Matters.

McNiff, J. (1998), *Action Research: Principles and Practice,* Oxon: Routledge.

Moon, J. (1999), *Reflection in Learning and Professional Development,* London: Kogan Page.

Propp, V. (1968), *The Morphology of the Folktale,* 2nd ed., Austin, TX: Texas Press.

Schon, D. (1983), *The Reflective Practitioner: How Professionals Think in Action,* New York: Basic Books.

Simpson, P. (2008), 'Stories', in M. Broussine (ed.), *Creative Methods in Organisational Research,* London: Sage.

Sparkes, A. C. (1996), 'The Fatal Flaw: A Narrative of the Fragile Body-self', *Qualitative Inquiry,* 2: 4, pp. 463–494.

Steiner, C. (1974), *Scripts People Live,* New York: Grove Press.

Wenger, E. and Lave, J. (1991), *Situated Learning – Legitimate Peripheral Participation,* Cambridge: Cambridge University Press.

Wenger, E. (2006), *Communities of Practice,* http://ewenger.com/theory/communities_of_practice_intro.htm. Accessed 3 November 2006.

White, M. (1975), *Narrative Maps of Knowing,* London: Sage.

Winter, R., Buck. A. and Sobiechowska, P. (1999), *Professional Experience and the Investigative Imagination,* Routledge: London.

York-Barr, J., Sommers, W., Ghere, G. and Montie, J. (2006), *Reflective Practice to Improve Schools,* 2nd ed., Thousand Oaks, CA: Corwin Press.

Chapter 12

Developing Reflective Learning Journals

Audrey Beaumont
(Educational Consultant and Academic Researcher)

Recent practice-based research in Initial Teacher Education (ITE) at the Liverpool Hope University has been concerned with the development of contemporary pedagogical practices relating to students' conceptions of learning and subsequent impact on their evolving professional identity, with the aim to understand the multi-factorial roles of the teacher-practitioner. The research project explores students' learning experiences following implementation of a transformative model of learning based on the principle of self-regulated learning (SRL) and explores several innovative course features, examining the potential to influence students' learning behaviour and evolving professional practice. It also investigates the relationship between the teacher and the student and the extent to which the roles assumed by both may be negotiated to maximize learning according to the learning environment.

The case study in this chapter supports a model for learning that is concerned with creating contexts and learning conditions that emphasize students as autonomous learners, taking greater responsibility and ownership for their own learning. The model promotes the importance of developing students' critical thinking and aligns to current trends in education in developing a practitioner research culture, embedded in reflective practice through peer dialogue (see Schon 1983; Fisher 2001; Gadsby and Bullivant 2010). It aims not only to convey a set of competences associated with skills development, but also seeks to promote higher levels of critical engagement with recognition of students' individual differences in epistemological understanding and knowledge construction.

The chapter focuses on methods for enhancing students' own meta-cognition within teacher education in relation to challenging their epistemological understanding and beliefs in learning *how* to learn. It should be noted, however, that the principles that underpin these methods are trans-disciplinary in nature and may be modified and used in multiple learning contexts and across subject disciplines in Higher Education. Initially, we explore methods to increase levels of student confidence and competences through enhanced student participation by examining a tutorial model that aims to secure optimal learning through identifying specific tutor and student roles. The second part of the chapter focuses on critical thinking and the development of Personal Learning and Thinking Skills (PLTS) through engagement with the new course content. It also examines the benefits to students of using a 'learning journal', or portfolio, as a learning aid to foster critical thinking, and as a dialogic and self-assessment tool towards self-directed learning.

Fundamentally, the changes in approach stem from classroom-based research that has been recently conducted in Higher Education in ITE to challenge current teaching and learning

practices. The components of the model have been constructed following conclusions drawn from the research evidence, that have formed the basis on which to reframe these practices towards a paradigmatic shift in education to foster autonomous learning within a lifelong learning framework.

The framework that underpins that project from which this case study derives considers the purposes and challenges for group teaching, and encourages practitioners to examine teaching styles and tutorial formats and their influence on learning potential, according to the theory of Lublin (1987) and his model for learning, which refers specifically to tutorials and how they are conducted. The approach involves the practitioner in a cyclical process of planning, action, observation and reflection, based on action research in which the characteristics of a tutorial structure are analysed and interpreted to determine students' levels of participation in relation to the teaching roles assumed by the tutor. For the purpose of this case study, 'tutorial' is used broadly as a generic term that includes any kind of group work facilitated by a tutor or teacher. Both large and small group settings are considered and their success evaluated in terms of group interaction, relative to levels of student participation and response.

Case study part 1: Tutorial model

Teaching contexts

From having taught for many years in primary and secondary schools before entering Higher Education, I developed the realization that the influence of teaching and learning styles on the learning potential of the individual has challenged my own professional practice, principles and values. In examining our own teaching performance, we inevitably search for methods that will maximize the learning potential of those students we teach. We tend to evaluate our practice on a daily basis, sometimes on a professional level with colleagues, or through independent reflective evaluation. At other times, such evaluation is undertaken in what could be described as an intuitive and subconscious activity, which subsequently informs future learning through the implementation of changes to our teaching styles. According to this type of practice, such styles tend to be evolutionary in nature, whilst the role of the tutor alternates between practitioner and researcher, dependent on the constructs of the learning environment and the context in which the teaching takes place. Thus, the research undertaken with undergraduate trainee teachers in the Education Faculty on how students become confident, autonomous learners, raised some fundamental questions regarding the conditions needed to achieve effective learning, such as:

- What is the key to student attention and engagement in learning towards acquiring conceptual understanding in a particular disciplinary domain?

- What is the influence of prior learning and conditioning on students' learning intention and potential?
- How as educators are we able to meet the needs of students with different academic entry levels and competences?

In the school environment, the affective behaviour of pupil response to the way in which a lesson is delivered may be easily observed according to the levels of interest and enthusiasm to participate in an activity. This may be determined by many factors such as teacher–pupil relationship, mode of delivery, style of teaching and levels of interaction between the teacher and the pupil. The degree to which effective teaching takes place, depends largely on the teacher's experience and professionalism to engage pupils in meaningful learning contexts that create opportunities in which to realize effective learning.

Students in Higher Education however, tend to display less explicit responses, where levels of involvement may be more ambiguous and difficult to measure. Lack of participation amongst these students is not necessarily seen as a true indicator of disengagement, but perceived more distinctly as a form of *passive involvement*, where it is assumed students have acquired the right attitude and skills to manage their own learning. This view, however, may be regarded as a false indication of the levels of learning that are actually taking place, as research suggests an optimal listening time of 40 minutes before students' attention and information processing capacity start to diminish.

In Higher Education, tutorial styles have been contentiously debated with respect to delivery of the most beneficial approach. Issues include structure and delivery of content, levels of tutor–student interaction, student group formations, etc. Whole cohort lectures, followed by smaller group seminars or tutorials, are by far the most commonly accepted forms of delivery. The characteristically intimate grouping of students in their seminar groups tends to provide a more congenial atmosphere in which to encourage discussion and exchange of ideas in order to develop further understanding of the central theme. Arguably, the different teaching styles of tutors who deliver the same module, together with the group dynamics, can affect student response and learning outcomes, regardless of the identical seminar material, which is often presented in scripted form as a set of guidance notes by the module leader or lecture provider. The pattern, nonetheless, remains the same; whole cohort lecture, usually of a predominantly didactic nature, followed by smaller group seminars. These smaller group seminars often start with a tutor-led, whole group discussion on the lecture theme, followed by paired or small-group discussion, which culminate in the sharing of ideas and outcomes, generally in the form of a whole group plenary.

My long-held understanding of this instructional approach, based on the classic encultured strategy of role-modelling, suggests that if tutor demonstration precedes the student activity, then it can generally be assumed that the majority of students will be sufficiently enabled to follow the procedure at their own individual levels. Yet another perception is that if the relevant theory and pedagogy is introduced at a pertinent moment

in time during the student activity, they will then make the relevant connections between practice and theory. So why is this for many students simply not the case?

Research findings

I questioned my own professional practice, explored the tenets of my educational philosophy from diverse perspectives and questioned the discrepencies that existed between my own expectations of students and students' ability to acquire specific knowledge and understanding. In response to my own research – which included observations, student questionnaires, end-of-course student evaluations and face-to-face discussions with my groups of students – I arrived at a number of conclusions. Those relating to the development of students as autonomous learners – the chief focus of this case study – are highlighted in italics:

(a) *Many students lacked the confidence in larger group learning contexts to contribute and discuss their knowledge and understanding of an issue;*

(b) *Some students lack the threshold concepts to enable knowledge construction, demonstrating low levels of subject knowledge, skills and understanding to ensure the necessary abstract conceptualizations, regardless of the concrete operations and activities undertaken in the workshop sessions;*

(c) *Learning behaviour is firmly embedded in students' current espistemological understanding and knowledge construction;*

(d) Students were unable to process and memorize the quantity and levels of information provided in the allocated short course period of time;

(e) *Differentials in attitude to learning; perceptions of what and what does not matter in knowledge acquisition, as part of a larger professional knowledge set;*

(f) *Unrealistic tutor expectations of how students are able to construct knowledge in perceived meaningful contexts;*

(g) Prioritization of learning of a subject disipline according to its profile and perceived importance of rank;

(h) *Student attitude and perception that the tutor is the provider of information, accompanied by students' lack of acknowledgement of their personal role in taking reponsibility for, and leading their own learning;*

(i) *Components of modules that are not a part of a formal assessment procedure, perceived by students to be of lesser importance resulting in lesser emotional commitment and investment;*

(j) Selective engagement with the online teaching and learning support material.

There is much evidence in pedagogical research to support a learning approach that is less didactic and that encourages students to actively engage with the lecture material. This trend

would seem to be moving towards a more systematic, interventionist, enculturing pedagogy, the principles of which are embedded in participation and interaction. As such, the developing rationale for group teaching not only prioritizes delivery of knowledge, but also emphasizes the acquisition of reasoning power, judgement and the application of principles that are associated with the concept of critical thinking. Such thinking promotes an understanding that clarification of thought is through talk and that providing the opportunity for group discussion allows the learner to play flexibly with language and ideas for the purpose of negotiating meaning and knowledge construction.

The tutorial model

With the goal of developing an approach that increases student participation and autonomy, a tutorial was planned that set out to identify the constitutional nature; type of task, pace of activities, tutor and student roles, learning resources, and the critical thinking skills to be developed (discussed later on in the chapter). This is illustrated in Table 1.

The learning objectives are concerned primarily with developing the students' critical reasoning powers through engagement with the lecture content, together with

Table 1: Tutorial Model

Time	Tutorial structure - components	Seminar activity	Tutor roles	Student roles	Critical Thinking Skills- PLTS/ (Bloom's Taxonomy)	Resources/ technologies
0.10	Lecture theme - tutor introduction	Teaching and learning environments	Explainer, clarifier, questioner	Passive; Listening and responding to questions	Self-manager, reflective learner (Knowledge, understanding)	Interactive whiteboard (IWB) & powerpoint presentation slides
0.05	Sub-group discussion	What constitutes an effective learning environment?	Questioner	Interactive; Collaborative discussion- sharing ideas and opinions	Effective participator, creative thinker, team worker (Knowledge, understanding)	Learning journal
0.10	Whole group discussion	Mini-plenary to share sub-group opinions and outcomes	Supporter, clarifier, questioner	Participative; Individual response & debate	Effective participator, reflective learner, self-manager (Knowledge, understanding)	IWB

(Continued)

Table 1: *(Continued)*

Time	Tutorial structure - components	Seminar activity	Tutor roles	Student roles	Critical Thinking Skills- PLTS/ *(Bloom's Taxonomy)*	Resources/ technologies
0.10	Sub-group activity	Prioritization of set of individual statements according to their perceived importance	Non-intervention	Interactive; Discussion & evaluation of statements	Effective participator, independent enquirer, creative thinker, team worker, *(Knowledge, understanding)*	Envelopes each containing a set of theoretical statements
0.15	Whole group discussion	Measurement of collective response to negotiate meaning and justify understanding	Supporter, questioner, challenger	Interactive; evaluation & comparison of sub-group results. Justification	Reflective learner, independent enquirer, Creative thinker, effective participator, *(Knowledge, understanding)*	IWB
0.15	Tutor-led theoretical input	Rationale and framework for an effective teaching and learning environment	Explainer, clarifier and questioner	Passive; listener	Reflective learner, independent enquirer, self-manager *(Knowledge, understanding)*	Powerpoint presentation
0.15	Tutor/ whole group evaluation	Evaluation of an effective learning environment	Questioner, supporter, clarifier, explainer, challenger	Interactive; Critical analysis and discussion	Effective participator, creative thinker *(Application, analysis)*	Visual support materials
0.30	Practical group activity	Problem-based task & application	Supporter, questioner, challenger	Interactive Collaboration; supporter, questioner, challenger	Creative thinker, independent enquirer, effective participator, self manager, team worker, reflective learner *(Application, analysis, synthesis)*	'Teaching and learning environment' group activity packs
0.10	Plenary – Whole group evaluation	Discussion & critique of sub-group outcomes	Supporter, questioner, clarifier	Interactive: Evaluation & critique	Critical thinking: - reasoning *(Evaluation)*	Learning journal

contextualization of the material and clarification of attitudes and values within an epistemic tutorial environment.

The fundamental aim to determine how students learn best is unreputedly at the heart of all teaching. In a previous presentation of a tutorial based on a similar theme, the introduction was tutor-led, with the pedagogical theory preceding the application. This resulted in a passive collective response and with little student participation. Students nonetheless demonstrated a certain level of engagement by readily taking notes, translating information and recording points made by the tutorial leader. However, apart from a few individuals, students generally appeared reluctant to contribute to the forum. Conversely, in a revised approach, student response was swiftly and confidently elicited through the reorganization of content and focus of attention. According to the modified delivery, sub-group activities are introduced early on in the session, with the main part of the tutor-led theoretical component *following* the application. It was observed that greater student involvement and enhanced interaction were common features of all sub-groups, and when the whole group reconvened, students were more likely to contribute to the discussion, demonstrating higher levels of attention and confidence.

In evaluative terms, a situation has thus been created whereby the tutor provides a framework for the the tutorial that gives signifcantly greater control and ownership to the students, whilst at the same time maintaining a lesser degree of tutor control. Arguably, such a structure may be considered both enabling and constraining: tutors leading students towards construing conceptual perceptions, yet, at the same time, enabling them to reorganize and extend the conceptual structure to frame new perspectives on topics, and so develop their conceptual abilities and autonomy as learners.

The transfer of ownership to the students provides the opportunity to establish views and opinions within a small-group situation in which students feel secure and enabled to express themselves within the larger group. The sociologist Erving Goffman (1971), who studied people's interactions with each other, talks of the ability to *define* ourselves within different social contexts and scenes and argues that it is a process of negotiation that evolves as each participant projects a self into the scene. The tutorial model facilitates participation as students are able to adopt a role of responsibility and ownership through discussion and negotiation within the group activity, whereby each defines the scene and member status within the group. Furthermore, when dividing into sub-groups, the formality of the large group setting is temporarily set aside, creating a more comfortable atmosphere that is more conducive to individual contribution and participation when the larger group reconvenes. As Northedge (1992) explains, '[t]his method has the particular merit of breaking up the social formation of the larger group, allowing new norms to be established in an unthreatening context and whereby tension has been dissipated through active social engagement'. The teaching roles adopted are primarily those of leader and facilitator, however the tutor also plays a complex and changing role as she changes her position from questioner, challenger, supporter, clarifier and explainer at different stages during the course of the teaching session.

Having acquired insight of how levels of student participation, understanding and confidence may be enhanced according to the dynamics of a tutorial, let us now turn our attention to the methodologies and specific course features, based on students' metacognitive development, that are not only instrumental in increasing levels of student engagement, but can also assist in developing autonomy of learning.

Case study part 2: Learning journals

Mosley et al. (2005) identified the key principles used in all teaching and learning frameworks that foster critical thinking. They include the *domain* of learning, the *content* of learning and the *processes* of learning, together with the psychological aspects associated with self-regulated learning. In response to my own action research, I was concerned with developing a model to create new contexts and conditions for learning that would challenge students' evolving epistemological understanding and knowledge construction through developing high levels of critical thinking as an integral part of the student learning experience. I based the approach principally on the QCA's framework (2007) for PLTS, which outlines the key cognitive and metacognitive processes for promoting *independence of enquiry* and *creative thinking* in students, towards becoming *reflective learners*.

Defining what is meant by thinking skills, however, can be difficult as there have been many points of view and notions, which have been promoted over a period of time, from Edwards Glaser's (1941) definition of critical thinking and Bloom's Taxonomy of Learning Domains (Bloom & Krathwohl 1956), to current understanding of the thinking processes supported by Bob Kizlick (2010), all of which could be said to have acclaimed value. Thus the links and corrrelation between the model for teaching and learning as described in the first part of the chapter (Table 1), and the integrated aspect of the PLTS framework, are intended to work in a complementary and interrelated manner in the teaching of transferable skills and can be developed across disciplinary domains and applied to multiple learning contexts. One of the ways in which this was achieved was by introducing a learning journal, otherwise referred to as a portfolio, to develop students' critical thinking ability.

What is the aim of a learning journal?

The concept of the learning journal was originally used in vocational training and has a long tradition in certain occupational groups, for example, amongst artists and architects. More frequently today, the learning journal is being used across disciplinary areas, including the educational and medical professions. Learning journals are collections of peoples' work, the results of their labour, that concisely document their personal development and their

achievements. Learning journals are dynamic as they are subject to change, just like the people they belong to. Unlike assessments given by a third party, which at least claim to provide an objective view of a person's work, portfolios can reflect the subjective view of their owners. Thus, they can complement third party assessments of ability by giving their creators the opportunity to express a personal appraisal of themselves.

The use of the learning journal as a tool for teacher education is now widely accepted in many countries. Its aim is to track personal learning curves and the processes involved in a certain phase of its owner's professional development and from a subjective point of view. Generally, the learning journal fulfils three main functions in teacher education:

1. It documents the learning process of an individual in certain circumstances and during a certain period.
2. It shows the students' particular achievements at critical points of their professional development through annotation and visual presentation.
3. It showcases what a student believes to be examples of their best work and thus documents what they are capable of doing.

In teacher education, the learning journal was implemented with the objective to develop students' reflective thinking and metacognitive processes by recording ideas through both the narrative and the analytical, developing explicit links to classroom practice and theory. The journal makes a valid and representative statement about the development and skill of its creator. As the course progressed, the learning journal became a tool for critique and peer group evaluation as students became critical friends in the process of review and modification. It also assisted students in the development of metacognitive processes linked to PLTS in facilitating and accelerating students' understanding of otherwise complex concepts. Furthermore, it was used as a tool for discussion during seminars and developed a sense of collaboration between students in shared meaning-making and knowledge construction.

The learning journal thus provided a means for students to record, assimilate and synthesize knowledge acquired. At the same time, it provided the opportunity ro reflect upon and critique their learning, both independently and with their peers. The journal, in effect, became much more than what may have been interpreted by the casual onlooker as simply a notebook, but as a log of their learning journey and as a monitoring and evaluative tool for students in their self-directed learning and emerging knowledge construction (Figure 1). Deakin Crick's (2007) reference to students' learning trajectory claims, '[t]he learning journey is scaffolded towards a more personally owned construction of knowledge through dialogue, using learning power dimensions, in which attention moves between the person and "the knowledge" to be acquired in the context of experience'.

The learning journal as a monitoring and evaluation tool for students in self-directed learning and emerging knowledge construction is illustrated below (Figure 1).

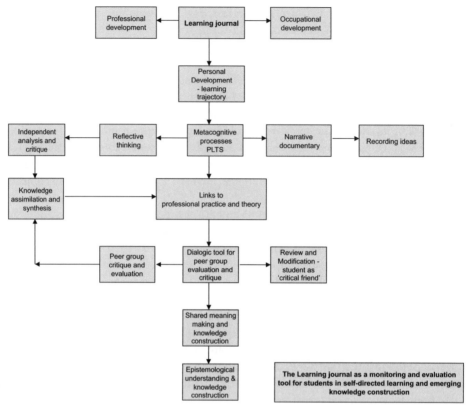

Figure 1.

Self-directed learning approach – pedagogical framework

The overall aim of the methodology was to challenge students' epistemological understanding and beliefs in shaping their academic and professional values through the pedagogical lens. From this perspective, I was able to devise a set of objectives from which to construct my teaching model and subsequently test my hypothesis, that self-directed learning, together with the associated skills, are essential qualities to be taught in the process of knowledge construction. These objectives are

- support active and collaborative learning in which students take responsibility for their own learning, including self-evaluation and monitoring of own progress;
- engage in collaborative, problem-based learning in which students are part of a peer teaching and learning process;
- develop students' disciplinary competences and associated pedagogy in which epistemological understanding and beliefs may be challenged and developed;

- promote self-directed learning to inform and shape students' perspectives on learning and rationale for teaching;
- enable students to become reflective learners through the process of independent and peer critique.

Based on these objectives a framework was developed, comprising the characteristics it was considered would foster autonomy of learning and that would transform students' attitudes and perceptions to becoming effective teachers. I could foresee this as a problematic transition due to the traditional way in which students perceive teaching and learning based on their own attitudes and prior experiences. I therefore incorporated the following set of course features, which I considered would be instrumental in achieving the objectives outlined above:

- personalized learning – activities aimed at students' own levels of ability;
- an active learning, problem-based philosophy;
- student-directed, self-enquiry approach, tutor-facilitated;
- metacognitive strategies (PLTS) to support the development of reflective and critical thinking;
- use of a learning journal as a teaching and learning resource to provide a trajectory of the student learning experience;
- blending focused learning and continuous provision;
- practice closely linked to theory and pedagogy;
- peer-assisted process – notion of the 'critical friend' to develop shared meaning making and knowledge construction.

With these objectives in mind, I decided to construct a series of non-prescriptive, open-ended learning contexts and develop multiple learning conditions, which would allow students to make their own choices and whilst doing so, develop students' own trajectories for learning. This would hopefully counteract the misconception that learning should be predominantly teacher-driven, and at the same time, liberate students in their understanding that a self-directed approach, in which they are leaders of their own learning, according to their own interests, is indeed in itself self-empowering.

The course structure and content, according to those course features described above, were designed to support a self-directed learning approach to develop reflective and critical thinking. The implementation of a learning journal was considered to be a fundamental aspect of the course design in providing a wide range of evidence to support students' professional development and emerging epistemological understanding.

A self-enquiry, student-led approach is one of the essential features of this teaching and learning approach, which is designed to allow students to develop a line of enquiry according to a chosen theme or topic of interest. According to this approach, students are

encouraged to develop their artistic ideas through practical exploration, peer review and self-evaluation, and develop an understanding of how to apply these ideas to their professional classroom practice.

(Student Handbook, Liverpool Hope University 2010)

Learning contexts: Focused learning and continuous provision

To achieve the intended outcomes as outlined above, the course implements a learning structure that aligns with the notion of 'continuous provision' and 'focused learning'. Typically, the teaching environment is constructed so that the focused learning element develops the foundation of students' theoretical understanding through structured, teacher-led activities with identified learning objectives, which characteristically direct students in their learning towards the intended outcomes. In contrast, continuous provision (i.e., the independent enquiry process) encourages students to make their own choices about their own learning trajectory according to personal interest and levels of confidence. Furthermore, through the individual student outcomes, students are more clearly able to understand the learning objectives, having constructed the mental process.

The question is, why should this be so? Such learning contexts provide a choice of practice-related, open-ended learning experiences that aim to develop student's conceptual understanding in a non-threatening, yet challenging context. These multi-learning, tutor-facilitated contexts are intended to encourage students to develop lines of enquiry that are of interest to them and that are relevant to their professional development. The nature of continuous provision allows students to develop comprehensive understanding of the modular themes in their professional training at any one time, through an approach in which students identify and research their own challenges and lines of enquiry. Thus, continuous provision becomes essentially student-led and is intended to challenge students' thinking, by inviting them to think outside the traditional parameters of what it means *how* to learn, essentially obliging them to move outside their comfort zone to explore alternative ways to acquire knowledge.

The dual nature of this approach is designed to support the growth of intrinsic understanding of the interrelationship and interdependence between practice and theory, together with the conceptual understanding associated with a particular subject discipline.

In addition, it promotes a view of learning that emphasizes the importance of shared meaning-making and knowledge construction through critical dialogue. The notion of peer teaching and learning, in which the learning process is peer-assisted, is realized through the concept of using a 'critical friend' and whereby the role of the critical friend is primarily one of collaboration in sharing and comparing ideas, challenging opinions and improving subject knowledge relating to the appropriate pedagogy and theory. The idea of paired learning

therefore requires students to participate in specific collaborative learning through focused dialogue and critical review of their professional practice. The exchange of ideas, recorded in the learning journal, is both fundamental and essential in the formation of higher-order thinking skills and is an important factor in challenging current epistemological percepts. The role of the tutor in continuous provision is largely one of facilitator, providing guidance to students on either an individual or group level. As such, the notion of personalized learning is developed, as the tutor's role adopts a complex combination of supporter, questioner, explainer, clarifier and challenger.

As a final observation, my research revealed the issue that 'components of modules which are not a part of a formal assessment procedure, are perceived to be of lesser importance resulting in lesser emotional commitment and investment'. While this outcome in itself is deserving of further discussion, it is nonetheless important to offer a brief solution to this particular issue affecting student engagement. The inclusion of a group plenary session at the end of course in which each sub-group shares their learning journey was a conscious feature to address the variable levels of student commitment and investment, with the intention of developing individual and team responsibility. This was realized in the form of small-group presentations in which groups of students worked in collaboration during the course to build a sense of cooperation on which to share their individual understandings and develop a rationale for teaching. Further, through the medium of the learning journal, students were able to engage in formative assessment by drawing on their conclusions to evaluate their professional progress. The notion of self-appraisal was indeed an added dimension to the framework, and assisted students in their learning, and demonstrated the extent to which it may be used to facilitate autonomous, self-regulated learning.

Conclusion

This chapter has explored the complementary components of an innovative course. The second section has examined closely a set of features belonging to a new pedagogical model to increase autonomy of student learning: interaction with the learning journal, PLTS, independent enquiry, collaboration and peer dialogue. The first part has addressed an approach to enhance student participation in tutorials through defining the roles of both the tutor and the student, and considered how these roles are shaped through critical thinking and their importance to conceptual learning. Schon (1983) develops the notion of 'the framing roles' in the teacher–learner relationship and suggests that they tend to be of the conventional kind, that is, a simple hierarchical system with the teacher very much in charge, setting the agenda, controlling the channel of communication and acting as 'gatekeeper' of a value system. According to such theory and practice, ownership of students' learning is taken away and the opportunity for active participation is reduced. Similarly, Goffman (1971) highlights the power of the tutor to define the scene and claims that the problem of

non-participation in learning groups arises because the students are inhibited by the well-defined active role of the tutor, which fails to provide opportunities to 'project a self'. As such, students have 'weakly defined and undifferentiated roles and infrequent opportunities for launching a projection of the self'.

If this is still widely acclaimed in teaching today, then it is imperative that educators examine closely their roles in relation to those of the learner and the influence of teaching styles on the students' learning potential. Furthermore, it still remains necessary for educators to reflect on the purposes and challenges of course design, together with consideration to the most effective methods in developing students' confidence and competences in which to be able to develop their critical thinking skills and autonomy of learning within the context of a rich and varied interactive teaching and learning environment. As creative tools for synthesis of learning, self-appraisal and peer dialogue, learning journals can be a powerful element of that environment.

References

Bloom, B. S. and Krathwohl, D. R. (1956), *Taxonomy of Educational Objectives: The Classification of Educational Goals by a Committtee of College and University Examiners,* Handbook 1: Cognitive Domain, New York: Longman.

Deakin Crick, R. (2007), 'Learning How to Learn: the Dynamic Assessment of Learning Power', *The Curriculum Journal,* 18: 2, pp. 135–153.

Fisher, A. (2001), *Critical Thinking: An Introduction,* Cambridge: Cambridge University Press.

Gadsby, H. and Bullivant, A. (2010), *Teaching Contemporary Themes in Secondary Education: Global Learning and Sustainable Development,* London and New York: Routledge.

Glaser, E. (1941), *An Experiment in the Development of Critical Thinking,* New York: Teachers' College, Columbia University.

Goffman, E. (1971), *The Presentation of Self in Everyday Life,* Harmondsworth: Penguin Books.

Kizlick, R. (2010), Thinking Skills Vocabulary and Definitions. www.adprima.com/thinkskl. htm.

Lublin, J. (1987), *Conducting Tutorials,* Kensington: University of New South Wales, Australia.

Mosely, D., Baumfield, V., Elliot, J., Gregson, M., Higgins, S., Miller, J. and Newton, D. (2005), *Frameworks for Thinking: a Handbook for Teaching and Learning,* Cambridge: Cambridge University Press.

Northedge, A. (1992), *Teaching Access: a Tutor's Handbook for the Modular Open Learning Access Course, Living in a Changing Society,* Milton Keynes: The Open University.

Qualification and Curriculum Authority (QCA) (2007), *The Personal Learning and Thinking Skills Framework,* http://curriculum.qcda.gov.uk/uploads?PLTS_framework_tcm8-1811.pdf.

Schon, D. A. (1983), *The Relflective Practitioner,* Aldershot: Avebury Books.

Chapter 13

The Overlooked: Landscapes, Artistry and Teaching

Paul Key
(University of Winchester)

This chapter takes its guidance from Elliot Eisner's exploration of what we can learn from the arts (Eisner 2002), his examination of artistry (Eisner 2003) and his conceptualization of the connoisseur (Eisner 1998). The discussion aims to expand on these ideas, establishing an understanding of their relevance to student teachers – in their personal arts practices and in their considerations of primary classroom teaching and learning. Presented as a reflective account, the chapter includes an example of a modular experience where students engage with these ideas, within the context of 'landscapes', through reading, making, discussion, writing and reflection. The chapter speculates that thinking and acting in artistic ways, including an emphasis on looking at and noticing things, can play a key role in students' enhanced and long-term professional development.

Artistry and Initial Teacher Education

An advantage of combining academic study while gaining Qualified Teacher Status (QTS), facilitated through university-based undergraduate Initial Teacher Education (ITE) programmes, is that a considered approach to education can be encouraged. For example, students at the University of Winchester, during the process of becoming primary school teachers, are not only required to meet the standardized requirements of the Training and Development Agency (TDA 2008) but also to 'question received wisdom', be 'politically astute' and become 'critically engaged'. This approach encourages students to think of themselves as moving towards a teaching identity of 'professional risk taking and creative thinking'. This ambition is felt across the programme as students move through various phases of their maturing teacher identity, building upon and transforming knowledge and skills through purposeful communities of learning. However, there remain challenges to this ambition, sometimes presented through student unease or limited willingness, where more pragmatic and instrumental decisions are taken ahead of those identified positively as being uncertain, creative or with an element of risk. This is probably understandable in any climate, including educational settings, where conditions are subjected to intense scrutiny and particular approaches to accountability (Eisner 2003); there is an inevitability of 'turning in on possibilities'. This chapter presents an aspect of the undergraduate ITE programme at the University of Winchester, which adopts an artistic approach to learning and to thinking about teaching, in an attempt to resist such 'turning in' and to remain open to possibilities.

As part of their ITE programme, students at the University of Winchester are invited to select a *special subject* for extended study, with an aim towards preparing for future primary school roles involving subject leadership. This chapter involves the Art and Design special subject choice. The art and design modules build on students' existing knowledge and skills towards a professional and pedagogic understanding of art and design, within a community that encourages an artistic approach to teaching and learning. This provides students with an opportunity to extend their art and design experiences in post-16 education settings, enhancing their portfolio of skills in drawing, painting, printmaking and three-dimensional studies. In these areas of study, the modules encourage students to adopt playful and inventive approaches to materials and visual, tactile and spatial explorations, helping to re-establish their artistic practices. Significantly, this approach to materials and visual, tactile and spatial explorations is embedded in an experiential and reflective model of learning. It encourages learning that 'integrates' ideas with 'personal knowledge and experience' and encourages a process of 'evaluation and reflection' (Salmon 1995) throughout the learning experience. The significance of this approach is two-fold: (1) it encourages students to engage and extend their own learning encounters; and (2) it mirrors an approach to teaching and learning relevant to their future careers in primary schools. As such, it is an intention of the modules in art and design that students *experience and feel* what it is like to learn, and ultimately teach, in these more personal or open ways, where ideas are transformed through negotiated and reflective practices, embedded in relationships between students and tutors (Addison & Burgess 2000; Addison et al. 2010). Importantly the modules encourage students to maintain, through personal explorations and investigations, their interests in looking, seeing and noticing. In turn, students are encouraged to reflect on these perceptions in similarly well-observed ways, engaging in, and reflecting on, both their artistic practice and, increasingly, their emerging teaching practice, via the ways of artists.

To enable a more comprehensive awareness of the nature of this artistic approach, we have made use of Eisner's arguments exploring 'what we can learn from the arts' (Eisner 2002) and his model of 'artistry' (Eisner 2003). Between these arguments Eisner shifts some of his general observations of learning in the arts to the employment of artistic practices to educational contexts. In addition, Eisner supports an extended vision of reflective practice through his conception and application of 'connoisseurship' (Eisner 1998). Within this discussion we are able to make links across these considerations by identifying their particular interests in expanded ways of looking and noticing.

Artistry and the importance of noticing things

Over a period of more than forty years Elliot Eisner has established himself as a good friend to art and design education, to broader debates about the nature and value of educational reform and to educational research. He has presented, on a number of occasions and in

various stages of refinement (Steers 2005), an argument that proposes that arts-based education 'makes vital contributions to education' (Steers 2005: 96). These contributions can be interpreted from both learner and teacher perspectives and include suggestions that the arts teach us:

- to engage in flexible purposing
- to pay attention to relationships
- to exercise the imagination
- to use materials as a medium
- to shape form to create expressive content

(Eisner 2002)

Aspects of these artistic qualities are reflected in the broad organization and emphasis of the art and design special subject modules at the University of Winchester. In particular, the modules encourage a 'purposefully flexible' and 'imaginative approach' to materials, objects and ideas, which we describe as 'playful and inventive', and they encourage paying 'attention to relationships', through looking and noticing. Where Eisner promotes Dewey's (1938) interpretation of 'flexible purposing' (see Eisner 2003), its translation to practice in the arts is relatively straightforward. Students are encouraged during practical activity to maintain an openness and flexibility to their intentions, avoiding the possible limitations of pre-determined outcomes. During 'this process ends shift; the work yields clues that one pursues' (Eisner 2003: 378). Vision plays a key role in these 'shifting aims' where artists remain alert to the nuances of the things they create, making dramatic or subtle changes, and influencing the coherence of the things they produce. Artists 'pay attention to the relationships' of their artistic interventions and actions, as work evolves and takes shape, adopting what Eisner (2002) refers to as a 'rightness of fit' (after Goodman 1978, cited in Eisner 2002) during an evaluative process of review.

In addition, through the 'exercise of the imagination' (Eisner 2002), where artists playfully reinvent and extend their worlds, a further interesting interplay between inventive activity and vision takes place. There is little debate that an education in the arts extends a perceptual sensibility, through extended sensory engagement, but by being imaginative with materials and ideas, by creating and seeing new things, our sense of the everyday is also heightened. Eisner (2002) suggests, 'It is ironic, but the enlargement of life through the arts is a powerful way to see what is lifelike. By making things larger than life or by recontextualising them, reality, whatever it is, seems to be made more vivid' (Eisner 2002: 83).

Artists appear committed to these detailed and panoramic visions, working in ways where they negotiate visual, tactile and spatial relationships as their work unfolds, transforms and emerges. Not only do they pay attention to local detail but to the broader contextual interplay and associations of ideas and materials. Beyond this they remind viewers and audiences to do the same: to pay attention and to notice things, to see the whole and to see its parts. It may be that these ways of noticing provide us with glimpses of what Maxine Greene

describes as 'wide-awakeness, of awareness of what it is to be in the world' (Greene 1995, cited in Eisner 2002: 383). Imaginative activity of this kind serves more than to fulfil the personal needs of artists but offers a socially reforming function in that it 'can liberate us from our indurated habits' (2003: 383).

In many ways, this playful and inventive approach, and emphasis on noticing things is not unusual for an art and design programme. However, we persist with these ideas through their translation to 'artistry', where we encourage these ways of acting and noticing in other contexts, notably primary classrooms. This approach supports the creative and risk-taking professionals the University of Winchester aims to encourage, providing a balance to the often standardized and homogenized processes of schooling, where 'artistry can serve as an important remedy to its mechanisation' (Eisner 2003: 373).

Making connections between these restless imaginative creative practices and the inventive and playful activities of teachers is relatively straightforward and certainly not exclusively formed by the arts. We encourage students to remain flexible and playful, open and adventurous in their thinking and in their teaching practice as they begin to find ways of expanding the sometimes-limiting orthodoxies of schooling. To support and strengthen this argument, it is useful to recognize that while playfulness, creativity and invention are often aims of education programmes, the rationales for these aims can be varied. At times creative and playful activities contribute to an agenda of personal development or well-being. More ambitiously, they can be considered as making contributions to a creative state of mind (Jones 2005), encouraging a critical capacity to engage with communities, in potentially liberating ways, and the reassertion of ourselves as 'makers' (Gormley in Hickman 2005) in apparently already-made worlds. Recognizing and understanding these rationales, enables students and teachers to embed their beliefs more successfully in practice, realizing that being playful, creative or inventive can be a means through which to achieve other significant ends.

Artistry and the connoisseur

A further step in helping students enhance their approaches to primary school teaching is through an extension of ideas of reflective practice. In the spirit of the module, and of other modular experiences, reflection plays a key role in student development, both within the taught sessions and within the assessment activities. To enhance awareness of reflective practice, artistry and 'noticing' remain relevant themes as tools for opening reflective observations and thoughts about practice, which may otherwise remain hidden; they become ways of 'softening' otherwise hardened practices. As our key guide to this discussion, Eisner (1998) is able to offer his notion of the 'connoisseur' to potentially broaden an approach to seeing, or at least to recognize that looking and noticing appear determined by, and contingent upon, a number of factors. Finding new ways of looking at and noticing the actions of learning, the organization of school structures, or the

presentation of a curriculum, demands ways of destabilizing existing approaches of looking, through more artistic interpretations. In this way vision may be potentially alerted to more creative or inventive alternatives.

Eisner's (1998) proposal of the connoisseur suggests that to appreciate the qualities of things, from wine to classrooms, we take information from a broad range of sources. The sources are shaped by social, historical or political relations. For example, when we look at a complex classroom scene we weigh up a range of factors during our observations, we consider our past experiences of children in the similar age range, our knowledge of national expectations or our awareness of local trends or traditions. As such, observation is never just a process of seeing, it builds knowledge gained from experience, reading, reflection, practice and discussion. Eisner suggests, 'Our perception and interpretation of events are influenced by a wide range of knowledge we assume to be germane to that classroom or situation' (1998: 66), an understanding of theory and practice appears to support a more 'differentiated' view of a particular scene. However, the very nature of language's desire to name or label things has the potential to restrict ways of viewing scenes, be they in landscapes or educational settings. For example, naming objects as trees or branches or leaves, can prevent us noticing their differentiated and distinct features.

One of the roles of the artist is to preserve these more carefully observed ways of seeing, to remain aware of nuance and difference. The labels and names we offer in education can equally return very particular ways of seeing things. By describing children and their growing awareness and imaginative representations of the world through terms such as 'levels', 'attainment', 'progress', 'ability', 'sets' or 'next step targets' can result in their more subtle but perhaps more significant contributions going unnoticed. 'The very order that they (labels) provide engenders expectations that often impede fresh perception. Labels provide a way of seeing. But a way of seeing is also a way of not seeing' (Eisner 1998: 67). This challenging suggestion puts teachers in a position of trying to find ways of maintaining ways of seeing, as connoisseurs, aware that what we see may already be shaped by experience and knowledge.

Whether we can ever cast off this burden is doubtful, but the suggestion remains that we can go some way to more artistic ways of seeing to enhance the breadth of our vision. 'If the visual arts teach one lesson, it's that seeing is central to making. Seeing rather than mere looking, requires an enlightened eye; this is as true and as important in understanding and improving education as in creating a painting' (Eisner 1998: 1). This 'enlightened' way of seeing can be enhanced through engagement with acts of looking, through the process of making art and through the things produced, as they begin to 'vivify our lived experiences'. The transformation of experiences to objects of art allows us to see things new and fresh and provides a powerful way of noticing. Eisner encourages teachers to explore the narrative of classroom experiences through the lens of the connoisseur, recognizing the relationship between seeing and knowing, in a process of qualitative enquiry. This process is grounded in the experience of the artist, helping to establish and maintain a 'vision of possibilities' (Clandinin 2005).

Learning to notice the overlooked

In the third year of study, art and design special subject study students at the University of Winchester engage in a pivotal module. In many ways its key function is to facilitate a transition, moving students through concerns about their own artistic practice, to enhancing their understanding of primary art and design education through characteristics of their artistic practice, in particular through playful and inventive approaches and broader ways of looking. We take advantage of the broad theme of 'landscapes' as a context for this activity and thinking, describing landscapes as 'locations' and referring to our engagement with them by noticing the 'overlooked'.

The module is described formally as Locations: traditions of landscape and the rituals of place, and involves three broad phases of enquiry. The initial phase introduces students to a number of social and geographical explanations of how citizens see and act in particular locations, and how these behaviours can begin to reduce our awareness of alternatives as they shape the particular lenses through which we experience the world. Through shared reading activities, students engage with a key module text, Meinig's (1977) 'The Beholding Eye: Ten Versions of the Same Scene'. In his introduction Meinig illustrates the challenge of attempting to describe a scene, as viewed by a group of people, reminding us that the group will see some of the same things, but in organizing these things in their heads, will see the landscape very differently.

> It will soon be apparent that even though we gather together and look in the same direction at the same instant, we will not – we cannot – see the same landscape. We may certainly agree that we will see many of the same elements – houses, roads, trees, hills – in terms of such denotations as number, form, dimension, and color, but such facts take on meaning only through association; they must be fitted together according to some coherent body of ideas … Thus we confront the central problem: any landscape is composed not only of what lies before our eyes but what lies within our heads.
>
> (Meinig 1977: 33)

Meinig continues by establishing a catalogue of ways of seeing landscapes presented under the following headings: landscape as nature, habitat, artefact, system, problem, wealth, ideology, history, place or aesthetic. Increasing student awareness towards these social, historical and political contingencies emphasizes the need to find ways of changing our outlook, to shift our thoughts to finding new ways of seeing. To this end investigations are encouraged in a range of locations, which notice the overlooked and make use of an idea where we 'journey with traveller's eyes' (de Botton 2003). In his exploration for *The Art of Travel*, de Botton examines our desire to travel and the challenges and sometimes disappointment this can present. We share some of these tensions with students, recognizing that 'we may be best able to inhabit a place when we are not faced with the additional challenge of having to be there' (de Botton 2003: 23). Realizing that our experiences of

places are at the 'mercy of physical and psychological demands' leads de Botton to explore the ways artists overcome such challenges. We identify John Ruskin urging us to put away cameras and draw the things we are looking at, recognizing detail and capturing beauty; we recognize artists documenting the mundane, photographing autobahn flyovers, and we wonder how our noticing would be enriched if, rather than travel overseas, and face disappointment, we took the advice of de Maistre and 'journeyed around our bedrooms' (de Maistre 1790, cited in de Botton 2003).

These artistic practices remind us, in the second phase of the module, that the arts enable and encourage a sensory awareness of how things are and an imaginative response to what they may become. By engaging with artistry we can remain 'wide-awake' (Greene 1995, cited in Eisner 2002: 383) to different ways of seeing and experiencing the landscapes in which we find ourselves. With this frame of mind, students are asked to produce a small A5 book that explores and represents a particular location or landscape. To support these artistic explorations we engage students with examples of systematic enquiry, often employed by artists, as devices to open up ways of seeing. For example, students make use of rules to generate journeys - in the spirit of Richard Long (an English artist who takes inspiration from and works in landscapes) or the Boyle Family (a family group of collaborative artists known for their three-dimensional casts of the surface of the *earth*) they identify routines to signify times of observation, they recognize the social habits or historic significance of particular places or they employ visual themes to structure investigations. The resulting books provide evidence of sustained enquiry and in some cases a real sense of students noticing things that would otherwise be left half-seen. We find students looking from different perspectives, looking down or up at randomly generated stopping points, inventing narratives within historic traditions of places or reinventing experiences of regularly taken routes by producing 'guidebooks to the overlooked'. There is a real sense of students embracing ways of looking, introduced through reading and discussion and developed through examples of artistic practices. They notice things otherwise not noticed, and they appear to pay attention to the relationships of things in their emerging work through the emphasis on systematic enquiry. It remains an interesting paradox that creative outcomes such as these are generated through strategic processes, where rules and regulating ways of acting force new observations and outcomes. This remains a theme that we extend with students across modules as they think about supporting inventive outcomes for children by establishing boundaries and expectations to learning activities, which, rather than constrain possibilities, can stimulate imaginative responses.

Once reminded of the things that may otherwise go unnoticed, we reflect further on the social, historical and political conditions that come to restrict such viewing, and ultimately acting, in particular landscapes. Matless (1998) explores the ways in which activity in rural landscapes has been governed by convention and often driven by the expectations of social class. This brings to the attention of students the often ritualized habits of landscapes and locations, and we consider further ways of challenging or breaking these conditions. We read about how ramblers protested for rights of access during the 1930s 'mass-trespass' on

Kinder Scout in the Peak District and how the folk musician Ewan MacColl promoted the rights of freedom exercised through outdoor activity beyond the confines of the industrial city. In turn, we explore more urban settings, airports, telephone boxes and supermarkets, through the structure of poetry, adding contradiction within its narrative to upset the habits of these places and resulting in collisions in aisles or unusual conversations with automated checkout facilities. These artistic inventions and visions begin to shift from the expected to the unexpected, from the seen to the noticed. They help students think beyond the normalized and expected conventions of places, through flexible and playful ways of seeing and thinking.

The final phase of the module shifts the location towards the classroom landscape and asks students to do two things: to engage children in activities where *they* begin to notice the overlooked and, as teachers, begin to use their own artistic visions to journey in the landscape of the classroom with fresh ways of seeing things. Where students engage children in processes of noticing the overlooked, we find some imaginative ideas translating to positive classroom practice. Groups of children have mapped routes around their classrooms, identified new places in classrooms to visit, recorded books of textures and surfaces from walks around corridors and drawn things sited above their usual visual focus. In reporting their considerations of school-based art and design, students have been able to see the potential in noticing the overlooked in a range of landscape locations. They have supported these ways of looking with a sense of reflection, recognizing the possibilities in location-based activities of engaging children in experiential and child-led activities. The broader student reflections present a feel for extending their 'vision of possibilities' and embracing the artistic approaches encouraged by Eisner (2002). There is also recognition from students that this is not straightforward and requires a dynamic approach to thinking about teaching and learning, which adopts different approaches to suit different aims and rationales.

Working alongside students during this third-year module has proved to be very encouraging. Although students are sometimes drawn to the security of safer and less adventurous activity, they regularly tackle the challenges of the unknown head-on and produce work to high standards with a carefully considered reflective feel. Perhaps, most importantly, they enhance their professional development with positive approaches to learning activities, showing a willingness to try things out in open ways, maintaining a more considered outlook, aware of the limitations presented by particular ways of seeing and doing things. The role of 'artistry' in supporting the construction of an ITE special subject experience has secured a strong foundation within a well-established culture of reflective practice.

At his most ambitious and speculative, Eisner's (2003) reconceptualization of education serves the 'preparation of artists', through his advocacy of the processes of thinking and acting that artistry supports. Although we have only explored a sample of these modes of operating, we can begin to see in them their potential in supporting artistic ways of approaching classrooms, which might in turn generate the artists Eisner is suggesting.

Where teachers embrace these qualities and translate them to their classrooms, artistry has the potential to form a new vision for education, liberating us from habitualized practices and valuing 'surprise', 'exploration', 'distinctiveness' and the 'quality of the learning journey'. This encourages the journey to be seen through travellers' eyes rather than accounted for by the efficiency of its speed, and allows opportunities to recognize and value things that may otherwise remain overlooked.

References

Addison, N. and Burgess, L. (eds) (2000), *Learning to Teach Art and Design in the Secondary School*, London: Routledge Falmer.

Addison, N., Burgess, L., Steers, J. and Trowell, J. (2010), *Understanding Art Education: Engaging Reflexively with Practice*, London: Routledge Falmer.

Clandinin, D. J. (2005), *A Vision of Possibilities,* in P. B. Uhrmacher and J. Matthews (eds), *Intricate Palette: Working the Ideas of Elliot Eisner*, Upper Saddle River, NJ: Pearson, pp. 163–182.

De Botton, A. (2003), *The Art of Travel*, London: Penguin.

Dewey, J. (1938), *Experience and Education*, New York: Macmillan.

Eisner, E. W. (1998), *The Enlightened Eye: Qualitative Inquiry and the Enhancement of Educational Practice*, Upper Saddle River, NJ: Prentice Hall.

—— (2002), *The Arts and the Creation of Mind*, London: Yale University Press.

—— (2003), 'Artistry in Education', *Scandinavian Journal of Educational Research*, 47: 3, pp. 373–384.

Goodman, N. (1978), *Ways of World Making*, Indianapolis: Hackett.

Greene, M. (1995), *Releasing the Imagination: Essays on Education, The Arts and Social Change*, San Fransisco, CA: Jossey-Bass.

Hickman, R. (2005), *Why We Make Art and Why it is Taught*, Bristol: Intellect Books.

Jones, S. (2005), *So Giotto Drew on Rock: Children's Right to Art and Everyday Democracy*, available from www.demos.co.uk/publications/sogiottodrewonrocks. Accessed 11 May 2011.

Matless, D. (1998), *Landscape and Englishness*, London: Reaktion.

Meinig, D. W. (1979), 'The Beholding Eye: Ten Versions of the Same Scene', *in* D. W. Meinig (ed), *The Interpretation of Ordinary Landscapes,* New York: Oxford University Press, pp. 33–48.

Salmon, P. (1995), 'Experiential Learning', in R. Prentice (ed.), *Teaching Art and Design: Addressing Issues and Identifying Directions*, London: Cassell, pp. 22–28.

Steers, J. (2005), 'Eisner in the United Kingdom', in P. B. Uhrmacher and J. Matthews (eds), *Intricate Palette: Working the Ideas of Elliot Eisner*, New Jersey: Pearson, pp. 91–101.

TDA (2008), *Professional Standards for Qualified Teacher Status* (QTS), Training and Development Agency (TDA) for Schools.

Chapter 14

Mirror Mirror: Experiential Workshops Exploring 'Self' in Social Work Education and Practice

Debbie Amas, Judy Hicks and Roxanna Anghel
(Anglia Ruskin University)

Teaching context

Social work education is entering a new phase of reform with an agenda to equip a capable workforce with skills to deal with the demands of relationship-based work with people who may be either vulnerable, dangerous and in need of effective safeguarding action. Much has been written about the importance of critical reflection in developing an emotionally resilient social workforce (Howe 2008; Ferguson 2005, 2011; White et al. 2006; also see D'Cruz et al. 2007; Fook 2002, 2004; and Morley 2008 on the importance of reflexivity in social work).

This case study explores a pilot programme at Anglia Ruskin University to deliver and evaluate the impact of creative arts approaches in helping social work students explore concepts linked to the unpredictability of practice. There were 5 workshops consisting of a self-selected group of undergraduate social work students. The sessions were held in a community centre off campus, providing an 'alternative' classroom location. We wanted to offer an appropriate environment for experiential learning, which in our view, requires a degree of privacy, quiet and space for creative activities. A model of creative groupwork provided the theoretical framework to support our teaching and learning methods (Benson 2001). There were two lecturers who worked as co-facilitators and one researcher who was a participant observer. The students gave their written consent to share the dissemination of this work, including the photographs in this chapter.

Professional context

Current literature on social work indicates that successive performance-controlled solutions to big problems such as child abuse have resulted in a major decrease in service-user contact and direct work skills. The Social Work Reform Board (SRB), formed from the Social Work Task Force Report (2010), and the initial reports commissioned by the new coalition government on Child Protection Services (Munro 2010a, 2010b) all point to over-burdened performance and management systems that take social workers away from their relational work and leave them unprepared for the emotional impact of cases:

> [P]revious reforms have concentrated too much on the explicit, logical aspects of reasoning and this has contributed to a skewed management framework that undervalues

the intuitive reasoning and emotions and thus fails to give appropriate support to those aspects.

<div align="right">(Munro 2010a: 35)</div>

The emphasis placed on outcomes in management supervision, rather than through focus on process, have heavily eroded a sense of the 'professional' self (Urdang 2010; Howe 2008). Much hinges on the balance between evidence and competency-based approaches and critically reflective approaches, to form what Knott and Scragg (2008) term the 'Informed Reflective Practitioner'. Crucial to our study is how creative arts can promote reflective educational processes to deepen an understanding of self and relational work (Simons & Hicks 2006). In his analysis of the Laming report into the death of Victoria Climbié, Ferguson (2005) points out what happens when we abandon an examination of inner processes in what are essentially relationship-based activities. Howe (2008) portrays the essential elements of the emotionally intelligent social worker as one who has a rounded sense of the personal and professional self within ethically sound practice. It is our contention that this learning relates to abstract concepts not easily taught in the classroom.

Intentions and objectives of the programme

The authors believe that an examination of inner processes is the key to effective critical reflection, which can be successfully accomplished experientially using the power of creative arts. Our intentions derive from our own experiences and training in creative arts that have brought us to a sense of praxis, the embodiment of skills, theory and practice (Banks 2006; Freire 1970). In order to mirror this process for the students, we extrapolated four emotional cornerstones of inter-relational work to address in our workshops – fear, risk, uncertainty and empathy – each linked to a creative arts activity. Our objective was to explore these themes in order to enhance critical reflection, awaken emotional intelligence and therefore build resilience (Howe 2008; Smith 2006; Ruch 2000; Kinman & Grant 2011). We also wanted to evaluate the effectiveness of creative arts approaches and their potential as new learning methods in social work education.

Types of activities

The activities included movement, visualization, painting, mask and story, sand tray and a final session focussed on evaluation, using a focus group and experiential methods of evaluation. At the end of each session students were given time to reflect and write in a journal that we provided and they kept at home. Some examples of the interconnectedness

between these activities and the students' learning are explored in the remainder of this chapter.

Movement

The movement element of the sessions in the programme created both the imaginative links between the art forms and the invisible thread that wove the experience together for the students. Van Manen (1990) describes retrospective reflection – or what Schon (1983) describes as 'reflection-in-action' – as 'the systematic attempt to uncover lived experience' (10). So we used creative movement as a process for uncovering and then encouraging each student to describe and explain their lived experience through motion. Movement, one of the oldest forms of human communication, can provide a medium for the individual to connect their life in a personally meaningful manner and involves kinaesthetic perception and other sensory modalities that are vital for healthy experiential learning. As one of the key aims of social work education is to foster a high level of critical reflection and reflexive analysis, both requiring engagement of the 'self', then surely creative movement must be an effective bridge into this other world of knowing the self (Chodorow 2000; Picard 2000). If, as Ixir (1999) and others (Dewey 1974; Kolb 1984; Schon 1987; Allen 1995) have suggested, the trigger for reflection happens at a moment of not knowing or of uncertainty, then engaging the students in a movement session would allow them to experience some of this 'not knowing' using a different framework, and one in which their experiences of learning would be embodied. Movement and dance open the way to this other form of knowing, one that invites a kinaesthetic intelligence (Gardner 1999; Levy 1995; Simons & Hicks 2006). This connects to a new interest in movement in the social sciences that is known as the study of 'modalities', which is linked to the movement of people, bodies, information, cars, walking and driving, all elements of everyday social work practice but neglected in social work literature (Ferguson 2009).

So we aimed to enable the students to explore this 'other world' of their own narrative, by using a grounding exercise at the start of each session. This way they began with a sense of embodiment, of learning about their physical centres, their own breathing rhythms and their own felt experience of tension and stress (Vetter et al. 2011; Halprin 2000). Encouraging each student to develop a sense of their own physicality built a stronger sense of the 'self' and hence a greater ability to trust their own process of moving, allowing in turn for greater freedom of expression. Moving and freezing in interesting shapes adds to the sense of fun and experimentation supporting this purely physical exploration.

A movement conversation in pairs follows – a gentle back-to-back exploration aided by relaxing music and qualities of rolling, swinging, rocking – and begins to build relationships

of trust within this new classroom. The students not only expressed relief at new levels of relaxation, they also had made physical contact with each other, requiring them to listen and respond to their internal dialogue. Confidence in the process gave students freedom to take risks, and deepen reflection for their journals. It may enable students to feel safer to explore the theoretical elements of the course (Simons & Hicks 2006), making connections between the affective and cognitive forms of learning. Developing sensory awareness in this way may help to promote independence of thought, concentration and focus (Warren 1984; Halprin 2000), all prerequisites for learning to become a creative practitioner.

So, in the central peak of the movement session, individuals created their unique dances that help to clarify, extend and define an emerging sense of self. Gradually these evolve into a group composition, from the individual to the collaborative, from a singular space to a collective space, from linear patterns to a spiral suggestive of interwoven themes and memories. Students were laughing, having fun, testing themselves, using all the levels of reflection, expanding spatial awareness and expressions of surprise and pleasure were abundant. A deep sense of empathy grew out of the resting shape like an amoeba running over the classroom floor (see Figure 1). Students expressed release, joy and openness in their exchanges about their dance creation.

Visualization

The use of guided visualizations in education has been explored by Hall et al. (1990) as a way to reconnect with the senses via the imagination. Hall suggests that this process sharpens the students' readiness for learning as it accesses unconscious stored memories and pictures often untapped by traditional methods. We wanted to link the imagination with unconscious memories, possibly from childhood, but certainly from a time where sensations could be experienced, and then 'lived in' during the session.

We used visualization so students could reflect on the impact of engaging with families in the home setting. Social work is an activity that takes place in peoples' homes, but, as Ferguson (2009) points out, it is the home visit that is generally ignored as an area of study in social work courses. Within the home, sights, sounds and smells mingle as a raw stew of senses, the very place where memory and emotions are stirred. Students must make sense of home situations and use their skills to sift out meaningful data: what am I observing here? Is the child safe? What are the risks to myself and others? What kinds of standards, impressions and values am I using and are they ethical? On a deeper level of consciousness, personal values may bring inert prejudices derived from the student's own past experiences. It is in these home settings that students must find strengths to make sound judgements and timely decisions that may have a profound impact on a child and families future. Social work commentators (Ferguson 2011; Munro 2010a, 2010b; Ruch 2000; Howe 2008) are now recognizing the importance of sharpening skills, such

Figure 1: Students create a shape through movement.

as observation, advanced communication and effective crisis management. By engaging the students' imagination we were asking them to reconnect with aspects of their past and to take risks in exploring vulnerabilities and strengths that will influence their practice in relational work. Therefore these experiences are a starting place for exploring fears and uncertainties and beginning the journey of building emotional intelligence and inner resilience.

In the visualization, students were guided through a journey in a garden where the senses were invoked in preparation for the discovery of a room from their past behind a door. Exploring the physical and sensory memory of this special room in a house that evoked a connection with their decision to become social work students, they were then invited to bring a symbolic object, one that represented a particular strength or value to them, back into the classroom. After forming a pictorial memory in their minds they were invited to re-represent the experience in a painting, therefore making an imaginative bridge between their strengths and the uncertainties in their professional journeys. The students then shared their work. An example of a symbolic object generated through this process is the water jug

Figure 2: Paintings of symbols from the visualization.

always full of clean pure water, a cultural symbol for one student of her inner strength and the meaning of this image for her learning (see Figure 2).

Mask and story

Masks interwoven with stories have a long and ancient history transcending cultures as a tool to explore 'self'. They explore characterization either through the physical lens of the mask or the interpretation of the text in a story. Therefore, they can be used to create new meanings and associations that have the potential to inspire learning about 'self' (Jones 2007; Gersie and King 1990). As a mask has a fixed expression, it 'encourages a concentration upon a particular aspect of the self, along with an emphasis on the expression of parts of the self usually denied expression' (Jones 2007: 153). Stories can act as metaphors for self-discovery, evoking strong imagery of adversity and survival. We used both methods to explore learning about resilience and emotional intelligence in order to make a connection with the dangers and risks involved in social work practice. If social work students are unaware of their own unconscious processes and the ways in which these can be mirrored in their professional relationships with service users, there is a possibility of being led into collusive situations, co-dependency and over-identification leading to loss of self-identity and esteem. Ultimately this is a deskilling process, which has been highlighted as a feature of poor practice in serious case reviews (Ferguson 2005; Munro 2010).

Recognizing the importance of avoiding these dangers was part of our intention to offer students a safe experience of learning about their unconscious processes and transforming them through a mirror. As facilitators we took risks in our strategies, understanding that the dynamics of the learner/teacher relationship may itself mirror either the childhood/student relationship or the student/service-user interaction. We discovered that the power balance between the students and ourselves, based on mutual risk and participation, resulted in a more equitable partnership (Freire 1970).

So, the learning in this session created a transformative opportunity for the students to understand how oppression and vulnerability are experienced both internally and in the external realities of practice. The story we chose invoked strong archetype characters who were benign, dangerous, vulnerable and at-risk, evoking inner feelings of hurt, sadness, anger and survival. After listening to the story, the students were invited to put on those masks and costumes that resonated with their emotional responses. Since the 'classroom' was already prepared with props, costumes and a variety of masks, the stage was set for the students to participate in their own story.

Once in full costume and their characters chosen, the students were invited to appear to themselves in the mirror and unravel the mystery of their new character to a facilitator (see Figure 3). The themes that emerged through the characterization revealed that the students experienced a cathartic release of emotion that freed them to reflect on the meaning of the outcomes designed for the session. As facilitators, we used Rogerian humanistic approaches to translate the emotions into cognitive understanding, and embodiment of the learning through the reflective processes in the session (Rogers & Frieberg 1994).

Sand tray

The final experiential workshop prior to the evaluation session involved the sand tray exercise. This method was developed by Margaret Lowenfeld in the 1930s to encourage children to explore themselves and their world through play (see Lowenfeld 1967), and has also been used with adults to integrate experiences. Sand can be used to portray a landscape of social work practice as a reflective tool in practice education (Amas 2007). The sand tray landscape offers opportunities for viewing a situation through new eyes and for bringing unconscious material into the conscious world of practice (Stevens 2004). It can be a deeply reflective learning experience for both the facilitator and recipient by generating movement from stuck places, looking at still images created within fluid sand landscapes.

Our exercise involved the students in creating a landscape in a tray filled with sand and a variety of small objects such as toy animals, small dolls, stones, glass beads and any interesting items that might evoke feelings or memories. These symbolic objects build a concrete picture of a specific experience, which clarifies for the learner the meanings inherent in their landscape. This then increases the depth of understanding and hence the level of reflexivity that the students acquire, preparing them for the challenges of moving into the

Figure 3: A student explores character through mask, costume and story.

practice world. We used the sand tray to explore the student's journey through the workshops emphasizing how resilience enables practitioners/students to manage the stresses of being a trainee social worker. A visualization reminding the students of the four cornerstones of this study guided them towards creating a specific landscape designed to illustrate their particular learning journey. Hence, the symbolic objects were used to shape a picture that represented a snap shot of this journey. They were invited to take photographs of their landscapes to keep as concrete representations of their experiences. For instance, one landscape

Figure 4: A students sand tray work showing reflecting on her personal journey.

(see Figure 4) featured a lion cub in the sand, which represented earlier life in another country. A small Egyptian figure representing a regal woman faced a small mirror in the sand, allowing the student to look back on her life, celebrating its richness. A box of treasure stood in the corner of the sand tray, symbolizing newly acquired skills for practice.

Critical reflection on outcomes

The programme evaluation combined a complimentary mix of traditional focus group discussion, and reflection on the learning for each student, with an artistic activity of a collaborative group painting. This involved students working simultaneously on a large open canvas, after a 'video-rewind' visualization to aid the memory of the detail of the experiences of each workshop. Creating a colourful collage together re-created, for the students, the sensory images of their passage through the workshops. Their reflective diaries were brought in to add to the evaluation.

The main themes outlined at the start of the case study, are explored here in relation to the feedback, both discursive and artistic. In sharing the value of the creative groupwork, students commented on group cohesion, authenticity and an atmosphere that was conducive to participation and learning, for example:

> The creative [format] has an impact on how the group behaves. We are involved here – in seminar we only sit and talk – here we are able to connect with each other.
>
> (Student X)

The groupwork activities also opened communication with figures of authority (the facilitators) leading to more democratic interaction and empowerment for the students; they recalled being given space for self-expression and learning through interaction, observation and feedback.

The movement elements of the programme resulted in outcomes that promoted relaxation, trust, openness and greater connection between the students. Their responses and memories brought to the conscious plane through movement and physical contact enabled creative expression, built relationships, reduced stress, encouraged deeper reflexive processes and thus extended their ability to communicate, grow in self-confidence and self-management: 'Movement relaxes you … it unlocks you and it gives you a relaxed mind to think' (Student 3). Physically it boosted energy levels and helped cognition due to the embodiment of the experiences. One student reported: 'I can imagine much deeper by putting myself in their shoes' (Student 2) – thus making a direct link to the Rogerian concept of an empathic response to others.

Being supported to face fears, and take risks was borne out from the experiences of the mask workshop and the sand tray exercise. The facilitators, both of them lecturers, felt this was in sharp contrast to the lack of challenge in many conventional teaching methods.

> I learned to take risks. I was having this anxiety about involving myself with practice [on observational placement]. I was anxious about whether I was going to be able to do it, how is it going to be … then I remembered – well I have the ability to do it, to take risks, to go through with all. I got this from here.
>
> (Student 1)

The development of resilience, the awareness of the student's strengths to manage challenges and obstacles in the learning environment and in practice was evidenced by this student:

> It was nice to talk about what I was representing through the painting. Because you don't know about your potential strength until you talk about it – if I wouldn't have been resilient, strong, then I wouldn't have been where I am now.
>
> (Student 1)

Current research (Kinman & Grant 2011) indicates that giving students the opportunity to explore concepts such as emotional intelligence using a strengths-focused approach augments resilience, and allowing them time out of the usual classroom activities supports their learning and self-development.

All the creative arts exercises enhanced the students' ability to deepen reflection, and to understand, through experience, the meaning of abstract concepts explored in the study, their interlinking and their practical application. Through engaging holistically, a more extensive self-exploration was triggered and hence a greater ability to look inwards and to see the 'self' as part of the learning partnership was achieved. One of the visualizations triggered these reactions, enabling the students to understand what reflection meant for her.

> The exercise about the garden was very powerful because that's when I felt I understand how to reflect. I had a very strong contact with my thoughts.
>
> (Student 1)

> It strengthened my understanding that I always need to reflect on something … it made me understand not only how important it is to reflect, but that as a social worker you can't do without reflection.
>
> (Student 3)

The term 'reflective practice' is used very commonly in social work education but it is clear from the case study participants that talking about reflection achieves very different outcomes from the creative exercises:

> [S]o a different approach to learning has helped – things I couldn't understand well in class, I can now – talking about reflection theoretically in class – I just had that experience here – and you don't forget it!
>
> (Student 3)

> [V]ery Western way we only concentrate on the theoretical part of it, and nothing else and I think that this is what you've addressed here.
>
> (Student 2)

Thus, the students were enabled to learn from what Yelloly and Henkel (1995) describe as 'conditions of safety and challenge in which unconscious creativity can be brought to bear on problem solving' (48). This relates to Schon's (1987) thoughts on encouraging a cycle of continuous learning that develops not only new educational roles based on partnership with learners, rather than expert/student dynamics, but also on the significance of providing a learning environment in which the fears, uncertainties and challenges of everyday practice can be faced and examined.

Given that this place of uncertainty and fear is inextricably linked to an emotional base that is unique to each individual learner, and, indeed, that as emotions are central to social work at all levels of practice and intervention, it is surprising that there is little engagement with emotions in the social work curriculum (Cameron and McDermott 2007). The theoretical elements tend to have pride of place in the classroom context and the physiological body, imagination and the senses in relation to social work theory have to date remained largely silent even though 'social workers work with bodies and are, themselves, bodies at work' (ibid.: 3).

In our programme, therefore, we aimed to redress this balance, recognizing how unexpressed emotions, both from life experiences and from learning on practice placements, may have an impact on the student's ability to manage and contain (embody) any new and unfamiliar emotions inevitably associated with working with people in distress, crisis or transition. The contemporary debate and changes referred to elsewhere in this chapter are calling for social work students to be better prepared in relation to the realities of practice (Ferguson 2011; Ruch 2000; Munro 2010). However, what has been omitted from all these recommendations is exactly how to achieve these changes and any recognition of the new learning styles required to re-engage students with their emotional and embodied selves. This necessitates a radical shift in classroom pedagogy away from a pure didactical approach towards a focus on experiential learning, which in this particular case study has been cultivated using the creative arts to demonstrate how the classroom can become a place of creativity and inspiration.

References

Allen, P. B. (1995), *Art is a Way of Knowing*, Boston, MA: Shambhala.

Amas, D. (2007), 'We All Love Playing in the Sand: Using Sand Play Therapy in Critical Reflection within Practice Placement', *Journal of Practice Teaching and Learning*, 7: 2, pp. 50–68.

Banks, S. (2006), *Ethics and Values in Social Work*, 3rd ed., Basingstoke: Palgrave Macmillan.

Benson, J. F. (2001), *Working More Creatively with Groups*, 2nd ed., New York: Routledge.

Cameron, N. and McDermott, F. (2007), *Social Work & the Body*, Basingstoke: Palgrave Macmillan.

Chodorow, J. (2000), 'Marian Chace Annual Lecture: the Moving Imagination', *American Journal of Dance Therapy*, 22: 1, pp. 5–27.

D'Cruz, H., Gillingham, P. and Melendez, S. (2007), 'Reflexivity, Its Meanings and Relevance for Social Work: A Critical Review of the Literature', *British Journal of Social Work*, 37: 1, pp. 73–90.

Dewey, J. (1974), *On Education: Selected Writings*, Chicago: University of Chicago Press.

Ferguson, H. (2005), 'Working with Violence, the Emotions and the Psycho-social Dynamics of Child Protection: Reflections on the Victoria Climbié Case', *Social Work Education*, 24: 7, pp. 781–795.

———— (2009), 'Performing Child Protection: Home Visiting, Movement and the Struggle to Reach the Abused Child', *Child and Family Social Work,* 14: 4, pp. 471–480.

———— (2011), *Child Protection Practice,* Basingstoke: Palgrave Macmillan.

Fook, J. (2002), *Critical Social Work,* Sage: London.

———— (2004), 'Critical Reflection and Transformative Possibilities', in L. Davies and P. Leonard (eds), *Social Work in a Corporate Era: Practices of Power and Resistance,* Ashgate: Aldershot.

Friere, P. (1970), *Pedagogy of the Oppressed,* New York: Herder and Herder

Gardner, H. (1999), *Intelligence Reframed: Multiple Intelligences for the 21st Century,* New York: Basic Books.

Gersie, A. and King, N. (1990), *Story Making in Education and Therapy,* London: Jessica Kingsley.

Hall, E., Hall, C., Stradling, P. and Young D. (1990), *Guided Imagery: Creative Interventions in Counselling and Psychotherapy,* London: Sage.

Halprin, A. (2000), *Dance As a Healing Art,* Mendocino, CA: LifeRythmn Books.

Howe, D. (2008), *The Emotionally Intelligent Social Worker,* Basingstoke: Palgrave Macmillan.

Ixir, G. (1999), 'There's No Such Thing as Reflection', *British Journal of Social Work,* 29: 4, pp. 513–527.

Jones, P. (2007), *Drama as Therapy,* 2nd ed., London: Routledge.

Levy, F. J. (ed.) (1995), *Dance and Other Expressive Art Therapies: When Words are Not Enough,* London: Routledge.

Kinman, G. and Grant, L. (2011), 'Exploring Stress Resilience in Trainee Social Workers: the Role of Emotional and Social Competences', *British Journal of Social Work,* 41: 2, pp. 261–275.

Knott, C. and Scragg, T. (2010), *Reflective Practice in Social Work,* 2nd ed., Exeter: Learning Matters.

Kolb, D. (1984), *Experiential Learning: Experience the Source of Learning and Development,* Englewood Cliffs, NJ: Prentice Hall.

Lowenfeld, M. (1967), *Play in Childhood,* New York: Wiley.

Morley, C. (2008), 'Teaching Critical Practice: Resisting Structural Domination through Critical Reflection', *Social Work Education,* 27: 4, pp. 407–421.

Munro, E. (2010a), *The Munro Review of Child Protection: Part One – A Systems Analysis,* UK Government, Department for Education, available at http://www.education.gov.uk/munroreview/downloads/TheMunroReviewofChildProtection-Part one.pdf.

———— (2010b), *The Munro Review of Child Protection: Part Two – The Journey of the Child,* UK Government, Department for Education, available from http://www.education.gov.uk/munroreview/downloads/Munrointerimreport.pdf.

Picard, C. (2000), 'Pattern of Expanding Consciousness in Mid-life Women: Creative Movement and the Narrative as Modes of Expression', *Nursing Science Quarterly,* 13: 2, pp. 150–157.

Rogers, C. and Freiberg, H. J. (1994), *Freedom to Learn,* 3rd ed., Englewood Cliffs, NJ: Prentice Hall.

Ruch, G. (2000), 'Self and Social Work: Towards an Integrated Model of Working', *Journal of Social Work Practice,* 14: 2, pp. 99–112.

Schon, D. (1983), *The Reflective Practitioner: How Professionals Think in Action,* London: Temple Smith.

——— (1987), *Educating the Reflective Practitioner: Toward a New Design for Teaching and Learning in the Professions*, San Francisco: Jossey-Bass.

Simons, H., and Hicks, J. (2006), 'Opening Doors Using the Creative Arts in Learning and Teaching Arts and Humanities', *Higher Education*, 5: 1, pp. 77–90.

Smith, M. (2006), 'Too Little Fear Can Kill You: Staying Alive as a Social Worker', *Journal of Social Work Practice*, 20: 1, pp. 69–81.

Stevens, C. (2004), 'Playing in the Sand', *The British Gestalt Journal*, 13: 1, pp. 18–23.

Urdang, E. (2010), 'Awareness of Self – a Critical Tool', *Social Work Education*, 29: 5, pp. 523–538.

Van Manen, M. (1990), *Researching Lived Experience: Human Science for an Action Sensitive Pedagogy*, London: State University of New York Press.

Vetter, R. E., Myllykangas, S. A., Donorfio, L. K. M. and Foose, A. K. (2011), 'Creative Movement as a Stress Reduction Intervention for Caregivers', *Journal of Physical Education, Recreation and Dance*, 82 (2), 1–58.

Warren, B. (1984), *Using the Creative Arts in Therapy*, London: Routledge.

White, S., Hall, C. and Peckover, S. (2008), 'The Descriptive Tyranny of the Common Assessment Framework: Technologies of Categorisation and Professional Practice in Child Welfare', *British Journal of Social Work*, 39: 7, pp. 1197–1217.

Yelloly, M. and Henkel, M. (eds) (1995), *Learning and Teaching in Social Work: Towards Reflective Practice*, London: Jessica Kingsley.

Chapter 15

The Labyrinth: A Journey of Discovery

Jan Sellers
(University of Kent)

Introduction

The ancient image of the labyrinth appears worldwide, in many cultural and faith contexts. Unlike mazes, labyrinths have a single twisting path to the centre, without walls. Since the 1990s, interest in labyrinths has grown, especially for spiritual and community development. The labyrinth presents a powerful image of journey, a metaphor that can be physically experienced through walking the labyrinth.

Labyrinth workshops and seminars, within and across disciplines, have been offered at undergraduate and postgraduate level, at the University of Kent and elsewhere. Objectives vary, and may include confidence-building; deepening reflection and creativity; exploring life journeys and career aspirations; supporting transition; and building professional values. In this chapter, I present a variety of ways in which labyrinths may be used to deepen the student experience. In so doing, I hope to demonstrate the transformative potential of the labyrinth as a creative teaching and learning resource and as a means of bringing a beautiful and restorative space into the academic environment and into the curriculum: a space for 'meditative and thoughtful learning' (Boys 2010: 136).

The labyrinth, as a resource for Higher Education (HE), brings with it a quality of quietness, a sense of stillness at its heart. As Lane (2006) comments:

> We all need time, not only for reflection, but for relaxation. We need time to renew ourselves, to strengthen our depleted resources. And if this has been true in the past, it has never been more so than in our own time – demanding and greedy as it is. We need silence as an antidote to the clamour, solitude as a barrier against the distractions, and slowness as a cure for the modern speed of life.
>
> (Lane 2006: 65)

The labyrinth can bring us these possibilities.

My own journey of exploration has had many unexpected twists and turns. My present role is Creative Learning Fellow at the University of Kent, within the Unit for the Enhancement of Learning and Teaching and part of Kent's 'Creative Campus' team. The 'Creative Campus' fosters opportunities and raises awareness of creativity at Kent at all levels; the Labyrinth Project has become part of this initiative. My earlier work at Kent focussed on student learning development and student retention and it was in recognition of this work that

I was awarded a National Teaching Fellowship (NTF) in 2005, with scope for a sabbatical and a project of my own choosing.

I had become increasingly aware of, and concerned by, the apparent increase in stress and pressure experienced by both students and staff. Some of the joy and the passion for learning – and the enjoyment, the laughter – seemed to have disappeared from the common experience at university. It is interesting that my own experience of informal learning – in dance – influenced my initial project plans. I joined a class (the Chantraine Dance of Expression) in the 1990s and found this a very affirming experience, lifting the spirits and increasing confidence and inner calm. I was strongly drawn to the balanced nature of each class and in particular, the time for quietness: 'the most important music – which I feel time and time again as a necessity of life itself – is the music of silence' (Chantraine 1998: 50; quotation translated from the French by this author). Might I find other ways in which breathing spaces, thinking spaces, opportunities for quietness, could be nurtured? With NTF funding, I set out to explore creative approaches that might foster a deeper and, I hoped, more joyful approach to learning. I found myself on an unexpected path: discovering, learning about, and working with labyrinths.

Labyrinth or maze?

What is the difference between a labyrinth and a maze? Where mazes have many dead ends, a labyrinth usually has just a single, though convoluted, path to the centre and back again. Mazes often have high walls; labyrinths are usually laid out to enable you to see the whole of the labyrinth at once. This creates a safe space to explore, though concentration is needed to follow the twists and turns of the path. To walk a maze is a confusing experience; a labyrinth is more of a journey of discovery.

Labyrinths have a 4000-year-old history and can be found in many parts of the world. The archaeology and history of labyrinths has been explored in several definitive studies: Kern (2000) and Saward (2003) show labyrinths in many forms and in many cultural and faith contexts including Buddhist, Christian, Islamic, Hindu and other traditions. The pattern appears in many different contexts, from ancient rock carvings to coins, pottery and Roman mosaic floor designs. England has eight of Europe's ancient turf labyrinths, where the pattern is cut into the ground, and there are many rock labyrinths in Scandinavia and elsewhere (Saward 2003).

Though there are many labyrinth designs, the patterns are loosely categorized as either classical (the earliest patterns) or mediaeval, as illustrated in the examples in Figure 1. The mediaeval example, on the right, is the design of the Chartres Cathedral labyrinth, built in the thirteenth century.

We do not know exactly how labyrinths were originally used. There are accounts in mediaeval times of community games and rituals, of prayer and meditation (Artress 2006a; Saward 2003). In the 1990s, Artress began to explore use of the labyrinth for spiritual

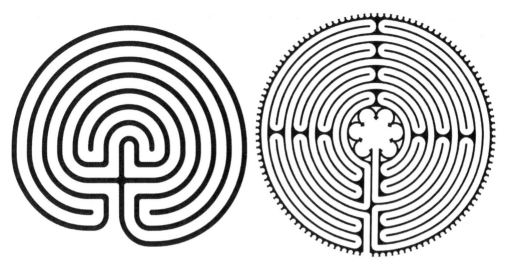

Figure 1: Classical and mediaeval labyrinth patterns (image: Jeff Saward).

development and found that a labyrinth walk can be 'a tool for transformation' (Artress 2006a: 176). It provides a peaceful, sometimes meditative experience with no prior need for experience in meditation. The narrow path requires concentration, allowing the mind to be 'in the present'. The experience refreshes but can also lead to profound insights (in common with meditation), can reduce stress and anxiety and foster creativity (Artress 2006a, 2006b).

A university Labyrinth Project

Before turning to examples of labyrinth workshops, I outline here the practical process through which the Labyrinth Project started and moved forward at the University of Kent. In 2007, I first read about the use of labyrinths at the University of Edinburgh (including the beautiful and permanent Edinburgh Labyrinth) as contemplative space open to all (Fox 2007; Williams 2011). I found few other ongoing labyrinth initiatives in Higher Education in the UK, with the exception of Dundee and East Anglia (Williams 2011; Oldfield 2011). I would like to acknowledge here the generous guidance of labyrinth facilitators, here and elsewhere, who have helped me on this journey. I set out to learn more, and found the experience inspirational. It became clear that the work carried out by Artress and others, exploring the labyrinth for spiritual development, could be taken forward in different ways. I saw clear possibilities for teaching and learning – for example, in fostering quiet reflection – in a secular university context. The labyrinth's international presence in so many faith contexts offered possibilities for use by students and staff of all

faiths and none. At the same time, I valued the possibilities for spiritual development at a personal level, and the scope for a quiet breathing space, in a beautiful setting, that the labyrinth afforded. This seemed to be something with great potential and an idea that I might bring to my own university (Sellers 2008a, 2009, 2010a, 2010b).

These reflections led to the creation of the Labyrinth Project at the University of Kent, in 2007, where a small group of enthusiasts was quickly formed. With the NTF funds, we acquired two, beautifully hand-painted canvas labyrinths: one kept on campus (with the crucial support of senior colleagues to find a central, large venue for use from time to time) and a smaller version (as interest grew) for other campuses and 'on the road' events. We began to experiment, first with labyrinth walks, then workshops and other events, and learned how to create temporary labyrinth installations – from chalk, from masking tape and – memorably – from chicken-feed (chopped corn, Figure 2).

Cost need not be a barrier. It is possible to create labyrinths from anything – from string and ribbons to 'found materials' in nature (see, for example, Buchanan [2007] and Williams [2011]). Further information is available through the Labyrinthos and Labyrinth Society

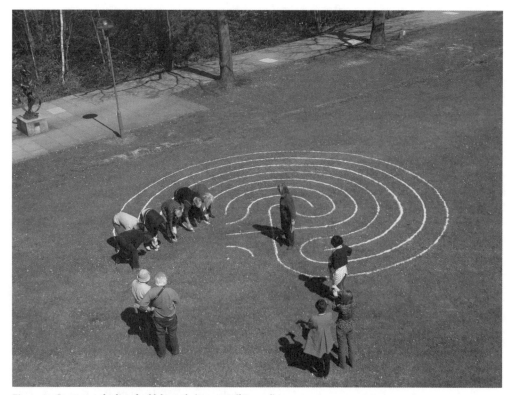

Figure 2: Creating a chicken-feed labyrinth (image: Jeff Saward).

websites (www.labyrinthos.net/layout, including the chickenfeed labyrinth (Saward & Saward 2011) and http://labyrinthsociety.org/). The skill lies in learning to draw the classical pattern. There is something very attractive in learning a 'secret' that is thousands of years old: the heart of the pattern – the 'seed pattern' – can be easily created and expanded to form the labyrinth. In practice, this has enabled presentations of workshops where space would not permit use of our canvas labyrinths. Labyrinth drawing now features as a creative activity in many of my own workshops.

Enthusiasm at the University of Kent grew. With the support of senior management, additional funding was secured. The Canterbury Labyrinth (Figure 3) was built in the summer of 2008, a resource for students, staff and the local community. We believe this to be one of the first labyrinths in the world to be built specifically as a learning and teaching resource. It is also a work of art and a potential performance space.

As the project developed, interest increased in developing expertise in facilitating labyrinth events. In May 2008, four of us trained as labyrinth facilitators with Veriditas, a non-profit organization set up by Artress. This was a powerful experience, a unique form of staff development that proved transformational. We gathered with others in Chartres to undertake a pre-qualifying workshop and a weekend of facilitator training, including the opportunity to walk the Chartres Labyrinth at night. The beauty of this experience will

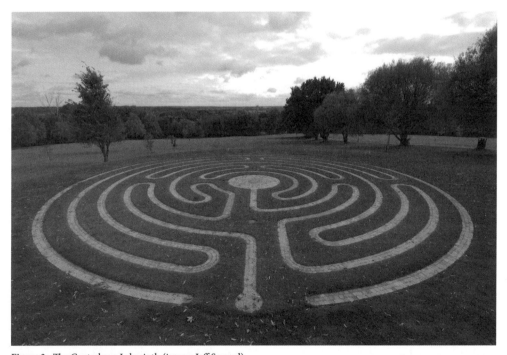

Figure 3: The Canterbury Labyrinth (image: Jeff Saward).

always stay with me. It was a time of emergence: building confidence in my own role and capacities, stepping into an uncertain future. The labyrinth walk can be from time to time a profoundly moving experience.

In 2010, Kent hosted the first Veriditas facilitator training in the UK. A growing number of colleagues at Kent and at other universities have undertaken this training, ranging from academics to counsellors and other student advisors. For information on facilitator training in various countries, see www.veriditas.org.

A labyrinth workshop

I now explore the process and experiences of a labyrinth workshop, followed by specific examples. Most Kent workshops are a collaboration with academic staff, within programmes at undergraduate and postgraduate level. An outline structure might be:

- Introduction
- Historical context (for those new to the labyrinth)
- Placing the labyrinth in context for this particular academic setting
- Exploration of agreed themes
- Practical guidelines for labyrinth walk
- Labyrinth walk and complementary activities
- Shared reflections
- Closing discussion.

There is no right or wrong way to walk a labyrinth: this itself is a real joy, in a context where students so often feel judged. Working alongside colleagues in specific disciplines, I have found that the labyrinth provides a quiet, reflective space within the curriculum: an opportunity for exploration that students and staff clearly value. The labyrinth is presented as a creative opportunity for reflection, with supplementary activities that can be undertaken whilst others are walking the labyrinth. There is no requirement to walk: this would be antithetical to the ethos and spirit of this work, and thus counter-productive. All participants are, however, required to observe two ground rules: to respect the experience of others and, following from this, to maintain the silence of the walk.

The opportunity for silence is an interesting one. I often draw on quiet music to set the scene and to screen background noise, but invite students to maintain silence themselves while they are walking the labyrinth, and while others are doing so. Silence is not necessarily typical of all labyrinth events, but I find that it challenges students in several positive ways. First, the quietness for some is a rare experience, bringing them onto uncertain ground: the challenge of the unknown. Second, the silence supports the process of the walk as a meditative experience with no prior knowledge of meditation being required (discussed further later in the chapter). Finally, silence adds a special dimension to the walk, reinforcing

the message that the labyrinth walk is, quintessentially, time for the individual, time for each person – a gift of time for themselves. In the course of walking, the individual experience is unmediated by others. The experience of silence, or even the expectation of quietness, can be very powerful. Lane notes, reflecting on 'tools for re-enchantment', that

silence can teach us who we are. It can nurture our souls and renew our vision.

(Lane 2006: 97)

Images arise readily during the reflective exercise after the walk; the labyrinth as a metaphor for journey is quickly understood. It is important to enable discussion, but students may well want to take time to reflect on their experience, and to raise questions and share experiences at a later stage, or reserve their experiences for writing. The parallel activities (books, leaflets, table-top (finger) labyrinths and quiet observation) offer opportunities for students to deepen their understanding, including the international and inter-faith nature of the labyrinth (Artress [2006a]; Buchanan [2007]; Curry [2000]; McCullough [2005]; Saward [2002, 2003]; Williams [2011]). Table-top labyrinths always attract interest and are especially useful for blind or partially sighted students and for wheelchair users; with care, the canvas labyrinth is accessible to users of hand-propelled wheelchairs, but not (due to the nature of the fabric) for electric wheelchairs.

The labyrinth is a crafted metaphor, a physical representation of an idea, as well as a real path that takes time to walk. To step onto the labyrinth is a step into the unknown, entering liminal space. A labyrinth pattern is unexpectedly complex, difficult to follow by eye; concentration is needed to follow the path, and this quiet process can be enhanced if walkers keep a relaxed downward gaze (Artress 2006b). The twists and turns of the path hold the mind in the present. Each labyrinth walk is different, for every walker: there is a shared path, but a unique experience. One simple approach to labyrinth walking is to regard it as being in three stages: release, receive, return. The walk-in is about releasing: letting go (of immediate concerns, for example). Time in the centre is about receiving: taking in and absorbing the experience. The way back is a return, and can also be seen as re-integrating: taking the experience back into the everyday world. For more on this and other approaches to labyrinth events, see Artress (2006b) and Curry (2000). Figure 4 shows a labyrinth walk using a portable canvas labyrinth.

Walkers are invited to add their reflections to a Labyrinth Diary. The following anonymous quotations illustrate their experiences:

A really valuable chance to take time out and follow the path. Funnily enough, my supervisor said 'Go for a long walk'. This has been the answer! I've had lots of interesting insights. Thank you!

It gave me time to think and reflect on my own journey as a whole, but also my journey as a student and through different experiences and relationships. It reminded me of yoga in the way that physical movement and repetition allows you to clear your mind.

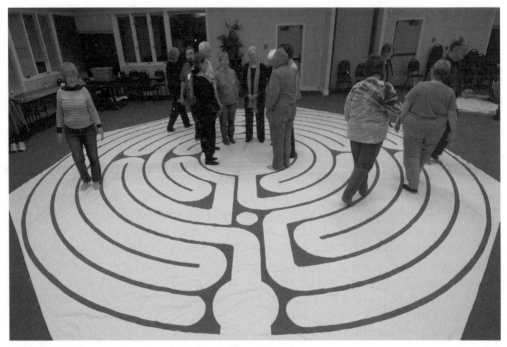

Figure 4: Walking a new canvas labyrinth (image: Jeff Saward).

I wasn't sure what to expect but I really enjoyed my walk around the labyrinth. It gave me time to reflect on some of the decisions I've made recently and have tried not to think about the long-term results. This gave me a chance to think about how I really feel without running away. It was a really helpful, calming and relaxing process, I feel much calmer and refreshed now.

Labyrinth workshops: Practical examples

I outline below some practical examples of labyrinth workshops, drawing on my own experience and those of colleagues at Kent and elsewhere. These have included a number of workshops in the Arts and Humanities, but I focus here on (a) disciplines that might initially seem less likely to be open to such an approach, including Business Administration and Primary Dental Care and (b) student transition. The labyrinth is also a fruitful object of study in a wide range of disciplines, including research projects (for examples of this at postgraduate level, see Rhodes [2008]). Figure 5 is an image from student coursework in a photography module, 'Photography and Intuition', at the University of Kent (Li 2011).

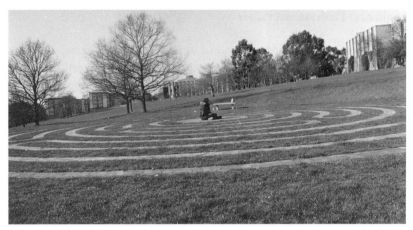

Figure 5: 'Contemplation' (image: Li An Li).

A literature search shows few accounts of teaching and learning with the labyrinth in HE. Examples include Sandor (2005) and White and Stafford (2008) with nursing students; Bigard (2009) exploring student transition; and Goode (in Bannen and Goode 2010) with Law students.

Business administration: Primary dental care

Labyrinth workshops are ideally suited for exploration of some of the deeper questions and challenges facing students, and these events have relevance both within and across disciplines. In leading a workshop for MBA students at City University, Cass Business School, I was asked to focus on deepening reflection and on encouraging student writing in this regard. The venue was an underground gymnasium, a space transformed by the visual impact of the labyrinth. After an introduction to the labyrinth, students were invited to reflect on what had led them to this MBA programme and their aspirations for the future beyond the purely material. Students were invited to walk the labyrinth and, on completion of the walk, wrote and sketched before discussing the experience. One unexpected outcome was the variety of ways in which the labyrinth appeared as a theme in subsequent coursework including final projects for this module.

A workshop with BSc Primary Dental Care students (University of Kent) included a walk on the Canterbury Labyrinth followed by a seminar. With a focus on confidence and developing the professional voice, these final year students shared reflections on the paths that had led them to this programme of study, followed by a thought-provoking discussion of changes they had experienced on the journey and their aspirations for the future.

Inter-disciplinary: Professional values

This conference workshop explored personal and professional values – a theme readily adaptable to many academic disciplines (Sellers 2008b). On arrival, participants found quiet meditative music and a slide show of beautiful labyrinths, drawing them well away from a traditional conference seminar context. We explored a number of issues close to our own hearts, asking ourselves about current pressures on our personal and professional values in HE. We identified the values most important to us, and considered how to sustain these, even in difficult circumstances. Issues and questions were listed. Moving from shared to individual engagement, participants were invited to draw from this list, or to consider their own reflections, through the quietness of a reflective labyrinth walk.

Social work: Law

Bernard Moss at the University of Staffordshire and Victor Goode at Central State University, New York (CUNY Law School), have used the labyrinth within the curriculum in Social Work and Law respectively, where a high level of stress can be anticipated as an occupational issue and is addressed as part of the programme of study. At Staffordshire, students participated in a labyrinth workshop as part of a 'Skills for Social Work Practice' module on dealing with stress, resulting in raised awareness and valuable discussion of stress levels and strategies (Moss, personal communication, 2011). At CUNY Law School, Goode's module 'Contemplative Practice for Social Justice Lawyers' includes labyrinth walks. Goode notes:

> Our goal is to help students learn how to ameliorate stress and develop insight and reflection on their work as lawyers… Our program represents a unique merger between an extension of meditative practice called 'engaged practice' and social justice work. Our program enhances not only our students' desire to do good, but also their capacity to be well.
>
> (Goode, in Bannen and Goode [2010: 8–9])

Student transition

The labyrinth is a valuable resource in supporting student transition, from pre-entry to graduation, including induction and changes of level of study (Bigard 2009). For visits by school children, the labyrinth is an attraction: mysterious, different, engaging. One colleague has used the labyrinth as a basis for story-telling, using the metaphor of journey as children find their way along the path (Lucy Rutter, personal communication, 2011; see Hancock (2007) and McCarthy (2007) on work with children). In a Widening Participation initiative, groups of local women were invited to walk the labyrinth and draw on their reflections as they considered whether university might be part of their future (Jayne Lawson, personal

communication, 2011). Counselling Service colleagues have led a workshop for students about to graduate, to build confidence as they moved towards the unknown: 'The idea is to open the heart and quieten the mind to follow its own story and path (Smith 2010: 11).

Bigard (2009) introduced the labyrinth at Central Michigan University within the First Year Experience Programme and the Academic Assistance Programme, supporting students new to university, mature and non-traditional students and those re-entering university (Bigard 2009: 143–44). As at Kent, 'the walking of the labyrinth was introduced to an entire university community and was thus embraced by several other departments' (Bigard 2009: 146).

Reflections and ways forward

Whether within disciplines or in a broader context, to engage with the labyrinth offers a challenge to students, an encounter with the unexpected. Students are frequently surprised by the inner quietness, and depth of reflection, arising from the walk, commonly recognizing their own need for 'personal space' as an outcome. The walk is often experienced as restorative, with fresh insights gained. More frequent walks may foster problem-solving and creative processes. Some students have taken the initiative and created their own small-scale labyrinths at home. Labyrinth projects are emerging at a growing number of universities; current plans include collaboration to share and pilot transferable teaching materials and ideas.

To embark on a labyrinth project requires one or more members of staff who are prepared to explore such work and develop expertise in labyrinth use. The project at Kent has been much assisted by University support at a senior level, and by access to a labyrinth both indoors and out. Working indoors, it can be a challenge to find rooms large enough; the practicalities of this should not be underestimated. A canvas labyrinth casts its own enchantment on any teaching space, including (in my own experience) a gymnasium, a faded staff-room and a porta-cabin. A labyrinth is, simply, a beautiful artefact: to offer this to students and staff, to share this beauty and to offer close engagement with this work of art, brings its own strengths and rewards, not least as a very visible way of valuing members of our university communities. Though a fabric labyrinth is very practical, it is not essential as temporary labyrinths can be created, either in advance, or by the group as a very satisfying activity that deepens the subsequent experience of a labyrinth walk.

Over the last four years, workshops within a range of academic disciplines and other contexts have illustrated the value of the labyrinth as a powerful and beautiful resource to support teaching and learning in Higher Education. Its potential is considerable. For me, this has been a journey that can readily be reflected in a labyrinth walk: unexpected twists and turns; new viewpoints; travelling alongside others for a while, and often finding myself alone; and a process of taking time, of slowing down and engaging with this work, that has led to a wide range of possibilities, of horizons widening. This has been a convoluted

journey; there is much more that can be undertaken. I will close with the words of one recent labyrinth walker:

A snapshot of the journey of my life, the momentary sensation of being lost, the moment of pure joy.

Acknowledgements

Part of this chapter first appeared in a paper at the Higher Education Academy Annual Conference, University of Hertfordshire, Hatfield, 22–23 June 2010.

Thanks are due to photographers Jeff Saward (www.labyrinthos.net) and Li An Li (contactlianli@gmail.com). 'Contemplation' by Li An Li first appeared in 'If Dreams Were Real', one of a series of bus posters highlighting creativity at Kent (www.kent.ac.uk/creativecampus).

References

Artress, L. (2006a), *Walking a Sacred Path: Rediscovering the Labyrinth as a Spiritual Practice,* revised ed., New York: Riverhead.

—— (2006b), *The Sacred Path Companion: A Guide to Walking the Labyrinth to Heal and Transform,* New York: Riverhead.

Bannen, N. and Goode, V. (2010), 'Navigating Stress on a Demanding Path', *CUNY Law: A Community of Justice* (CUNY Law School magazine) (Fall), pp. 8–9.

Bigard, M. (2009), 'Walking the Labyrinth: an Innovative Approach to Counseling Center Outreach', *Journal of College Counseling,* 12: 2 (Fall), pp. 137–148.

Boys, J. (2010), *Towards Creative Learning Spaces: Rethinking the Architecture of Post-compulsory Education,* London: Routledge.

Buchanan, J. (2007), *Labyrinths for the Spirit: How to Create Your Own Labyrinths for Meditation and Enlightenment,* London: Gaia.

Chantraine, F. (1998), *La Danse de la Vie* (Paroles pour Vivre series), Paris: Cerf.

Curry, H. (2000), *The Way of the Labyrinth: A Powerful Meditation for Everyday Life,* New York: Penguin Compass.

Fox, C. (2007), 'Quiet Space for Retreat If the Spirit Takes You', in *Times Higher Education Supplement* (2 February), available from www.timeshighereducation.co.uk/story.asp?sectioncode=26&storycode=207669. Accessed 29 April 2011.

Hancock, G. (2007), *108 Ways to use Labyrinths in Schools,* 2nd ed., Las Vegas, NV: Hancock and Associates.

Kern, H. (2000), *Through the Labyrinth: Designs and Meanings over 5000 Years,* English ed., New York: Prestel.

Lane, J. (2006), *The Spirit of Silence: Making Space for Creativity,* Totnes, Devon: Green Books.

Li, L. A. (2011), 'Contemplation' (photograph) in 'If Dreams Were Real' (poster series), Canterbury, University of Kent, Creative Campus, at www.kent.ac.uk/creativecampus

McCarthy, M. (2007), *Kids on the Path: A Manual for Bringing the Labyrinth Experience to School Children,* Santa Fe, NM: Labyrinth Resource Group.

McCullough, D. W. (2005), *The Unending Mystery: A Journey through Labyrinths and Mazes,* New York: Anchor.

Oldfield, Steve (2011), 'Welcome to the Labyrinth at UEA', University of East Anglia, available from www.uea.ac.uk/csed/resources/labyrinth. Accessed 29 April 2011.

Rhodes, J. (2008), 'Labyrinth Research Bibliography', in *The Labyrinth Society,* available from http://labyrinthsociety.org/research-bibliography. Accessed 29 April 2011.

Sandor, M. K. (2005), 'The Labyrinth: a Walking Meditation for Healing and Self-care', *Explore: the Journal of Science and Healing,* 1: 6, pp. 480–483.

Saward, J. (2002), *Magical Paths: Labyrinths and Mazes in the 21st Century,* London, Octopus.

—— (2003), *Labyrinths and Mazes of the World: a Definitive Guide to Ancient and Modern Traditions,* London: Gaia.

Saward, J. and Saward, K. (2011), *Labyrinthos,* available from www.labyrinthos.net. Accessed 29 April 2011.

Sellers, J. (2008a), 'Labyrinths in Universities and Colleges', in *The Labyrinth Society,* available from http://labyrinthsociety.org/labyrinths-in-places. Accessed 29 April 2011.

—— (2008b), 'At the Heart of the Labyrinth: Reflecting on Our Values', Staff and Educational Development Association (SEDA) 13th Annual Conference, Birmingham, 18–19 November. See www.seda.ac.uk/confs/birm08/programme2.htm. Accessed 29 April 2011.

—— (2009), 'Exploring the Labyrinth', *Educational Developments,* 10: 1, pp. 15–16.

—— (2010a), 'Teaching and Learning with the Labyrinth' (poster and interview), at Learning Development in HE Network (LDHEN/ALDinHE), 7th Annual Symposium, Nottingham, March. Interview at www.aldinhe.ac.uk/symposium10/. Accessed 29 April 2011.

—— (2010b), 'The Labyrinth: A reflective journey', paper (NTF strand) at Higher Education Academy Annual Conference, University of Hertfordshire, Hatfield, 22–23 June.

Smith, M. (2010), 'The Canterbury Labyrinth', *AUCC Journal* (Association for University and College Counselling) (May), pp. 8–11.

White, M. J. and Stafford, L. (2008), 'Promoting Reflection through the Labyrinth Walk', *Nurse Educator,* 33: 3 (May/June), pp. 99–100.

Willams, D. (2011), *Labyrinth: Landscape of the Soul,* 2nd ed., Iona: Wild Goose.

PART V

Learning Technologies and Assessment

Chapter 16

Alternatives to the Essay: Creative Ways of Presenting Work for Assessment

Emma Bond and Jessica Clark
(University Campus Suffolk)

Experience is the result, the sign and the reward of that interaction of organism and environment which, when it is carried to the full, is a transformation of interaction into participation and communication.

(Dewey 1934: 22)

Introduction

University Campus Suffolk (UCS) is a relatively new initiative for university education in Suffolk (UK). Its commitment to widening participation and the lifelong learning agenda is demonstrated through the diversity of students enrolled on Higher Education (HE) programmes. Students come from a variety of social and educational backgrounds and have a wide range of academic abilities and levels of achievement. Located in the Division of Applied Social Sciences, the courses that we teach adopt a critical stance and aim to provide some challenging ideas on the wide-ranging developments in the fields of sociology, politics, social policy, psychology, anthropology and geography. Modules have a strong academic focus and facilitate a number of important undergraduate academic skills such as reflection, critical thinking and autonomous learning. Contemporary society's knowledge economy calls for graduates to have the ability to 'incorporate information from multiple sources, determine its veracity and make judgements with the view of generating new knowledge or processes and generally includes problem solving, decision making, logical reasoning and creative thinking' (Lee and Ho 2004).

Crucial to this process of learning is assessment (NCIHE 1997). The dichotomy between viewing assessment as a task to be given to students or as a powerful tool for learning (Palomba and Banta 1999) has been the subject of much debate and is a prominent public policy issue (Ewell 2003). Ramsden (2003) discusses the power of assessment to determine the quality of student learning, and this chapter explores our experiences of introducing creative assessment in an undergraduate module. The student perceptions of the assessment as an effective and powerful tool for learning are discussed, drawing on constructivist theories of learning and experiential learning theory.

Assessment practices play a 'subtle, complex and enormously important role in the students' experiences of learning' (Maclellan 2001: 308). While assessment is understood as such in educational theory, in practice it can be easily subjected to reductionist attempts

to measure learning outcomes. However, 'creativity has now entered the discourse in higher education' (Kleiman 2008: 209). Courses at UCS are informed and underpinned by the institution's assessment strategy, which states that 'assessment strategies within a course/route are varied to suit the different learning styles of students and to assess breadth and depth of knowledge and understanding and a wide range of skills' (UCS 2010). Sound knowledge is based on interconnections as 'cognitive growth lies not just in knowing more but also in restructuring that occurs when new knowledge becomes connected with what is already known' (Biggs 2003: 75).

Contemporary HE assessment is subject to multiple pressures, for example, the need to engage in part-time work can turn students into very strategic learners (Bloxham & Boyd 2007). Teaching and assessment methods need to foster active engagement with learning tasks (Ramsden 2003). The use of presentations as a form of assessment in HE has distinct benefits (Petty 2009), however, the dominant use of individual PowerPoint presentations, explored in the subsequent section, can have a negative impact on both the learning and assessment experience of students.

Background to the study

There is a complex interrelationship between effective assessment strategies, course design, structure and learning outcomes (Bloxham & Boyd 2007). Certainly in our experience, the use – or rather *misuse* – of PowerPoint in student presentations has not only challenged the possibilities of effectively measuring knowledge and understanding but also the boredom thresholds of both tutors and students! Maclellan (2001) suggests that if students perceive a need to understand the material, in order to successfully negotiate the assessment they will engage in a deep approach to their learning. In spite of giving timely and detailed guidance and advice to students on delivering effective presentations, all too often students used slides to provide text-dense material that they read from. This can be highly problematic for tutors to assess effectively and the very positive educational principle that underpins the strategy – peer-to-peer teaching/knowledge-sharing is often lost in the monotony of the process.

'Artful teaching requires autonomy' (Anderson 2002: 34). Concerned that very precious opportunities for learning were being lost and to increase levels of student engagement, it was decided to adopt a more creative approach to the presentations. The assessment of a final-year undergraduate module was changed from a presentation to a 'creative presentation' (using art, structure, poetry, song, film, etc.) that encouraged originality, an imaginative approach and to 'think outside of the box'. This change reflects both the proliferation of more diverse and experimental forms of assessment, and multiple forms of knowing within an increasingly culturally and socially diverse HE environment (see Gleaves & Walker 2008: 41) and reinforces the argument that creativity is imperative for adaptive graduates who can balance complexity, innovation and efficiency (Knight & Yorke 2004).

Introducing creative assessment

An important and salient feature of this definition of creativity is creative thinking, which can be thought of as a mental process through which a person generates new and valuable ideas or creates a new invention.

(Ogunleye 2006: 96)

The United Kingdom Quality Assurance Agency (QAA) in 2006 suggested that assessment tasks and associated criteria should be effective in measuring attainment of the intended learning outcomes. Buss (2008: 304) points out that creative assessment has its challenges. The way that assessment is designed, the methods used and the criteria adopted are all mechanisms for enabling and promoting the desirable type of learning (McDowell 1996). QAA subject benchmark statements cover Bloom et al.'s (1956) categories in the cognitive domain of knowledge, understanding, application, analysis and evaluation (Yorke 2002). The challenge is in how these can be constructed to be meaningful, as Poon Teng Fatt (2000) suggests below:

Knowledge objectives emphasise remembering and relating. Also, abilities and skills refer to organised ways of dealing with materials and problems but abilities and skills objectives emphasise the organising of material to achieve a purpose.

(32)

Knight (2002) argues that while assessors look for evidence of achievement, evidence is a teleological concept. The importance of language and articulation to thought and learning seems widely accepted within education (Cheetham and Chivers 2001). However, as McIntosh (2008: 131) points out, '[i]n the process of moving away from "the literal word" to more symbolic approaches to representation, the question shifts to one of interpretation'. MacDougall adds to this by suggesting that '[u]nlike knowledge communicated by words what we show in images ... is a different knowledge, stubborn and opaque but with a capacity for the finest detail' (MacDougall 2006: 6).

The criteria for the module require students to demonstrate knowledge and critical theoretical understanding of the different historical and contemporary constructions of childhood. However, the skill and dispositions of critical thinking that are central to the assessment criteria are outcomes of a singular personal and societal value (Palomba and Banta 1999), and the concept of thinking is itself polymorphous (Knight 2002). According to McDowell (1996) a relevant factor to successful outcomes is whether students receive clear guidance about what was expected and how they would be judged. The importance of exploring assumptions surrounding creative work needs sharing between teachers and students and should be emphasized to avoid commonplace misunderstandings (Shreeve et al. 2000). Students were told that they could use any creative medium they wished for their presentation from the use of visual images, for example, a collage, painting, drawing or sculpture; digital media in the form of film or photography; or an audio/video presentation

or drama, song or poetry. The guidelines also discussed 'performances of understanding' and detailed the benefits for student learning gained from these more innovative presentations.

While the students appeared initially cautious the module grades noticeably rose – not just for the presentation element of the assessment but also for the written critical paper. The informal feedback from the students was also overwhelmingly positive. The quality and range of the presentations improved dramatically – incorporating a wide range of media, for example, films and collections of photographs, sculpture, collage and visual representations to role play, rap and poetry. Entitled '21st Century Childhood', the following poem from that first year offers a wonderful example of Leitch's (2006: 552) observation: 'Writing and traditional forms of enquiry do not completely convey the sense of felt embodied knowledge in the same way that an image, a poem, a sculpture or a play does.'

21st Century Childhood
Is it wrong to pick up a knife?
With which to threaten someone's life?
Is it ok when it's done by a soldier?
Or simply by somebody who is older?
Is violence inherent in all?
But merely not recognised among the small?
Is crime something we fear,
In those of which we rear?
Has crime among children always been known?
Or is it something which has grown? Is the issue new or old?
Does society need to be told?
Has society created this deviant tool?
Out of a person so young and small?
Hoodies, guns, sex, slums
Knives, thieves, the lies they weave
And now in these times of change, where lives rearrange, and youth grasps hold of much which is directed only at the old,
We must not fear or shed a tear
But deal with what has become the childhood of the 21st century.
By Kirsty Martin

Module development – from creative assessment to embedding creativity

The new strategy appeared to be involving students in a more active approach to their learning. Reflecting MacDonald et al.'s (2000) study that assessments, although sometimes viewed by students as 'difficult' and 'time consuming', are by far the most valued learning tools that encourage students to understand the content and the concepts that consolidate

and reinforce learning. The role of reflection is also fundamental to practice (Jarvis et al. 2001), and Minton (2002) discusses using experience and reflecting on experience in order to improve. Critically reflecting on students' experiences of creativity was intended to inform practice further and lead to future developments in both the module and course as a whole.

Unlike cognitive approaches to learning, the experiential learning style is holistic, including perceptual and behavioural as well as cognitive strategies (Boyatzis and Kolb 1995). Drawing on experiential learning theory and the broad understanding that ideas are constantly being formed and reformed by experience, the module encourages such student reflection through discussion and debate on the ongoing blog. The blog provided a space for students to respond to specific formative tasks, upload pictures and photographs and debate lecture topics. New information and communication technologies do not simply provide information for users; instead, 'they carry images, narratives and fantasies that work on the imagination as much as the intellect' (Buckingham 2007: 78) and take advantage of this convergence between technologies, cultural forms and practices. This process of generating and exploring images is discussed by McIntosh as follows:

> Utilising the 'active imagination' process through the development of 'images' acts as a method of data collection. The data are in effect both self-generated and self-collected by the individual who engages in the active imagination process. It is in the act of imagining and the construction of the image that significance and questions resulting out of the reflective reproduction begin to be formulated.
>
> (McIntosh 2008: 141)

Students were asked to generate images of the spaces that they inhabit and use within their daily lives entitled 'My world' and post them onto the blog:

Figure 1.

As MacDougall (2006) argues, images contain much more than just rational thought.

> Images reflect thought and they may lead to thought, but they are much more than thought. We are accustomed to regarding thought as something resembling language … but our conscious experience involves much more than this kind of thought. It is made up of ideas, emotions, sensory responses and the pictures of our imagination.
>
> (MacDougall 2006: 2)

Symbolic interactionism emphasizes the importance of recognizing the individuality and the importance of supporting and enhancing learners self-esteem (Cheetham & Chivers 2001). The importance of contributing to learner confidence with an emphasis on student choice is further reinforced by Rogers's (1969) ideas surrounding the importance of the development of a sense of ownership of learning by the learner. This was facilitated through the extensive use of group discussion both online and face-to-face and is an example of the neo-Piagetian position that cognitive engagements with other students are powerful stimuli for learning and of Vygotsky's analysis of learning as social acts (as discussed by Knight 2002). Gleaves and Walker (2008) argue that many students within HE are not able to see the development of ideas because of issues relating to modularization or time. The use of the module blog was thus imperative in terms of providing a space for students to continuously consider issues. The blog can thus be viewed as a form of ongoing reflective learning.

Creativity itself has often been regarded as an individual activity of self-expression or realization. However, Cropley (2006) argues that it is in fact a socially influenced phenomenon relying on social support networks. 'This recognition can help foster the courage to deviate from what everyone else is doing' (Cropley 2006: 6). The importance of the blog can thus be further emphasized as the provision of space through which the beneficial effects of creativity can be facilitated (Larey and Paulus 1999).

Kolb (1984) outlines learning as a continuous circular process of creative knowledge grounded in experience, while Anderson (2002: 39) suggests that '[c]reativity is not a radical novelty in the sense that it is divorced from what precedes it'. There are, therefore, repeated opportunities for students to discuss both the concepts and topics covered in the module and to reflect, make suggestions and receive advice on ways in which their work may be improved before the summative assessment.

Researching creativity

The qualitative research study took place early in 2011 with a voluntary group of students. The approach emphasizes the fairly wide consensus of qualitative research as a 'naturalistic, interpretive approach concerned with understanding the meanings which people attach to phenomena' (Snape & Spencer 2003: 3). Within this approach '[n]arratives are an appropriate

way in which to capture and understand educational experiences' (Leitch 2006: 549). Through using self-completion reflective diaries and focus-group discussions, the research sought to gain understanding of the students' perceptions and experiences of creative assessment. The synergistic nature of focus groups (Morgan 1997) and individual self-completion diaries have been advocated as effective methodological partners (Kramer 1983). The ontological stance adopted within this project is one that relies upon participant's own interpretations to provide relevant understanding of the research issues, reflecting the multifaceted and diverse nature of the human experience.

The ethical implications of working with students were carefully considered and ethical approval sought from the UCS ethics committee. Students were provided with an information sheet detailing the rationale behind the project, research objectives and proposed methods before they volunteered for the project. The data has been anonymized.

Offering participants the time and tools in the research context provides 'valuable insights into their worlds of experience and meaning making' (Burke 2008: 25). This supports Minton's (2002) perspective of the need to reflect on the learning experiences of the participants, which was in itself beneficial to the learning process. As MacDonald et al. (2000) suggest, the manner in which the learners view, review and critically reflect on their own experiences is central to adult learning.

Findings and discussion

Participants in the research identified unanimously that engaging in a creative presentation was a positive experience that resulted in increased enjoyment of not only the assessment itself but the module in its entirety. They enthusiastically recalled the creative presentations that they had seen – praising the work that had gone into the presentation and the originality of the ideas. The data from the focus groups and diaries provided a range of issues that participants felt were relevant when exploring creative assessment in HE: academic skills and employability; peer collaboration and learning; vulnerability and the presentation of self; and motivation and effort.

Academic skills and employability

Participants in the focus groups were asked how they felt initially about engaging in a creative assessment. The responses varied but apprehension was identified by many:

> Why? Why do we have to do this? We're not art, or, like, photography students. What's the point of it?
>
> (Roxy)

Hated it. [laughs] I did. I found it really hard to, you know, 'think outside the box'.

(Paula)

It was 'creative thinking … as a mental process through which a person generates new and valuable ideas' (Ogunleye 2006: 96) that students expressed they found difficult. The unfamiliarity with creative assessment methods was responsible for the initial anxiety.

However, other students were excited and pleased:

I loved it. I like 'art stuff' and it will up my grade as I'm not good at anything else.

(Jemma)

Jemma felt more confident about engaging in a creative assessment as opposed to, for example, a traditional written essay, as she felt that her abilities were more suited to this type of assessment; reinforcing some of the ideas by Rogers (1969) regarding ownership of learning and the impact of self-esteem on learner engagement and success (Cheetham & Chivers 2001).

Given the choice I would do it all the time.

(Jemma)

Creative skills are key requisite skills in the workforce (Ogunleye 2006), and it was particularly interesting, therefore, that many of the students (who often enter teacher training after graduation) were quite adamant that the different types of skills involved would benefit them both during the course and as graduates. Making a comparison to PowerPoint presentations, Clara stated:

Teaching 5 year olds isn't done with PowerPoint is it? Being creative and flexible is what makes a good teacher, you can't just read off slides can you?

(Clara)

The role of creativity and creative thinking as higher-order skills essential for graduates to succeed in the workplace is evidenced in the existing literature (Knight & Yorke 2004) and further reinforced by the participants.

I don't think that those '1st' students are necessarily 'the best', the academic ones that can write really well are not the ones that'll make the best teachers.

(Clara)

Creative assessments were seen by participants as allowing them to demonstrate a range of different but equally – if not more so – relevant skills; appropriate to both their success upon the module and degree and also within wider society.

Peer collaboration and learning

Cropley's (2006) argument that creativity is not just an individual endeavour but a social activity was further reinforced by the findings. Participants expressed enjoyment in watching and being part of other student's creative assessments. These ranged from performances and monologues to sculptures, photography, art and poetry. Students identified that despite some similar topics being chosen, all of the presentations were completely different and the monotony of watching endless, very similar PowerPoint presentations was avoided, and instead they become valuable learning opportunities.

> This is a module where I learned something new every single week, it's completely different to anything else we do.
>
> (Clara)

By engaging with assessments individually and by being part of or exposed to other student's work, the idea of assessment as an integral part of learning is further developed (Huddleston & Unwin 1997: 112).

> There are so many choices! I would change my ideas all the time and learned and got ideas from watching all the others.
>
> (Paula)

The diversity in creativity is illustrated in the example below:

Clara's presentation was a monologue where she played a fourteen-year-old girl discussing the risks and benefits of children's use of online spaces.

Figure 2.

Frieda's construction of a 'house' sculpture where each brick represents a different way in which the media is involved in children's and young people's private or home domains (both pictured below) are just two examples of the wide variety of creative presentations

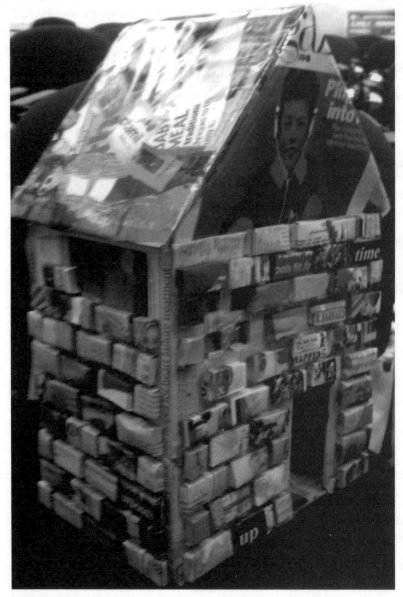

Figure 3.

Paula's work (pictured below) compared the United Nations Convention on the Rights of the Child (UNCRC) with the African Charter reflecting issues that she found to relevant to the course but also pertinent to her own life experiences and commitments:

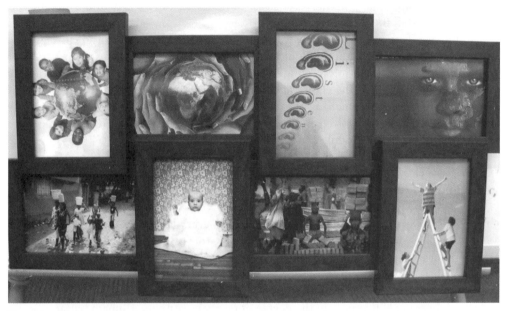

Figure 4.

Motivation and effort

The participants stated that they found the creative presentations an exciting endeavour that encouraged them to work harder.

> It's more involved, I remembered loads more stuff and did much more research.
>
> (Paula)

> I found loads of different kinds of resources, newspapers, YouTube videos, you know.
>
> (Roxy)

The students identified that the work and effort they put into the creative presentation made completion of the associated critical paper easier.

> I reckon I did twice as much research than I would have done usually, so when I come to write the critical paper – I'm about half way – I remember loads more.
>
> (Clara).

Maclellan's (2001) argument that, if students perceive a need to understand the material in order to successfully negotiate the assessment, they will engage in a deep approach to their learning is pertinent here. We suggest that by requiring students to do more than just tell us what they know (Biggs 2003), through a creative assessment they engage in a deeper approach to learning that is both beneficial for the student's experiences of the module and their success within the assessment itself.

The independent nature of the assessment provided students with a great degree of flexibility and choice. This autonomy allowed students to engage in creativity in a variety of ways with different students interpreting and engaging in the different categories of creativity (see Boden 2001: 96–97). The choice and autonomy encouraged with creative assessment allowed learners to conceptualize and use definitions of creativity in different ways. They saw the research process involved as more thorough and they saw themselves as being more involved within both the module and the assessment.

Reflections and conclusions

Creativity is a word 'constantly being encountered in everyday life' (Ruhammar and Brolin 1999: 259). This enquiry has attempted to explore the role of creativity in assessment within Higher Education. Our approach offers 'an alternative to the behaviourist approach to learning' (Buss 2008: 303) and reflects the shift towards reflective student-centred approaches to learning in HE (Cowdroy & de Graff 2005).

Indeed there are 'differences in the degree of people's creativity' (Ruhammar and Brolin 1999: 270) but, in spite of this diversity, adult learners share common characteristics and have expectations about the learning process with their own set patterns of learning (Rogers 1996). The five central processes that underpin successful learning include wanting to learn; needing to learn (motivation); learning by doing; getting feedback on how the learning is going; and making sense of what has been learnt (Race & Brown, 1998). The participants in our research identified how the creative presentations allowed them to get excited and be motivated by the assessment itself, and as a result they felt they had worked harder and gained more by engaging with them.

Learners vary in how they absorb information and how they transform information into meaning (Kolb 1984). There is a relationship between the different learning styles and teaching and learning strategies (Buch & Bartley 2002). The data presented here suggests that the degree of autonomy and choice involved in completing a creative assessment results in flexibility in the approach, which is inclusive of learning styles and needs.

Our research suggests that combinations of creative methods promote constructive engagement with learning activities that lead to changes in understanding. According to the principles of andragogy, 'the art and science of helping adults learn' (see Knowles 1980: 43), adults are viewed as taking responsibility for determining their own skill agenda and their self-concept moves from dependency to self-directing. As Entwistle and Smith (2002: 338)

point out, 'personal understanding is essentially a developmental concept', and encouraging student understanding of different perspectives and theories within the module through creative assessment capitalizes on this ability and further enhances an ability to synthesize information and the analytical and evaluative skills essential to successful learning and future employability.

The role of creative presentations should not be underestimated, as the process by which students come to reach deeper approaches to learning can be facilitated by engaging in the representation of meaningful knowledge. Yorke (2002: 156) argues that 'assessment tends to be a pragmatic exercise that is primarily informed by custom and practice'. The creative approach adopted here encouraged both students and staff to 'think outside of the box' and be more flexible and autonomous in their approach to assessment.

References

Anderson, D. R. (2002), 'Creative Teachers: Risk, Responsibility and Love', *Journal of Education*, 183: 1, pp. 33–48.

Biggs, J. (2003), *Teaching for Quality Learning at University*, 2nd ed., Buckingham: Open University Press.

Bloom, B. S., Englehart, M. D., Furst, E. J., Hill, W. H. and Krathol, D. R. (1956), *Taxonomy of Educational Domain of Educational Objectives: The Classification of Educational Goals*, New York: David McKay.

Bloxham, S. and Boyd, P. (2007), *Developing Effective Assessment in Higher Education*, Maidenhead: Open University Press.

Boden, M. A. (2001), 'Creativity and Knowledge', in A. Craft, B. Jeffrey and M. Leibling (eds), *Creativity in Education*, London: Continuum, pp. 95–102.

Boyatzis, R. E. and Kolb, D. A. (1995), 'From Learning Styles to Learning Skills: the Executive Skills Profile', *Journal of Managerial Psychology*, 10: 5, pp. 3–17.

Buch, K. and Bartley, S. (2002), 'Learning Style and Training Delivery Mode Preference', *Journal of Workplace Learning*, 14: 1, pp. 5–10.

Buckingham, D. (2007), *Beyond Technology: Children's Learning in the Age of Digital Culture*, Cambridge: Polity Press.

Burke, C. (2008), 'Play in Focus: Children's Visual Voice in Participative Research', in P. Thompson (ed.), *Doing Visual Research with Children and Young People*, Oxon: Routledge.

Buss, D. (2008), 'Secret Destinations', *Innovations in Educational and Teaching International*, 45: 3, pp. 303–308.

Cheetham, G. and Chivers, G. (2001), 'How Professionals Learn in Practice: an Investigation of Informal Learning amongst People Working in Professions', *Journal of European Industrial Training*, 25: 5, pp. 248–292.

Cowdroy, R. and de Graff, E. (2005), 'Assessing Highly-creative Ability', *Assessment and Evaluation in Higher Education*, 3: 5, pp. 507–518.

Cropley, A. (2006), 'Creativity: A Social Approach', *Roeper Review*, 28: 3 (Spring), ID: 02783193.

Dewey, J. (1934), *Art As Experience*, New York: Berkley.

Entwistle, N. and Smith, C. (2002), 'Personal Understanding and Target Understanding: Mapping Influences on the Outcomes of Learning', *British Journal of Educational Psychology*, 72, pp. 321–342.

Ewell, P. T. (2003), 'Assessment (Again). (Measuring Academic Achievement)', *Change*, 35: 1, pp. 4–6.

Gleaves, A. and Walker, C. (2008), 'An Exploration of Students' Perceptions and Understandings of Creativity as an Assessment Criterion in Undergraduate-level Studies within Higher Education', *Irish Educational Studies*, 27: 1, pp. 41–53.

Huddleston, P. and Unwin, L. (1997), *Teaching and Learning in Further Education Diversity and Change*, London: Routledge/Falmer.

Jarvis, P., Holford, J. and Griffin, C. (2001), *The Theory and Practice of Learning*, London: Kogan Page.

Kleiman, P. (2008), 'Towards Transformation: Conceptions of Creativity in Higher Education', *Innovations in Education and Teaching International*, 45: 3, pp. 209–217.

Knight, P. T. (2002), 'Summative Assessment in Higher Education: Practices in Disarray', *Studies in Higher Education*, 27, 3, pp. 275–286.

Knight, P. and Yorke, M. (2004), *Assessment, Learning and Employability*, Buckingham: Society for Research into Higher Education (SRHE)/Open University Press.

Knowles, M. S. (1980), *The Modern Practice of Adult Education*, New York: Cambridge Books.

Kolb, D. (1984), *Experiential Learning Experience as a Source of Learning and Development*, London: Prentice Hall.

Kramer, T. (1983), 'The Diary as a Feminist Research Method', *Newsletter of the Association of Women in Psychology*, Winter, pp. 3–4.

Larey, T. S. and Paulus, P. B. (1999), 'Group Preference and Convergent Tendencies in Small Groups: a Content Analysis of Group Brainstorming', *Creativity Research Journal*, 12, pp. 175–184.

Lee, T. S. and Ho, T. P. (2004), 'Teaching Thinking Skills in E-Learning: Application of The Bloom's Taxonomy', in C. Looi, D. Jonassen and M. Ikeda (eds), *Towards Sustainable and Scalable Educational Innovation Informed by the Learning Sciences*, Amsterdam: IOS Press, pp. 678–681.

Leitch, R. (2006), 'Limitations of Language: Developing Arts-based Creative Narrative in Stories of Teachers' Identities', in *Teachers and Teaching: Theory and Practice*, 12; 5, pp. 549–569.

MacDonald, C. J., Gabriel, M. A. and Cousins, J. B. (2000), 'Factors Influencing Adult Learning in Technology-based Firms', *Journal of Management Development*, 19: 3, pp. 220–240.

MacDougall, G. (2006), *Film, Ethnography and the Senses: The Corporeal Image*, Princeton: Princeton University Press.

Maclellan, E. (2001), 'Assessment for Learning: the Differing Perceptions of Tutors and Students', *Assessment and Evaluation in Higher Education*, 26: 4, pp. 307–318.

McDowell, L. (1996), 'Enabling Student Learning Through Innovative Assessment', in G. Wisker and S. Brown (eds.), *Enabling Student Learning Systems and Strategies*, London: Kogan Page, pp. 158–165.

McIntosh, P. (2008), 'Reflective Reproduction: a Figurative Approach to Reflecting in, on, and about Action', *Educational Action Research*, 16: 1, pp. 125–143.

Minton, D. (2002), *Teaching Skills in Further and Adult Education*, London: Macmillan.

Morgan, D. L. (1997), *Focus Groups as Qualitative Research*, 2nd ed., Thousand Oaks: Sage.

NCIHE (1997), *Higher Education in the Learning Society Report of the National Committee (1997)*, London: HMSO.

Ogunleye, J. (2006), 'A Review and Analysis of Assessment Objectives of Academic and Vocational Qualifications in English Further Education, with Particular Reference to Creativity', *Journal of Education and Work*, 19: 1 (February), pp. 95–104.

Palomba, C. A. and Banta, T. W. (1999), *Planning, Implementing and Improving Assessment in Higher Education*, San Francisco: Jossey-Bass.

Petty, G. (2009), *Teaching Today: A Practical Guide*, 4th ed., London: Nelson Thornes.

Poon Teng Fatt, J. (2000), 'Understanding the Learning Styles of Students: Implications for Educators', in *International Journal of Sociology and Social Policy*, 20: 11/12, pp. 31–45.

QAA (2006), *Code of Practice for the Assurance of Academic Quality and Standards* in *Higher Education section 6 Assessment of students September 2006*, available from http://www.qaa.ac.uk/academicinfrastructure/codeOfPractice/section6/COP_AOS.pdf. Accessed 18 March 2011.

Race, P. and Brown, S. (1998), *The Lecturers' Toolkit*, London: Kogan Page.

Ramsden, P. (2003), *Learning to Teach in Higher Education*, 2nd ed., London: Routledge.

Rogers, A. (1996), *Teaching Adults*, 2nd ed., Buckingham: Open University Press.

Rogers, C. (1969), *Freedom to Learn*, Columbus: Charles Merill.

Ruhammar, L. and Brolin, C. (1999), 'Creativity Research: Historical Considerations and Main Lines of Development', in *Scandinavian Journal of Educational Research*, 43: 3, pp. 259–273.

Shreeve, A., Vaughn, S. and Kelly, C. (2000), 'What Do You Mean Creative? Staff and Students' Conceptions of Creativity', Paper presented at the 1st Northumbria Creativity Conference, August, Northumbria University, Newcastle.

Snape, D. and Spencer, L. (2003), 'The Foundations of Qualitative Research', in J. Ritchie and J. Lewis (eds), *Qualitative Research Practice*, London: Sage, pp. 1–23.

University Campus Suffolk (2010), *Assessment Strategy*, available from http://www.ucs.ac.uk/About/Ourpolicies/StudentPolicy/AssessmentStrategy.pdf. Assessed on 18 March 2011.

Yorke, M. (2002), 'Subject Benchmarking and the Assessment of Student Learning', *Quality Assurance in Education*, 10: 3, pp. 155–171.

Chapter 17

Creativity-mediated Training, Social Networks and Practitioner Enquiry in Higher Education

Jouaquin Paredes
(Universidad Autonoma de Madrid)

Agustin De La Herran and Daniel Velazquez
(Universidad Nacional Autonoma de Mexico)

Introduction

This chapter explores how to renew teaching and continuing teacher training by building an online network among teachers, applying Higher Education student-centred practices with creativity in a virtual community.

We present our view of continuing teacher training where teachers are brought together in a virtual community. This Action Research (AR) process involves teachers from all domains who made innovations to their courses in a traditional Mexican university, and shared their educational findings with colleagues. The results are modest for now. We will show the process and techniques, discuss possible explanations for results and recommend changes for the future.

Accelerating changes with creativity

Change in university education has several accelerators, such as training through creativity, collaborative learning, educational innovation projects and information and communications technology (ICT) (Hoban 2002; Clegg 2008; James 2009).

Creativity is an attractive motivator. For us, creativity is a characteristic of knowledge (Herrán 2008a, 2008b). In consequence, creativity is a way of structuring student-teacher relationships. Creativity-mediated training fosters integral education, not just creativity.

Reflections on collaborative learning and innovation projects are accelerators when they address change to some aspect of the university curriculum and have an impact on relevant units (degree, college, university), when they generate dialogue, empowerment, when they are evaluated and when they endure over time as reflective processes in teacher thinking about their own practice.

Teachers who adopt creativity-mediated training do so via a variety of processes. We offer a proposal involving AR and ICT that came out of a process of continuing education where teachers of different subjects in a Mexican interdisciplinary university committed to undertaking change.

Helping teaching to ask in a virtual community

Formación Mediante Creatividad is a project that promotes AR with ICT in universities (Figure 1). Above all, it addresses the way in which ICT helps to build communities of practice around new ways of teaching and seeks to empower teachers.

The Formacion Mediante Creatividad Project started off asking teachers about their practice and involving them in reflection via a workshop that included input on ICT methods.

First, we asked about creativity, and it was a bit disheartening to discover mostly conventional ways of using creativity in classroom. Then, during the training workshop, it was possible for participants to learn about a variety of issues related to the teaching profession and creativity. Above all, it was a chance to prepare them for the process of AR with the support of ICT, and to experience the teaching profession as a process of reflection on the practice, where one grows and solves problems while working in a community with others.

As AR, this project addressed several questions: are students ready to respond openly and creatively to problems that arise in this subject? Do the assignments proposed to students allow them to respond creatively? What kind of relationships foster deeper inquiry and more creative responses by students in the class? What role do resources play in creative responses?

In the intensive workshop, participants explored the following themes: foundations and the purpose of university education, the concept of creativity, creative teachers and students,

Figure 1: Formación Mediante Creatividad Project.

creative teaching, assessment of creativity and planning for the implementation of creative teaching techniques, ICT in teaching and the use of social networks as a means of teaching and professional development.

In the section on teaching methods the following topics were dealt with:

- Conventional participatory techniques: improved direct instruction, instruction techniques by other 'experts', the 'nine points' method, motivation circles, mindmaps, cooperative text commentary, flyers, brainstorming, role playing, puzzles, problem solving, project method, case study, research project (as a teaching technique), subject immersion, group learning, seminars, Phillips 6.6, one-minute evaluation.
- ICT-based techniques: concept maps, autobiographies, reconstructions and inventions, evocative work with multimedia, photos, images and captions, post-it notes, emotional use of texts and the social network itself, in the direction of what McIntosh (2010) has proposed. Forums should host discussions on problems regarding the implementation of techniques, blogs become notebooks for each teacher that can be commented on by other teachers, pictures and videos provide evidence and presence in equal measure. Groups can work on specific creativity techniques and research problems.

Formal commitment is a usual part of AR processes: in this case it involved modifying the curriculum to include aspects of creativity, developing a mini-work project with students, creating a physical and virtual network with colleagues, evaluating materials handed in by students, bi-weekly assessments of other colleagues' contributions (mini-projects, materials analysis, issues), and maintaining a blog or personal space on the network for reflections. In many AR processes teachers have various kinds of incentives (financial, certification). For our part, they have only received academic benefit in the form of certificates.

The curriculum that each participating teacher applied was required to include one or more of the creative techniques addressed in the workshop, and these had to refer to a relevant aspect of programme design. At the same time, teachers were organized into physical pairs in their schools. The pairs played a critical role in implementation because peers helped each other, although not always. A report was prepared by the facilitators that was made available to the group as feedback on the network.

The second AR step consisted of putting the curriculum into practice. This continued until the end of the semester, and involved several months of work where evidence was gathered regarding what happens in order to better understand the teaching method applied. The local team met bi-weekly to discuss the problems that arose, and solutions and issues were posted on the network.

During the process, facilitators and participants posted helpful documents (technique descriptions, evidence collection methods, students' comments, documents produced by students and teachers).

During the meetings, discussions took place on how to organize techniques, what could be achieved with them and how effective they had been with the group of students. This

dialogue about practice should be interesting enough to set in motion a similar dynamic among local colleagues (in their department or specialism) who share a concern for transforming their teaching. When teachers start talking about successful activities applied in their class, the dialogue is fruitful, particularly when it involves something that others can reproduce with the help of a particular resource.

Concurrently, messages were received on the network regarding progress on the curriculum, which constituted each teacher's personal journal entries. Along with text, there were pictures and videos of classes, and student productions that make it possible to establish a dialogue on the progress of projects. The facilitators gathered evidence on the process and provided feedback to the group in order to conduct a reflection on practice. These bi-weekly moments for reflection face-to-face and on the social network were key to the development of each project.

The third AR step led to a report on outcomes. Teachers related what happened in a report with audiovisual backup. They shared what and how they taught and how they responded to doubts, concerns and encouragement by their colleagues. All of this served to generate new courses of action in the classroom and a report of what had been learned in the process.

In the form of a social network, ICT provided a medium for accessing information documents that complement the course work. It also provided a repository for entries and extended discussions, as well as a virtual space for sharing experiences. During the semester, participants in the social network posed questions about aspects of each technique, concerns regarding evaluation or evidence, all type of difficulties, hopes and fears. There was also a rubric to ensure minimum quality in network interactions.

The data obtained allowed the group to grow in the knowledge of creativity applied to their own teaching and the very nature of their own teaching. A community of practice was institutionalized. This project aimed, therefore, to empower teachers through doing research into their own practice with the help of a social network.

Analysis of the project

Although teacher opinions reflected a limited conceptual view of creativity when we first asked them before the process, there was a general perception of freedom to organize their teaching actively, they were aware of working as a team and they tried to create engaging spaces for their students.

A social network can do little without an effort to dynamize and promote participation, which is everyone's responsibility. As a result of the intensive workshop, we were expecting spontaneous organization by teachers. Teachers should modify programmes to include elements of creativity, develop a project with students, create a physical and virtual network with colleagues, evaluate materials submitted by students, valuing contributions from other colleagues, and talk with each other in order to take decisions.

Participants were enthusiastic to join the social network and their expectations regarding the external change agents (researchers) were very high. Sixty teachers attended the course, out of the seventy who had enrolled. About twenty teachers spontaneously joined together in groups around teaching techniques (some belonged to more than one technique group): concept maps (eight [teachers]); autobiographies, reconstructions and inventions (five); evocative work with multimedia (five); didactic projects (five); photos, images and captions (four); post-it (four); emotional use of text (four); and case study (three). In other words, of the eight techniques chosen, six were ICT-based.

Specifically, teachers were persuaded of the advantages of renewing, professionalizing and yet humanizing their community of practice in the network through various activities:

- Creating and customizing their own profile.
- Joining teaching-technique groups covered in the workshop phase to discuss progress in bringing creativity into the university and to plan events.
- Creating new groups for teaching techniques not yet specified in the network.
- Creating a physical and virtual network with colleagues (two or three), so that each participant was supported by another participant who shared their concerns about the project, as well as by a critical friend, and that they be linked together at some point in the network.
- Becoming coordinator of a technique group and being responsible for updating the research team and the overall community of the group's progress.
- Doing additional reading about teaching techniques and ICT mediation in creativity-mediated training. To this end, relevant links were provided on the Welcome page.
- Sharing photos of their work, music and spoken reflections with others.
- Participating in forums on specific issues regarding the chosen technical or other more open content, including questions on procedure.
- Modifying the curriculum of the subject they teach to include elements of creativity for individual work or local teams.
- Sharing knowledge regarding how complexity of material changes in terms of the objectives, methodology, resources, evaluation, etc.
- Posting evidence (already defined).

This demanding participation rubric was only partially fulfilled.

Of the 69 teachers participating in the network, seven participants uploaded their teaching change proposals to the network. They all reflected perfect understanding of the process but there was no interaction in the forums.

When almost four months had passed since the establishment of the social network, the process was reactivated by a message encouraging teachers to continue their training through the web. From that point, there began to be some emails about the design of creative techniques embedded into materials, as well as some interaction on the platform. The emails

also expressed apologies for the delay, uncertainty about responding correctly, and a desire to move forward in the commitment made at the workshop.

The project seemed doomed to a teacher-expert relationship. It became necessary to break this tendency and move towards AR. The team decided to do the following:

1. Receive all material generated by each participant by email, and request permission to publish it simultaneously in the network. It was also decided not to go beyond step 1 until there was considerable teacher participation in the network to avoid hindering the process of elaboration and delivery.
2. Announce the presence of a technique on the network after a significant percentage of the teachers to whom it has been proposed were present. Suggest that each participant join a group on the technique that they used.
3. Give feedback to the group and build knowledge together by drawing from their contributions, their outlook and the researchers' outlook.
4. Ask some participants to assess along with the team of experts on how well each proposal fitted into creativity-mediated teaching, thus getting a joint view and starting a dialogue.
5. Facilitate this dialogue in a mailing list, forum, chat or audio-conference with the whole group scheduled at a particular day and time, with the support of additional reviewers to guarantee dynamic interaction.
6. To request, a little later, evidence of results from student recipients of the new curriculum, such as something from a class (photo of interaction highlights/production involving or by students) or a short video (one minute) of students regarding their opinion on the application of the technique, which could be prepared by students themselves to enlighten and encourage colleagues.
7. Prepare joint reports by technique and knowledge areas including student data.

Some teachers raised universal questions: 'How can I as a teacher incorporate new techniques in order to progressively foster the development of what could constitute a new work strategy? Will these proposals be a hybrid or a syncretic mix of my past [practice] and these options?' asked one teacher who had extensive experience.

Later in the semester, participants were asked by email to say if they had adopted any type of proposal, however small, such as changes in curriculum to include elements of creativity, projects done with students, physical or other networks created with peers, materials presented and evaluated by students, feedback by peers and decisions made in the course of action.

Some new responses were obtained (including contributions to the social network). They were the following: three practical case studies, one autobiography and one didactic project through social network. All had a high level of quality.

Some evidence was also received. One participant was told that their photos needed to show them interacting with the group to see the kind of interactions that took place (so that their account of the technique would be supplemented with evidence to make it more real

to the other participants and encourage repetition of the experience). We received evidence with photographs of students working together. Likewise, videos were received of students who expressed a high opinion of the creative processes in which they took part.

At the end of the semester we asked the participants, in light of what their peers presented, to talk about the future of their projects, particularly in relation to certain questions posed at the outset, and others that they wished to formulate. A number of answers arose to questions posed at the beginning:

- Teachers were taking on proposals that provided room for creative solutions by their students.
- Students seemed willing to give creative responses.
- The students valued greatly that teachers changed the kind of participation in their classrooms.
- Some resources were associated with the changes adopted.

Other questions remained unanswered, and these belong to a user-expert logic: has the dialogue in the physical and social networks helped to improve my understanding of how to make another type of teaching possible? Does 'getting down to work' with other teachers function as an engine for change? What good has it done teachers to look for creativity in their students?

Early results from the start-up of the Formación Mediante Creatividad project attested to the difficulty of generating participation among those who have never been asked to do so, and of proposing a platform for education through creativity where there is no tradition of giving students a say. One in ten teachers who originally joined the project have decided to undertake a process of change towards creativity-mediated training.

Participation has to do with the nature and design of communities (Stuckey & Barab 2007). Tensions between the following arise in the design of web-supported communities:

- *content transmission and engaged participation*: the network provided technical materials on creativity while encouraging commentary.
- *open-ended participation and bounded participation*: the participation was in some sense determined by the AR process itself, but was also open-ended.
- *predefined structure and emergent structure*: the social network was continually adjusted to the needs of participants.
- *concern with usability and sociability*: close attention was paid to understanding the interaction within the platform in order to make it a place for sharing and growing professionally.

Formación Mediante Creatividad is an in-service professional development community. It is based on three premises for building online communities (Stuckey & Barab 2007): it is an active process, it is not only about community design but also about being responsive and it designs

for community continuity. The community is useful for professional growth. It is intended as a vehicle, and some participants along with its promoters are encouraging participation.

Creativity was a powerful mark of the community, as well as its practice and identity. However, it was not attractive enough to provoke an avalanche of participation. It was overrun by other conditioning factors.

The causes may lie in the very nature of participant commitment to a community. Stuckey (Stuckey & Barab 2007) found that in twelve successful web-supported communities of practice, all communities held some sort of face-to-face encounters as a factor for community engagement. Although there were encounters at the beginning, unfortunately others were not planned afterwards, and the encounters that were planned (working with peers and critical friends) were not sufficiently binding with the rest of the community.

Conclusion

As results, we present changes in educational practices that introduce creativity, as well as strengths and weakness of social networks used by teachers as a means of reflective practice. What was observed was that Higher Education teacher-centred practices through creativity-mediated training are possible. The benefits included that teachers who joined the process ended up generating creativity-mediated learning opportunities in their own classes. The disadvantages included that nothing happens virtually that was not already happening in reality. To what extent does the lack of a prior community affect the operation of the virtual community? There has been some naivety regarding the strength of the theme of 'creativity' to attract teachers' engagement and social networking as a tool.

It also happens that there was no expressed interest in the topic of creativity before starting the project. Teachers shared a relatively close geographical area, the lack of participation referred to excessive workload, the voluntary nature of participation was very conditional, the time allocated for the project was too short, and the required proof of participation served to inhibit participation. Thus, the dynamics of real communities appears in the genesis of virtual communities.

References

Clegg, P. (2008), 'Creativity and Critical Thinking in the Globalised University', *Innovations in Education & Teaching International*, 45: 3, pp. 219–226.

Herrán, A. de la (2008a), 'Creatividad para la formación', in J. C. Sánchez Huete (ed.), *Compendio de Didáctica General*, Madrid: CCS, pp. 557–606.

Herrán, A. de la (2008b), 'Didáctica de la creatividad', in A. de la Herrán and J. Paredes (eds), *Didáctica General: La práctica de la enseñanza en Educación Infantil, Primaria y Secundaria*, Madrid: McGraw-Hill, pp. 79–123.

Hoban, G. F. (2002), '"Working" Chapter Self-study through the Use of Technology', *International Handbook of Self-study of Teaching and Teaching Education Practices,* 2, 9–14.

James, A. (2009), 'How do New Designs for Education and Education Leadership Include Concepts of "Least Intrusive Education (LIE)"'? Or other forms of student-driven curriculum?' in *Proceedings of the European education research Association conference,* Goteborg: ECER.

McIntosh, P. (2010), 'The Puzzle of Metaphor and Voice in Arts-based Social Research', *International Journal of Social Research Methodology,* 13: 2, 157–169.

Stuckey, B. and Barab, S. (2007), 'New Conceptions for Community Design', in R. Andrews and C. Haythornthwaite (eds), *The Sage Handbook of e-Learning Research,* Los Ángeles: Sage, pp. 439–465.

Conclusion

Arts-based Inquiry as Learning in Higher Education: Purposes, Processes and Responses

Digby Warren
(London Metropolitan University)

Perspectives

The way of looking at subjects (whether controversial, sensitive or difficult) from a symbolic perspective that was not confrontational I felt was very powerful in its subtlety.
(Student from a course on 'Managing Diversity', quoted in Chapter 6 of this volume)

L ooking across the chapters in this book, we can identify a number of common themes in relation to the goals, methods, challenges and outcomes of arts-enriched pedagogies as applied to professional and other (non-arts) disciplines.

Collectively, the approaches illustrated in these case studies represent various types of 'arts-based inquiry', a term borrowed from the research literature that Louise Younie (Chapter 2) has aptly extended to the learning and teaching domain. In her definition, arts-based inquiry refers to 'student practical engagement with any art form – poetry, photography, painting, narrative, sculpture, dance, music, etc. – as they reflect on their experiences'. It offers opportunities for students 'to engage in their own creative process' and to 'draw out' the learning they have acquired.

Similarly, Debbie Amas and colleagues (Chapter 14) explain how creative methods are processes for 'uncovering', then describing and elucidating students' lived experience. Since these methods are multi-sensory, multi-faceted and multi-layered forms of expression, as Clare Hopkinson (Chapter 7) and Karen Stuart (Chapter 11) remind us, they can generate rich insights, often by unlocking unconscious ideas, feelings or memories. By tuning into the aesthetic imagination and intuition, poetry and other arts can, as Christina Schwabenland (Chapter 6) explains, facilitate new awareness beyond 'pre-existing cognitive frames of understanding'. Art forms, as Mark Rickenbach (Chapter 8) cites from other research, can enable people to 'relax, open their minds, and become motivated to learn'. The learning power of arts-based inquiry, Dave Griffiths (Chapter 4) suggests, might also lie in the process that Gregory Bateson termed 'double description', whereby perspectives arising from creative methods lend new, binocular vision to old or concurrent experience.

The notion of 'dual perspective' also pertains, as Craig Duckworth (Chapter 5) notes, to the concept of 'spect-actor' proposed by Augusto Boal, where audience members participating in drama-based education adopt the perspective of being (as Duckworth puts it) 'at once emotionally engaged and dispassionately critical'. Double perspective is also the

essence of 'metaphor', that figure of speech that evokes a comparison between one thing and another that is different but analogous to it. The fruitfulness of metaphor as an educational tool, as Christina Schwabenland (Chapter 6) shows, is that can open up exploration of both 'similarity and difference'. Above all, art forms employ metaphorical language, which, as Paul McIntosh says (see Introduction), can enable messages and dialogue 'not possible by more literal language'. At the same time, metaphor combines two functions – theoretical and poetic – and underpins both reasoning and imagination (as posited, respectively, by Ricoeur 2003 and by Gibbs 1999, cited in McIntosh 2010: 158), thus furnishing a powerful resource for learning.

Arts-based activities can also encourage paying 'attention to relationships' among the elements of the things observed and then depicted in artistic forms, as Paul Key (Chapter 13) explains, drawing on Eisner's notion of 'artistry'. This process of 'noticing', rather just 'seeing', can heighten our perception of 'reality' and stimulate 'wide-awakeness' to the world (a term coined by Maxine Greene, cited by Eisner). The 'powerful way of noticing' entailed in converting experiences into art objects can be extended to looking afresh at the 'locations' we inhabit as teachers, learners or developing professionals.

As noted in the Introduction to this book, arts-based methods create possibilities for 'transformative learning' approaches concerned with whole person development. An influential theory of adult education, 'transformative learning' derives from Mezirow's (1991) notion of 'perspective transformation', which occurs through critical reflection on our assumptions, towards 'a more inclusive, discriminating, and integrative perspective' (167). Critical reassessment can be triggered by encounter with differing viewpoints or personal or social crisis (Taylor 2008: 6). Mezirow's theory has been criticized for relying too heavily on rationality. Proponents of more holistic versions of transformative learning emphasize that it involves 'use of all the functions we have available for knowing, including our cognitive, affective, somatic, intuitive, and spiritual dimensions' (quotation cited in Taylor 1997: 49). Goodwin (2007) argues that ways of knowing accessed through intuition and feeling are also aspects of scientific insight and creativity, and so should be included within a holistic educational process in Higher Education. More dramatically, Ronald Barnett (2007) calls for an 'ontological turn' in our approach to Higher Education, one that takes seriously the student as a 'human being' and cultivates the 'will to learn'. For this kind of shift, he proposes, we need a new 'vocabulary' that speaks of 'energy', 'engagement', 'passion', 'journey', 'being' and 'becoming'.

In a number of case studies in this book there are affinities with transformative learning. Sometimes the connection is quite explicit. Noting the potential of the arts to facilitate self-awareness of perspectives, as advocated by transformative learning theorists, Louise Younie (Chapter 2) stresses that this practice requires safe spaces 'where perspectives can be realized and challenged'. In their programme of experiential workshops, Debbie Amas and colleagues (Chapter 14) constructed sessions intended to provide a 'transformative opportunity for the students to understand how oppression and vulnerability are experienced both internally and in the external realities of practice' in social work. Their approach reflects the 'emancipatory'

concept of transformative learning originated by Paulo Freire (1984), aimed at exposing systems of oppression and fostering greater equity and justice in society.

In place of the concept of education as 'transformation', Babs Anderson and Jo Albin-Clark (Chapter 1) prefer the notion of 'iterative reframing' as it emphasizes the capacity of creative methods to encourage students 'to review their own ideas, concepts and beliefs in the light of those of others and that of their own learning'. A similar concept of 'reframing' is also employed by Clare Hopkinson (Chapter 7) who suggests that creative writing 'can allow students some emotional distance and reframing of their experience', and by Karen Stuart (Chapter 11) who, likewise, explores how storytelling can help to 'reframe' one's understanding of experience and thus allow constructive change to occur.

All these orientations correspond to an educational approach to the challenge of student diversity, which Warren (2005) classifies as a 'transformative approach'; it rests on a commitment to promoting social justice, a 'relational' cultural stance that 'seeks commonalities [across difference] via dialogical exchange' (246), and 'a participative pedagogy in which students and teachers are co-learners' (245). At the heart of all the practices captured in this book, as foregrounded in the Introduction, is the goal of incorporating the human and spiritual dimensions with Higher Education learning. It is quest that resonates with a growing number of teachers who are concerned, like Chickering et al. (2006) are, that the emphasis in Higher Education on rational empiricism and vocationalism has led to 'neglect of larger human and societal issues concerning authenticity, spiritual growth, identity and integrity, purpose and meaning' (5).

Educational goals

The lecturers who have provided the accounts of their educational practice in this volume turned to arts-based approaches with a range of educational goals in mind:

- as an antidote to content-led curricula, standardized and didactical approaches to teaching, and passive modes of learning (chapters 1, 2, 3, 4, 10, 12, 13, 14, 15, 16, 17);
- to counter-balance the dominance of techno-rationalist models in education and 'depersonalized ways of knowing and learning' in medical training (Chapter 2; see also chapters 7, 8), using embodied learning (chapters 2, 6, 7, 14, 16) to connect the senses and imagination with affective and analytical forms of learning, and methods that can engage different learning styles (chapters 3, 12, 16);
- to stimulate student engagement with learning opportunities and maximize learning potential (chapters 12, 15, 16), including the pursuit of their own learning objectives and greater autonomy in learning (chapters 1, 15, 16), working with peers or a 'critical friend' (chapters 4, 15, 16, 17) and developing a sense of belonging or community (chapters 10, 11, 15, 17);

- to facilitate among learners/practitioners a deeper understanding and 'ownership' of fundamental concepts or theories in the discipline or profession, exploring their relevance to practice and to students' own lives and experience (chapters 1, 3, 4, 5, 8, 11, 12, 13, 14, 16, 17);
- to accentuate human, cultural and ethical dimensions of the subject or professional field; as Gherardo Girardi (Chapter 3) maintains, this is significant in a discipline like mainstream Economics, which has traditionally focused on mathematical models that rest on assumptions that economic behaviour is driven purely by rationality. Trainee medical doctors in Mark Rickenbach's case (Chapter 8) were able, through song lyrics, to explore the different perspectives held by other age groups and gain a wider view of life. The development of 'ethically literate graduates' is the central objective of Craig Duckworth's (Chapter 5) use of applied drama in a module on Applied Ethics, and ethical considerations are directly addressed in the learning aims and processes of other case studies too (chapters 3, 6, 14);
- to develop students' deeper understanding of professional practice and values, including relations with clients – what Sue Spencer (Chapter 9) calls the 'human side of caring' – and students' own capacity to deal with the emotions involved (chapters 2, 7, 8, 9, 11, 12, 13, 14);
- related to the above goal, to build professional identity, confidence and resilience. Karen Stuart (Chapter 11) worked with practitioners in Children's Services to help create a new 'multi-professional identity' for multi-agency teams. Paul Key's (Chapter 13) work in initial teacher education strives to encourage students to develop a teaching identity of 'professional risk-taking and creative thinking'. Debbie Amas and colleagues (Chapter 14) seek to help Social Work students to deal with 'unpredictability of practice' as 'emotionally intelligent' professionals. The MA programme in Leadership and Management described by Dave Griffiths (Chapter 4) aims to help participants deal with the 'uncertainty' presented by organizations as complex systems and uses the musical exercise to explore notions of leadership as 'improvisation' and 'performance'. Emma Bond and Jessica Clark (Chapter 16) use 'creative presentations' and a class blog to develop Education students' understanding of 'constructions of childhood' and their creative skills for future teaching practice. Jouaquin Paredes and colleagues (Chapter 17) instituted a programme to activate and nurture the development of creativity in teaching and learning through the establishment of an online network to support a community of teachers in Mexico who were invited to participate in action research projects;
- to foster student reflection and insight (all cases), self-discovery/self-knowledge (chapters 3, 9, 14) and metacognition (chapters 11, 12, 15, 16), and develop creative thinking abilities (chapters 10, 12, 13, 16, 17); as Debbie Amas and colleagues (Chapter 14) affirm, 'examination of inner processes is the key to effective critical reflection' and can be achieved experientially through arts-based methods;
- to enable serious learning through 'play' or 'playfulness': this idea is implicit in activities such as applied drama or group creations (images, movement), and in the notion of the

'zonal' activities discussed by Dave Griffiths (Chapter 4) – creative activities designed to take participants out of their 'comfort zones' while providing a stimulus for reflection; and Clare Hopkinson (Chapter 7) sees encouragement of a more playful spirit among students as a key aspect of facilitating learning through use of poetry. A fully fledged 'playful' approach underpins the course discussed by Paul Key (Chapter 13), where play is construed as a catalyst for inventiveness, attentiveness and openness in thinking and practice;

- to provide transformative learning experiences engendered by interpersonal communication, reflexive dialogue and collaborative learning (chapters 1, 3, 4, 5, 6, 11, 14, 15, 16, 17). On this point, Babs Anderson and Jo Albin-Clark (Chapter 1) draw a distinction between 'cooperative' and 'collaborative' group learning, suggesting that the while the first involves working jointly to achieve a goal, the second entails 'adjusting one's intention to take account of the input of other(s) and thus requires a higher level of self-awareness, self-belief, motivation and negotiation'.

Learning processes

As shown in the collected chapters, arts-based inquiry manifests in a variety of learning processes, with certain features in common.

Experiential learning

Central to all of the case studies is the use of creative methods as vehicles to stimulate exploration of and reflection on prior experience, by means of art/imagery (chapters 2, 9, 10, 13), film (Chapter 3), video or photography (Chapter 17), music-making (Chapter 4), 'applied drama' (Chapter 5), poetry or lyrics (chapters 6, 7, 8), stories/narratives (chapters 11, 12), learning journals that include visual representations and integrate 'both the narrative and the analytical' (Chapter 15), combinations of the above through creative-reflective assignments (chapters 2, 16), and other practical exercises involving paper sculptures (Chapter 1), movement, masks or sand trays (Chapter 14).

Some approaches are consciously based in an experiential learning ethos and philosophy. For example, on the MA programme in Leadership and Management discussed in the case study by Dave Griffiths (Chapter 4), prior learning acquired through experience in leadership roles is valued equally with formal qualifications at selection, and the range of course activities are designed to generate reflection on, and new understanding of, that experience and the nature of 'leadership' in the participants' own contexts. Emma Bond and Jessica Clark (Chapter 16) embrace experiential learning as a 'holistic' process that incorporates perceptual, behavioural and cognitive strategies of learning, and introduced

an ongoing blog – where students posted images and responses to formative tasks and class debates – to support reflective learning and facilitate creativity. As Paul Key (Chapter 13) explains, the art and design modules in their Initial Teacher Education programme are 'embedded in an experiential and reflective model of learning'; students develop new ways of 'noticing' through exploring and artistically representing a particular landscape or location, and then apply that experience to bringing fresh vision to the classroom 'landscapes' or spaces where they are gaining practical experience as emerging teachers. Karen Stuart's use of storytelling (Chapter 11) is deliberately constructed around Kolb's experiential learning cycle, combined with a psycho-dynamic model of the human development cycle, to enable insights and lessons from previous professional experience to be surfaced and change to be instigated.

Many activities are direct forms of experiential learning in themselves, such as learning about teamwork via collective music-making (Chapter 4), grappling with ethical issues depicted in dramatic scenarios (Chapter 5), reflecting on one's life 'script' through engaging in storytelling (Chapter 11), undertaking group creations (Chapter 14), or walking a labyrinth, which, as Jan Sellers (Chapter 15) reveals, can provide a peaceful, meditative space for deepening reflection and creativity and contemplating one's life journey or career aspirations. In the case study presented by Louise Younie (Chapter 2), medical students gained first-hand experience of art, music and dance therapies. For the students in the Fashion course discussed by Ruth Marciniak and colleagues (Chapter 10), the museum visit provided a chance to encounter directly examples of iconic design to inspire their course assignment, while also learning how to work together as a team. With regards to storytelling, Karen Stuart (Chapter 11) calls her approach 'narrative inquiry', adopting the term from a recognized research technique. She underscores the power of stories as 'sense-making tools', 'political tools' and 'professional tools' that can facilitate critical insight into human relationships, oppressive practices and workplace dynamics, and generate new ways of thinking and new solutions.

Use of metaphor and symbolic objects

As is apparent from the range of creative methods outlined above, arts-based inquiry inherently involves the use of symbolic objects – poetry, song lyrics, images, sand or clay sculptures, found objects, masks, stories, etc. – as tools for activating and connecting metaphorical and analytical thinking.

The American educationalist, Parker J. Palmer, sees symbolic objects as means to access inner knowing, allowing 'the shy soul to speak' without being intimidated by the 'headstrong' intellect (Palmer 2003). In a similar vein, Sue Spencer (Chapter 9) observes that when dealing with sensitive topics, such as students' feelings about end-of-life, 'words are often difficult to find … [but] images can stimulate insight and understanding'. Christina Schwabenland (Chapter 6) finds that that poetry offers a 'gentle, rather than confrontational

way' to explore difficult issues, such as attitudes to sexual orientation, and also 'promotes empathy', a quality desirable for 'living well in plural society'. Narratives also deploy symbolic material, as Karen Stuart (Chapter 11), citing Gabriel, shows, thus enabling engagement with imagination and 'empathetic forms of understanding' (Koch, cited by Stuart). She adds that 'by using metaphor to encode our stories, we can be offered the safety and distance to share events that would otherwise remain private'.

Metaphor is a central theme in many of the creative methods described in this volume. Symbolic objects encapsulate metaphor. Music-making (Chapter 4) becomes a metaphor for teamwork, leadership and 'improvisation' in organizations. The labyrinth (Chapter 15) is a metaphor for the journey of learning or life itself. Stories produced 'metaphors for change' (Chapter 11).

Holistic learning

Art-based approaches also make possible holistic forms of learning that integrate intuition, emotion and logic as well as somatic and relational aspects of learning. Poetry is a type of 'embodied knowing' (Clare Hopkinson, Chapter 7) and offers 'permission to go beyond words and the rational self' (Sue Spencer, Chapter 9). Having to represent 'reality' as objects of art, Paul Key (Chapter 13) explains, requires students to integrate sensory engagement, imagination and systematic thinking. Embodied learning was facilitated by Debbie Amas and colleagues (Chapter 14) who used movement at the start of each class to establish a sense of physical, emotional and mental presence – thereby allowing 'greater freedom of expression' and 'freedom to take risks' – and guided visualizations to 'reconnect with the senses via the imagination'.

Challenges and limitations of methods

For all their potential to generate rich and powerful learning experiences, arts-based methods also present particular challenges and limitations, as revealed in a number of case studies.

To begin with, we need to be mindful, as Dave Griffiths (Chapter 4) flags up, citing the classic work by Gareth Morgan (on images of organizations), that metaphors can constrain our way of seeing as well as creating insight. In addition, as Clare Hopkinson (Chapter 7) notes from the literature, poetry can also 'oppress', or its usefulness might be undermined by elements of paradox within it. Equally, stories can be oppressive, for instance, if used to proselytize or bolster control, as Karen Stuart (Chapter 11, citing Gabriel), points out – unless 'countered with non-dominant narratives or at the very least critical commentary'.

There are also ethical issues of teaching, indicated by Christina Schwabenland (Chapter 6), around the way our frameworks and practices may be experienced by (international)

students from very different cultures who are little prepared for finding their deepest assumptions being challenged – to which she offers poetry as a gentle approach.

When faced with creative methods, students can be worried about their lack of artistic skills (Chapter 1) or blocked by their 'internal critic' (Chapter 7), so they need to be reminded that the point of the exercise is engagement, that 'artistic merit is not an important criterion', it is more important to create something 'personal and meaningful to them' (Sue Spencer, Chapter 9).

Unfamiliarity with arts-based methods can cause some students initial anxiety (Chapter 16) or some potential resistance, as Sue Spencer (Chapter 9) found with respect to role play, and Karen Stuart (Chapter 11) discovered when asking students to write a metaphorical story. Groupwork anxieties or dynamics may also surface (chapters 1, 7, 10).

These methods often uncover suppressed or unconscious emotions, attitudes or beliefs (as illustrated in chapters 9, 11, 14). While sometimes this can lead to a 'cathartic release of emotion' (Chapter 14), there can also be mixed reactions (see below) from students, and it can be hard, as Christina Schwabenland (Chapter 6) observed, to predict the effects of different exercises.

Role of lecturer

Hence, when working with creative methods there is a need for teachers to establish clear boundaries and ground rules (see chapters 2, 6, 7, 9) and provide careful facilitation, in order to build rapport and trust. In Clare Hopkinson's experience (Chapter 7), a balance has to be struck in considering the safety of the group: if too unsafe, students may not engage, but if too safe they may not be sufficiently 'inspired to reflect on their practice'. Regulating ways of acting, Paul Key (Chapter 13) suggests, can actually stimulate rather than constrain students' creative responses. Karen Stuart (Chapter 11) employs a purposively structured process for 'narrative inquiry' in the classroom, beginning by clarifying the purpose of the activity, using an ice-breaker and unfolding a story as a model.

Besides creating a positive and collaborative environment, the role of lecturer proposed in most case studies is that of a 'facilitator' who is both a source of expertise and mentor of active learning. It is, as Audrey Beaumont (Chapter 12) submits, a 'complex and changing' role: while primarily a 'leader and facilitator', the lecturer is also a 'questioner, challenger, supporter, clarifier and explainer'. The idea of being a 'challenger' is echoed in the characterization by Babs Anderson and Jo Albin-Clark (Chapter 1) of the teacher as a 'provoker of thinking'. This notion tallies with Erica McWilliam's (2007) vision of the lecturer as a 'meddler in the middle', mutually involved with students in 'assembling and dissembling cultural products designed to inform, entertain, subvert, problem-solve and investigate' (8; italics in original).

The other quality deemed fitting is that of authenticity. Louise Younie (Chapter 2), for instance, observes how transformative learning was marked by everyone becoming

'more open and honest with each other'. Clare Hopkinson (Chapter 7) realized that it was important to the learning process for her as the facilitator to be 'honest' with students about her own vulnerable feelings in sharing a poem with them. Likewise, Sue Spencer (Chapter 9) discovered that she needed to be more self-disclosing about her own experiences related to the issues (around death and dying) being communicated in class.

Assessment issues

On the matter of assessment, Louise Younie (Chapter 2) highlights the necessity of choosing methods appropriate to 'the nature of the learning on the course'. In her case, critical thinking was assessed by means of an academic essay, reflection and self-awareness via a learning diary, and imaginative thinking through an art form in the students' creative-reflective piece.

A parallel issue is the question – raised in the case study by Jouaquin Paredes and colleagues (Chapter 17) – of how to evidence changes in pedagogical practice, intended to build creativity in the curriculum, as part of an action research project. Here it concerned a voluntary group of working teachers, but the issue is generic to any type of professional education or development driven by action research. The authors, acting as project facilitators, proposed the use of photographs and videos documenting classroom interactions and student reactions and examples of work produced by students. They also encouraged creative ways to capture the teachers' ideas about their practice, including 'music and spoken reflections with others'.

Following the advice of the educational literature, Emma Bond and Jessica Clark (Chapter 16) reiterate the importance of providing students with clear guidance about assessment expectations and standards. In the context of arts-based assessment, they stress the need to ensure that 'assumptions surrounding creative work' are explored between teachers and students, and the potential learning benefits of creative approaches are clarified. They found that students learnt continuously and gained new ideas from watching each other's presentations, reinforcing the value of 'assessment-as-learning' and peer-to-peer knowledge-sharing. Their case study also endorses the positive impact of allowing students a degree of choice and autonomy in assessment, an approach which both caters for different learning needs and styles and motivates deeper engagement with assessment (shown in improved grades not only for the presentations but also the subsequent written critical papers).

Outcomes

Turning to the main outcomes of arts-based inquiry, as revealed by our case studies: in general, there was improved motivation and participation by students, including increased enjoyment (chapters 2, 3, 4, 6, 10, 15, 16), greater connection between participants

(chapters 3, 7, 14) and boosted energy levels and cognition (chapters 14, 16). The pedagogical approach provided space for self-expression (chapters 14, 16) and facilitated 'more democratic interaction' (Chapter 14) and co-learning between students and teachers. Other benefits included enhanced confidence and self-belief (chapters 2, 12, 14, 15) and development of a capacity for resilience or staying-power (chapters 4, 7, 14).

However, there were also mixed responses from students. For example, Sue Spencer (Chapter 9) found that although students were ultimately positive about the learning experience, a couple of them had felt anger at being made to feel vulnerable. The doubt and anxiety that participants at first felt about the music-making task described by Dave Griffiths (Chapter 4) was balanced by the realization of being 'in the same boat'. Emma Bond and Jessica Clark (Chapter 16) report that some students felt initial apprehension about doing creative presentations, but others were excited at the opportunity to bring in 'art stuff' to this type of assessment.

In many instances, creativity was stimulated, and even inspired some students to re-engage with personal creative activity, as Louise Younie (Chapter 2) mentions. The museum visit (Chapter 10) impelled students to 'think imaginatively' (as one of them said), and the music-making exercise (Chapter 4) tapped into participants' creativity. Walking the labyrinth (Chapter 15) helped to foster creative processes, as did producing images (chapters 9, 13, 14).

Another prevalent theme was the deeper reflection and approach to learning enabled by creative methods (chapters 13, 14, 15, 16), bringing new insights and appreciation of abstract concepts (chapters 3, 12, 13, 14, 16) while also challenging students' epistemological beliefs (Chapter 12). Craig Duckworth (Chapter 5) observes that student participation in applied drama promotes 'engaged critique' of ethical dilemmas, which he defines as 'a form of critical reflection that is at once outside and inside other agents' moral experience'. The creative exercises devised by Debbie Amas and colleagues (Chapter 14) provided direct experience of reflection, not just 'talking about reflection theoretically in class' (as one student commented). Audrey Beaumont (Chapter 12) shows how learning journals became tools for reflective thinking and self-appraisal, aided by peer dialogue with a 'critical friend', so enabling personal construction of knowledge and critical review of own professional practice. Through the process of team-based music-making, Dave Griffiths (Chapter 4) suggests, participants gained a taste of experience in 'macrocognition', that is, concerted group performance arising from a shared sense of what the situation demands.

A number of case studies also demonstrate that transformative learning was facilitated. For example, the Social Work students who attended the experiential workshops run by Debbie Amas and colleagues (Chapter 14) were engaged 'holistically' and gained deeper awareness of their own values, emotions and inert prejudices. Similar growth was achieved by students on the course offered by Louise Younie (Chapter 2), as well as more openness towards others and to alternative perspectives. Clare Hopkinson's (Chapter 7) students also developed a deeper understanding of the emotional dilemmas and values of nursing practice, and increased empathy. Equally, the practitioners who worked with Sue Spencer (Chapter 9) experienced a heightened sense of their emotional responses to health care situations and

how to cope with them. Participants who walked the labyrinth, as Jan Sellers (Chapter 15) illustrates, also acquired insights into personal and professional values or gained greater clarity about their aspirations for study or for the future. All these examples testify to the potentially transformative impact of arts-based inquiry as a holistic approach to learning.

References

Barnett, R. (2007), *A Will to Learn: Being a Student in an Age of Uncertainty*, Berkshire: Open University Press.

Chickering, A. W., Dalton, J. C. and Stamm, L. (2006), *Encouraging Authenticity and Spirituality in Higher Education*, San Francisco: Jossey-Bass.

Goodwin, B. C. (2007), Science, spirituality and holism within higher education, *International Journal of Innovation and Sustainable Development*, vol. 2, no. 3–4, pp. 332–339.

McIntosh, P. (2010), 'The Puzzle of Metaphor and Voice in Arts-based Social Research', *International Journal of Social Research Methodology*, 13: 2, pp. 157–169.

McWilliam, E. L. (2007), 'Is Creativity Teachable? Conceptualising the Creativity/Pedagogy Relationship in Higher Education', In 30th HERDSA Annual Conference: Enhancing Higher Education, Theory and Scholarship, 8–11 July, Adelaide. See http://eprints.qut.edu.au/15508/1/15508.pdf.

Mezirow, J. (1991), *Transformative Dimensions of Adult Learning*, San Francisco: Jossey-Bass.

Palmer, Parker J. (2003), 'Teaching with Heart and Soul. Reflections on Spirituality in Teacher Education', *Journal of Teacher Education*, 54: 5, pp. 376–385.

Taylor, E. W. (1997), 'Building on the Theoretical Debate: a Critical Review of the Empirical Studies of Mezirow's Transformative Learning Theory', *Adult Education Quarterly*, 48: 1, pp. 34–59.

——— (2008), 'Transformative Learning Theory', *New Directions for Adult and Continuing Education*, 199 (Fall), pp. 5–15.

Warren, D. (2005), 'Approaches to the Challenge of Student Cultural Diversity: Learning from Scholarship and Practice', in J. Fanghanel and D. Warren (eds), International Conference on the Scholarship of Teaching and Learning: Proceedings 2003 and 2004, London: Educational Development Centre, City University, pp. 237–253.

Index

Page numbers in **bold** refer to figures, those in *italic* refer to tables